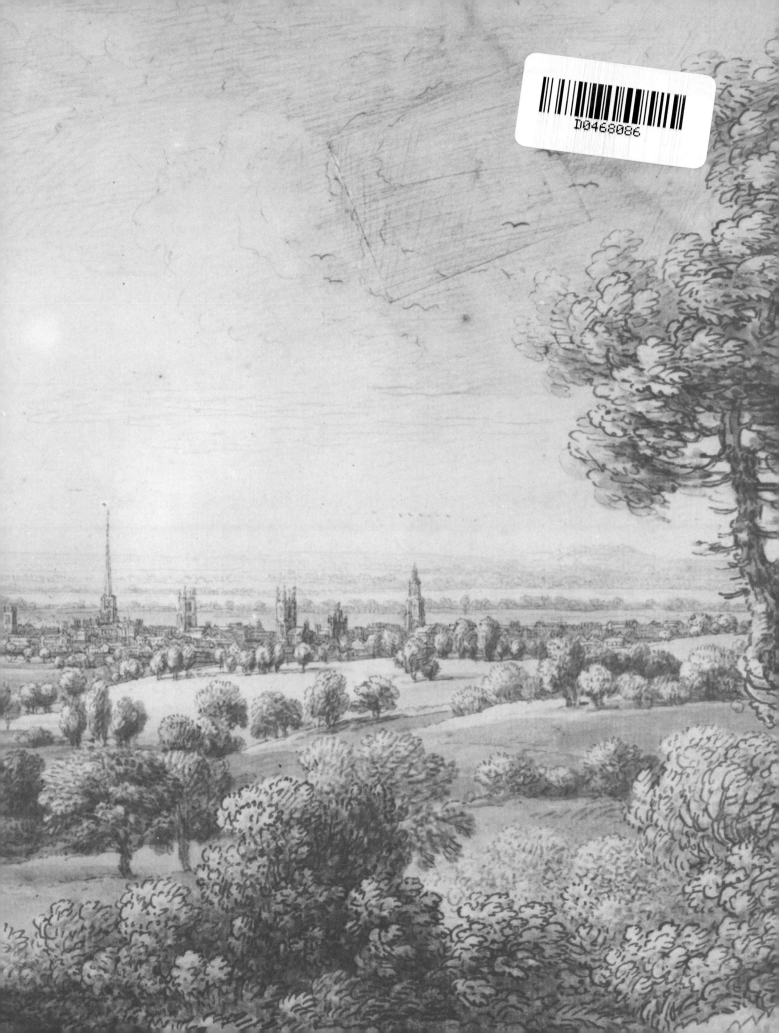
D0468086

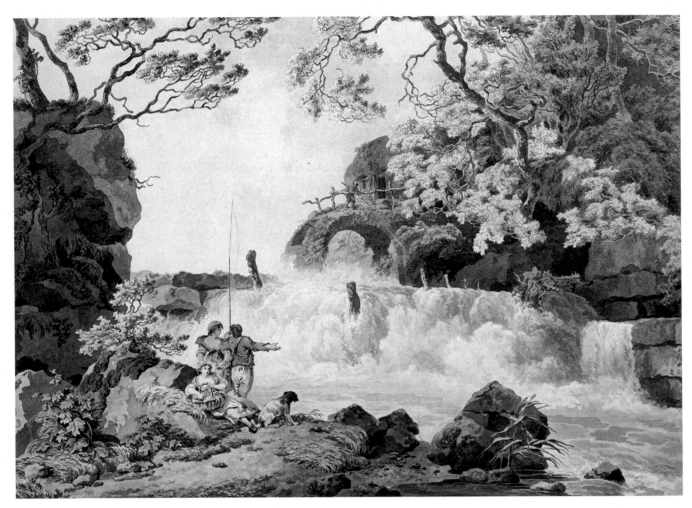

Francis Wheatley (1747-1801) Christie's

This is in neat grey ink and watercolour, and it is dated 1784. The subject is an Irish one, the Salmon Leap at Leixlip, and this can sometimes increase price. It is a perfect example of eighteenth century elegance in draughtsmanship. Wheatley's trees are all of a wiggle, and he pays great attention to the docks and reeds of the foreground.

Understanding Watercolours

H.L. Mallalieu

Antique Collectors' Club

© Huon Mallalieu 1985
World copyright reserved

ISBN 0 907462 39 1

First published in 1985
for the Antique Collectors' Club
by the Antique Collectors' Club Ltd.
Reprinted 1986
Reprinted 1988

All rights reserved. No part of this publication may be reproduced, stored in a retrieval system, or transmitted in any form or by any means electronic, mechanical, photocopying, recording or otherwise, without the prior permission of the publishers.

British Library CIP Data

Mallalieu, H.L.
 Understanding Watercolours.
 1. Watercolour painting, English — Collectors
and collecting.
 I. Title
 759.2 ND1928

The endpapers : J.B.C. Chatelain
Half-title : George Chinnery
Tail-piece : Thomas Rowlandson

Printed in England by the Antique Collectors' Club,
Church Street, Woodbridge, Suffolk.

The Antique Collectors' Club was formed in 1966 and now has a five figure membership spread throughout the world. It publishes the only independently run monthly antiques magazine *Antique Collecting* which caters for those collectors who are interested in widening their knowledge of antiques, both by greater awareness of quality and by discussion of the factors which influence the price that is likely to be asked. The Antique Collectors' Club pioneered the provision of information on prices for collectors and the magazine still leads in the provision of detailed articles on a variety of subjects.

It was in response to the enormous demand for information on "what to pay" that the price guide series was introduced in 1968 with the first edition of *The Price Guide to Antique Furniture* (completely revised, 1978), a book which broke new ground by illustrating the more common types of antique furniture, the sort that collectors could buy in shops and at auctions rather than the rare museum pieces which had previously been used (and still to a large extent are used) to make up the limited amount of illustrations in books published by commercial publishers. Many other price guides have followed, all copiously illustrated, and greatly appreciated by collectors for the valuable information they contain, quite apart from prices. The Antique Collectors' Club also publishes other books on antiques, including horology and art reference works, and a full book list is available.

Club membership, which is open to all collectors, costs £15.95 per annum. Members receive free of charge *Antique Collecting,* the Club's magazine (published every month except August), which contains well-illustrated articles dealing with the practical aspects of collecting not normally dealt with by magazines. Prices, features of value, investment potential, fakes and forgeries are all given prominence in the magazine.

Among other facilities available to members are private buying and selling facilities, the longest list of "For Sales" of any antiques magazine, an annual ceramics conference and the opportunity to meet other collectors at their local antique collectors' clubs. There are over eighty in Britain and more than a dozen overseas. Members may also buy the Club's publications at special pre-publication prices.

As its motto implies, the Club is an amateur organisation designed to help collectors get the most out of their hobby: it is informal and friendly and gives enormous enjoyment to all concerned.

For Collectors — By Collectors — About Collecting

The Antique Collectors' Club, 5 Church Street, Woodbridge, Suffolk

'That Art, which gives the practis'd pencil pow'r
To rival Nature's graces; to combine
In one harmonious whole her scatter'd charms,
And o'er them fling appropriate force of light.
I sing, unskilled in numbers.'

The Revd. William Gilpin

Contents

Colour Plates

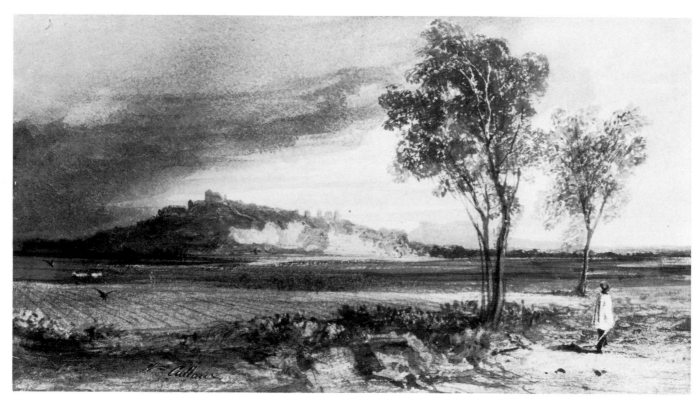

William Callow (1812-1908) M. Gregory
(see detail on page 148)

Introduction

This book does not set out to be an art history, nor will it provide a comprehensive survey of a remarkable, if circumscribed and unpretentious, contribution to the cultural development of Western Europe, and thus to the civilisation of the world. It is not even an attempt to recruit fellow enthusiasts for a branch of art that I personally find always appealing and sometimes great. Its purpose is rather to indicate to those who may already have been attracted ways in which they may see more clearly, and enjoy more fully. If I had to make a list of the truly great artists of the world, J.R. Cozens, Girtin and Turner would find a place, but this is not to deny that there were many feeble if not dreadful artists among the competent painters of the English watercolour school, just as there are many jobbing hacks in the ranks of those commonly styled Old Masters.

Art historians have often posed the question "Why England?" in passing reference to the supreme development of watercolour painting, and they have rarely if ever paused to answer it. I will pause, but I too will provide no answer that is ultimately satisfactory. What I hope to do is to place the development and the achievements of the English and later British artists who used the medium in their social and scientific context. At the very least this may help to explain why so many artists thought that the medium was worth their while to use, and why so many collectors and connoisseurs have felt the results to be worthy of their attention.

More often than not connoisseurship seems to be a matter of travelling backwards. The collector of Chinese porcelain may start with blue and white and travel backwards through the familes vert and rouge to the purity of Sung. The youth whose early affairs were with the lavish enticements of rococo and baroque may come in his maturity to the quiet certainties of the Renaissance. Among the English watercolourists my own first love was Hercules Brabazon Brabazon — although one cannot love him half so much when one learns that his original surname was Sharpe — but now I would give all the Brabazons that the excellent amateur ever produced for one perfect John Robert Cozens.

A satisfactory love affair with the English watercolour school must be a matter of changing and improving taste. It must also be an affair of self discipline. It is not good enough to feel "that is rather nice and very like so-and-so". You must know that it is by so-and-so before you buy it. This book is intended to show you how to look, and ultimately how to know. It does not presume to be a manual of taste, since ultimately there must be as many shades and varieties of good and bad taste as there are observers.

The illustrations and examples have been selected to make a point, rather than to provide a visual summary of the school from its beginnings to date, and for the most part they have ignored the stylistic developments of the twentieth century, when despite great practitioners such as Paul Nash and David Jones, the English watercolour painters must be considered as part of a larger artistic whole. However, the basic principles of looking are the same in any century.

Many people have advised and helped me along the way, and I must particularly thank Anthony Reed, Jeremy Lemmon, Crispian Cartwright, Simon Carter and Audrey Flannery for their various comments and criticisms of the early versions of

my manuscript. Gilli Ardizzone the restorer, John Ford of Ackermann and Philip Poole, the great penman of Drury Lane, were most generous with expert advice in their specialist fields. Stuart Milne's lucubrations on Gaelic provided, as always, a twilight relief. Many of the photographs have been taken by Charles Chrestien, and I trust that they will stand as a testament to his skill. My thanks also to Christopher Barrett for painting his version of the Laporte progression.

Above all I must thank my wife Fenella, who has kept the grindstone turning, not least by the promise and provision of superb dinners to mark the passing of the various stages of composition. This book is dedicated to her, and to the memory of my father, Sir Lance Mallalieu, who first provoked my interest in the English watercolour painters and their achievement.

H.L.M. 1985

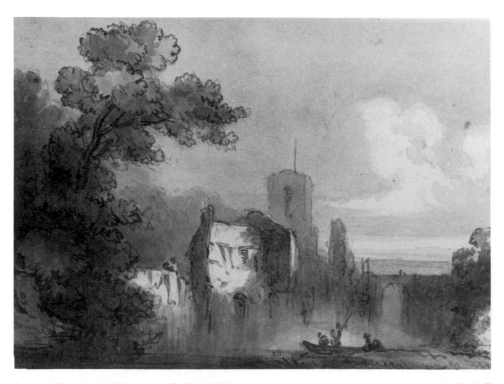

James "Drunken" Robertson (fl.1815-1836) B. Kendall
(see detail on page 107)

A First Bibliography

It is conventional to place a select bibliography at the end of a book. In this case it would be as well to put the bibliography before the book, since there are a number of general works which should be on every collector's shelf — and frequently in his hands — before he so much as ventures into a gallery or attends an auction. More technical works are listed at the end of the appropriate sections. Those given here are listed in order of personal esteem, rather than alphabetically.

Iolo A. Williams, *Early English Watercolours*. This was first published in 1952, when it attracted a dispiriting lack of attention. However, since it was a labour of both love and scholarship undertaken by one of the most civilized and knowledgeable collectors of his day, it gradually became not only essential reading, but a collectors' item in its own right for the cognoscenti, and it was at last reissued by Kingsmead Reprints in 1970. It takes the story up to the careers of the artists born in the early 1780s, and it is a joy to read. Subsequent researches have inevitably added to it, but Williams remains the essential key to understanding the early period.

Martin Hardie, *Watercolour Painting in Britain*. Published by Batsford between 1967 and 1969 in 3 volumes, which cover the whole subject up to the end of the nineteenth century. It seems almost churlish to say so, but the third volume is the most valuable. This appeared after Hardie's death and was completed and edited by Dudley Snelgrove, Jonathan Mayne and Basil Taylor. It has a wide-ranging and useful bibliography which is particularly strong on monographs and biographies of individuals. The very basic equipment without which no collector can hope to prosper is Williams together with Volume Three of Hardie.

J.L. Roget, *History of the 'Old Watercolour' Society*, 1891. This seminal tome, which was compiled from the notes and manuscripts of the long-serving secretary of the O.W.S., J.J. Jenkins, was reissued by the Antique Collectors' Club in 1972. It contains a great deal of first hand information, and has provided the basis of many subsequent studies. Many artists who were not actually members of the Society are also covered, and as a bonus, the book provides an invaluable sidelight on the artistic and acquisitive attitudes of the latter part of the nineteenth century. It will often give the clue to fruitful lines of research.

These are all pleasant and useful to have and will give you the background. Some, of course, are out of print.

A General shelf: Cosmo Monkhouse,*The Earlier English Water-Colour Painters,* 1980; C.E. Hughes, *Early English Watercolours,* 1913 (revised, 1950); Randall Davies, *Chats on Old English Drawings,* 1923; Sir John Rothenstein; *Introduction to English Painting,* 1933 (revised 1965); Laurence Binyon, *English Water-Colours,* 1941; *Aspects of British Art,* ed. W.J. Turner, 1947; Henri Lemaître, *Le Paysage Anglais à l'Aquarelle, 1760-1851,* 1955; Graham Reynolds, *A Concise History of Watercolours,* 1971; Andrew Wilton, *British Watercolours 1750-1850,* 1977; Judy Egerton, *English Watercolour Painting,* 1979. Of these I would particularly recommend Lemaître, if your French is good enough. Naturally it has not been translated.

The last group covers the art historical side of the subject. In his *Collecting Drawings* of 1970, Ken Etheridge took a more utilitarian approach, covering some of the topics which will appear in this book. Techniques, as well as the social history which was the setting for the English school, are the province of a delightful volume by Michael Clarke, *The Tempting Prospect,* 1981.

H.L. Mallalieu, *The Dictionary of British Watercolour Artists up to 1920,* 2 vols, 1976, 1979. Modesty forbids any general comment on this Antique Collectors' Club publication, so I quote only the note appended to the show copy on the Tate Gallery bookstall: "This is the standard work on the subject."

The serious collector should attempt to amass the annual volumes issued by the Old Water Colour Society's Club, or at least make sure that he has access to a set, as also the volumes of *Walker's Quarterly* which were published by the late lamented Walker Galleries of Bond Street. They will be expensive, but are invaluable.

The first major work on Scottish artists was Sir James Caw's *Scottish Painting 1620-1908* (Kingsmead reprint, 1975). This is still a pleasure to read since Caw had the soul of a poet as well as the eye of a connoisseur, but for more recent research there is D. & F. Irwin, *Scottish Painters at Home and Abroad, 1700-1900,* 1975. The equivalents for the Irish are W.G. Strickland, *A Dictionary of Irish Artists,* 1922 (reprint 1965), and Anne Crookshank and the Knight of Glin, *The Painters of Ireland c.1660-1920,* 1978. The last authors have a volume devoted to watercolour painters in preparation.

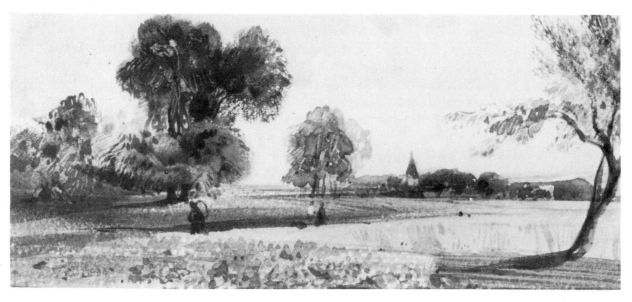

Thomas Shotter Boys (1803-1874)
(see detail on page 149)

Christie's

1. The Watercolour

The term watercolour, when used by way of contrast to an oil painting, is in fact a misnomer. In an oil painting the pigments are bound to each other and to the surface with linseed or other oil. 'Water' colour pigments are bound to the paper not with water but with gum arabic, which is obtained from the acacia tree. The water, which evaporates, is merely used to spread and dilute the colours, as turpentine is with oil paint. In logic, perhaps, we should speak of oil paintings and gum paintings, or of watercolours and turpscolours. However, the word is sanctified by the usage of four centuries, and it would be more than pedantic to object to it now.

Although the practice of watercolour painting did not originate in England, and has had a distinguished history in many other countries, it is fair to claim that between the seventeenth and the nineteenth centuries English artists brought it to a perfection which has not been equalled elsewhere or at other times. Many factors contributed to this, and the exact weight and significance which should be given to each is a matter for endless art historical argument, which while fascinating in itself does not immediately concern us here.

At least one factor, however, is of considerable importance to anyone seeking to understand and appreciate the achievement of the English watercolour school. In the latter half of the eighteenth century and for much of the nineteenth, those who collected watercolours and who criticised the work of professional artists, were likely to have some grounding in the basic techniques of the art and some experience of trying to produce a drawing for themselves. This was an invaluable aid when judging whether a watercolour had worked and whether the artist had achieved his aims. Creative artists — painters, composers, playwrights or whatever — all too often sneer at their critics, and their public, on the spurious grounds that only a creator can be a competent judge of what is created by another. This is of course nonsense, just as it would be to argue that no artist has the objectivity — or the talent — to be a good critic or a worthwhile connoisseur. But at the same time, any serious collector of watercolours should make the effort to paint a watercolour for himself, at least once, if only to see just how difficult it is.

By the end of the eighteenth century some sort of ability with the pencil — a word which was then used for any sort of small or medium sized artist's brush — had become one of the accepted and expected social graces for both ladies and gentlemen. Lessons from a drawing master were a usual part of the season in London or Bath, and those who stayed at home would often employ a local man or solicit visits from a travelling professional. The greater part of the income of most artists was derived from teaching. It was natural that many drawing masters should attempt to exploit the fashion by devising methods and techniques which were easily assimilated and copied, and even if these were unlikely to produce great art, they were equally unlikely to disgrace either pupil or master. Some teachers went further and published lesson books giving stage by stage instructions for the amateur to follow. These were more than just an early form of painting by numbers, since the student had at least to create the basic composition for himself.

"I am about to introduce to your notice, gentle reader, the progress of a drawing." Thus John Laporte in his book, *The Progress of a Water-Coloured*

Drawing, which appeared in about 1812. It is worth giving a summary of his progression, and perhaps attemping to follow it, since it will enable an amateur today, as then, to produce something like a watercolour of that time, albeit in a rather old fashioned style.

Below we print the most important stages in Laporte's progression (eleven out of the original fourteen). On the opposite pages Christopher Barrett has attempted to follow them, giving his comments on the way. (Mr. Barrett's comments are printed in italics.)

In his introduction Laporte gives a list of equipment, which could be simplified for modern use, although no extra colours should be used. It is obvious from the list that his method was intended for indoor composition rather than open air work.

"For this sort of drawing the following colours, brushes etc. will be found necessary:- Prussian Blue; Yellow Ochre; Madder Lake; Light Red; Indian Red. Half a dozen flat brushes; a dozen camel-hair brushes of different sizes; one dozen large saucers; two smaller ditto unglazed; two middle-sized pieces of sponge; two pint basons for clean water; two or three small quills, with pieces of sponge fixed at the end of them: these are extremely useful, either to produce half tints, or to take out anything done wrong, or to soften any lines which have been made too hard."

Laporte's own demonstration composition is a romantic Claudian landscape with groups of trees, a ruined castle along one side of the horizon, and a few figures to give interest to the foreground. In general his method is to work from the sky downwards.

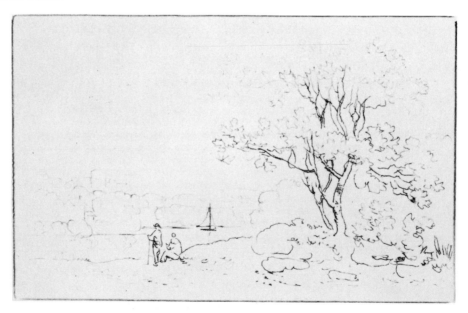

The first stage, naturally enough, is to prepare a rough outline of the whole composition.

Next: "Stretch some paper on a board, or drawing-frame; then, before you begin your drawing, make enough of each of the three colours, yellow ochre, light red and

The paintings are painted to the same scale as the original Laporte pictures, 7¾ x 5ins. The paper used is 140lb, not Arches. Colours have been restricted to Prussian blue, yellow ochre and light red. The madder lake and Indian red mentioned by Laporte are only used by him in the final stages. In the case of the madder lake he uses it for the seated figure in our stage 10 having washed out the light red he had used in our stage 9, only to change his mind again for the final stage where the figure is again light red.

In watercolour one can use a remarkably restricted palette to achieve a very full and colourful effect. Because of the transparency of the medium, pigments, which in other paints seem dull, in watercolours are very bright. For example, the bright yellow of the sky in the Laporte is made using yellow ochre, which in the tube or pan looks more like a brown. To paint the same sky using oil paint one would have to use a much more intense pigment.

The brushes used are fewer than the eighteen suggested by Laporte. A large No. 1 sable brush now costs £50, so the amateur might think twice about starting at all, but much can be done with only a few brushes as long as they are of good quality. In watercolour good work cannot be done with poor brushes. One needs at least one large flat wash brush for laying in large areas of colour (£4) and some sable brushes — say a No. 8 (£9) and a No. 4 (£3). A good brush should always come to a fine point, so that even with a large brush it is possible to work in detail. Of course the more brushes you have the more convenient the painting process becomes.

Outline drawing. This does not need to be detailed as it only serves as a guide for the main areas to be coloured.

The drawing board should be propped up at an angle of about 30° when laying in large areas such as the sky. You should work fast without rushing, so that one

Prussian blue, in separate saucers, to do all the sky... Everything being now prepared, turn your drawing upside down; and then from the outline (as your drawing is turned), taking a flat brush'' put in the colours for the sky.

Wash these colours over with water to blend and soften them, repeating these operations with more colour and more water some three or four times until the whole sky is in harmony. Allow it to dry.

Next decide where you want clouds and ''take out the lights in the sky'', again using a brush and water, or rubbing with a piece of bread from nearest the crust. At this stage you have presumably turned the drawing the right way up.

colour blends into the next. Notice in the Laporte example that he does not attempt to follow the outline in his drawing very carefully. Because the colours are so pale it matters very little if you end up with a mess at this stage. In this example the blue was made too strong, which is very easy to do with Prussian Blue, but by the final stage the effect appears more unified because it is seen in the context of stronger darker colours.

The clouds should be stopped out using a sponge or absorbent paper while the sky is still wet. If, as here, the sky is allowed to dry the clouds can be put in by rubbing the surface of the paper with a rubber or scratching the paper with a sharp knife.

You should now work over the sky once more with very thin washes of the three colours, and if the effect seems too bright, make a grey by mixing the three and superimpose this, remembering to put less grey towards your source of light.

Now work over your original outline to make it "full", complete and correct".

Allow the painting to dry before putting in the shadows for the clouds. To make the grey, less Yellow Ochre is needed than Light Red and Prussian Blue.

Drawing out the design. This can be put in quite strongly using a sharp 4B pencil. The distance should be drawn more lightly. The drawing plays an important part right through to the finished work where some of the drawing remains visible. The Laporte is very much a 'watercoloured drawing' rather than a watercolour painting.

"The distance must first be laid in by a grey, nearly or just the same as the shadows of the clouds nearest the strong lights." You then work forward with darker stages of grey. Put in the first colours on the trees and other major features of the composition. (This grey ground was a feature of earlier watercolours, and it was already falling out of fashion when Laporte produced his book.)

Put in the clouds and their shadows, using greys.

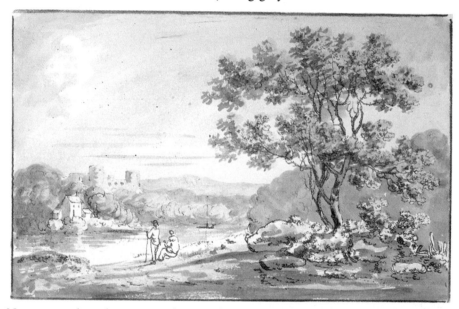

Next strengthen the grey washes on the more distant objects, and work forward. (This process was known as 'dead colouring.') Then strengthen the colours.

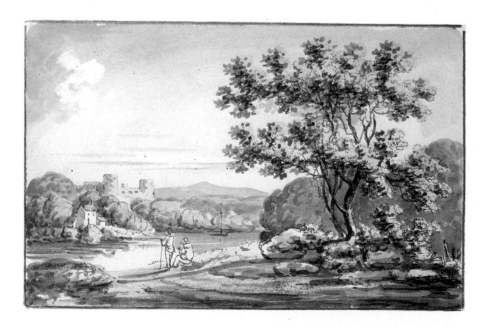

Deadcolour the distance using the grey mixture used for the clouds. Notice how the grey goes slightly green as it goes on top of the yellow sky.

Here you can see the same grey on the white foreground, and some colour introduced into the background.

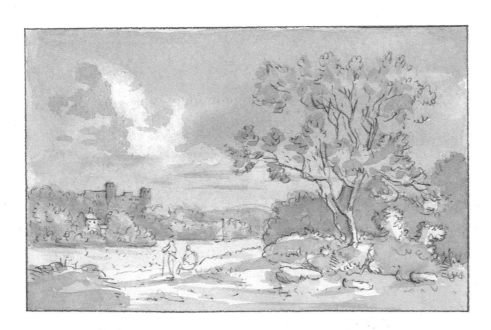

At this point the distance should be complete, but further emphasis is now given to the second, or middleground, and to the foreground.

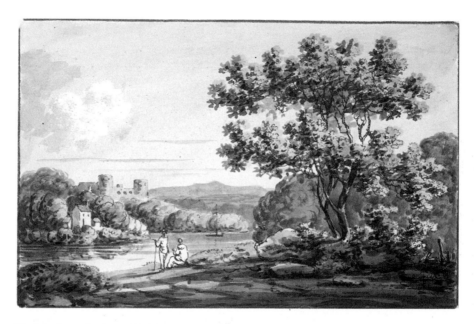

Finish the whole as highly as you can, putting in and colouring any foreground figures.

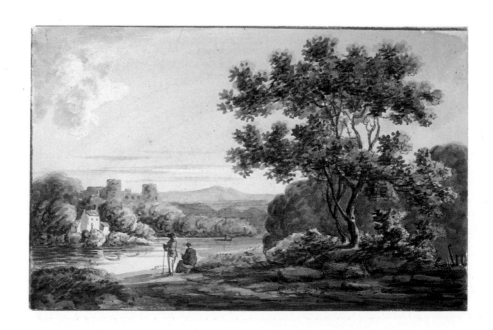

A wash of Light Red is put on the foreground making the grey underpainting go slightly purple. The yellow and blue were mixed to put the colour into the trees.

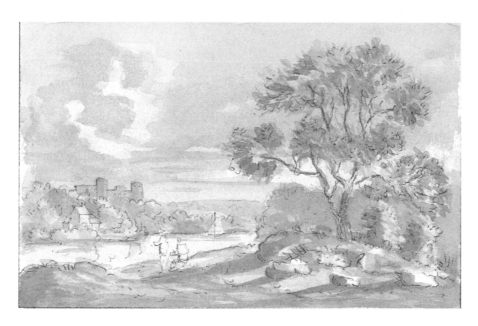

The colours were strengthened and the background worked on almost to completion. The form and structure of buildings, trees and rocks should be made clear at these stages and a darker grey can be useful for this.

Stop (or 'fetch') out the highlights, using a wet brush, bread, a sponge or a pointed scraper.

Finally check the harmony and strength of the colours and touch up any weaknesses.

The foreground receives more attention. Colours are strengthened and made warmer and the form of the tree developed.

Contrasts were increased by adding stronger colours in the foreground and deepening the shadow areas. An extra cloud has been added by scratching the paper with a sharp knife and then the shadow areas of the clouds strengthened. A little very pale blue was put in over the castle and in parts of the distance and on the water in order to cool the colours and to create more sense of depth in the painting.

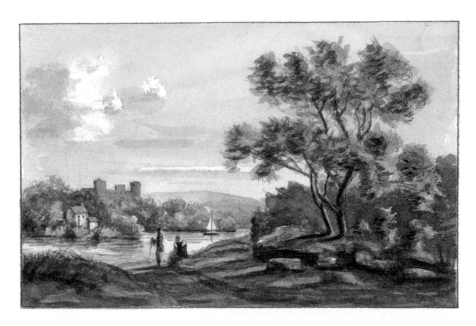

If you have followed these instructions with devotion and patience — although Laporte does not say so, it appears that the drawing should be allowed to dry between several of the stages — you should now have a passable watercolour in the late eighteenth century manner to add to the portfolio with which you delight your friends of a winter's evening. More probably you have a muddy embarrassment. Your actual drawing, too, is likely to be weak, whereas Laporte's original readers would probably already have had a fairly systematic grounding in this basic skill. As Henry Gyles, a glass painter in York, had put it in the middle of the seventeenth century: "for I remember when I did learne to draw before I did draw well, I desired to learne to paint; but my Master Mr. Wm. Martins ye Elder answer'd me very wisely, that I must not run before I could go."

Whatever the result in artistic terms, if you do try to follow this exercise for yourself, you should emerge from it with a surer feeling for what is a professional watercolour, and what an amateur.

There are many books of lessons by artists. Here I give a few more which will give the flavour of their respective periods.

Henry Peacham, *The Gentleman's Exercise,* 1612.

Julius Caesar Ibbetson, *An Accidence or Gamut of Painters in Oil and Water-colours,* 1803.
A Process of Tinted Drawings, 1805.

Edward Dayes, *Instructions for Drawing and Colouring Landscapes,* 1805.

David Cox, *A Treatise on Landscape Painting and Effect in Water Colours,* 1813.
Progressive Lessons on Landscape for Young Beginners, 1816.
A Series of Progressive Lessons, c.1816.

John Heaviside Clark, *Practical Illustrations of Gilpin's Day,* 1824.

Henry William Burgess, *Views of the General Character and Appearance of Trees,* 1827.

J. Ruskin, *The Elements of Drawing,* 18.

Nathaniel Everett Green, *Hints of Sketching from Nature,* 1871.
Foliage Exercises for the Brush, 1888.

L. Richmond & J. Littlejohns, *The Technique of Water-Colour Drawing,* n.d.

Adrian Hill, *On the Mastery of Water Colour Painting,* n.d.

Equipment

You will no doubt have taken advantage of modern commercially prepared colours. The first recorded watercolourman appears to be Alexander Browne, a Covent Garden drawing master who taught Mrs. Pepys in the 1660s, and who advertised "rightly prepared" colours of his own manufacture at his "Lodging in Long-Acre, at the Sign of the Pestel and Mortar, an Apothecary's Shop". In general in the seventeenth century, and for much of the eighteenth, apothecaries were the usual source of supply for artist's materials, and since they were not above bulking out their colours with sand, most artists mixed their own. However, by the 1780s

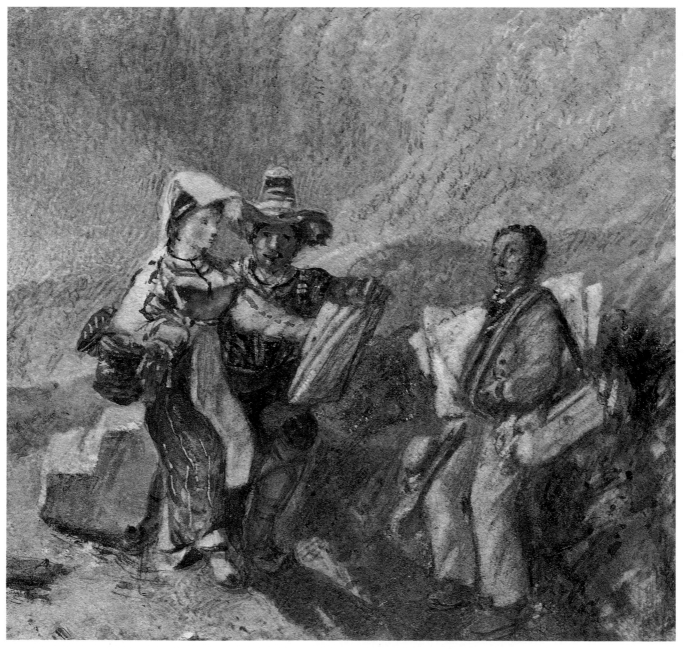

(Christie's)

Joseph Mallord William Turner (1775-1851). A detail from a view of Lake Albano painted by Turner in about 1828. An artist — perhaps even the artist — is showing his work to a pair of passing peasants. He is cumbered about with a great deal of equipment, but still less than would have been required by an oil painter intent on working from nature. The drawing of the figures here, incidentally, differs very little from Turner's style in the previous decade.

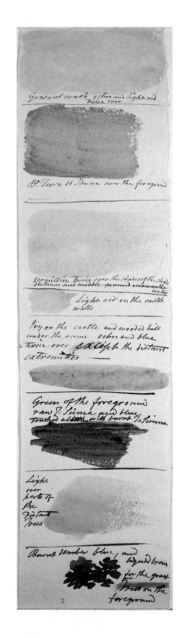

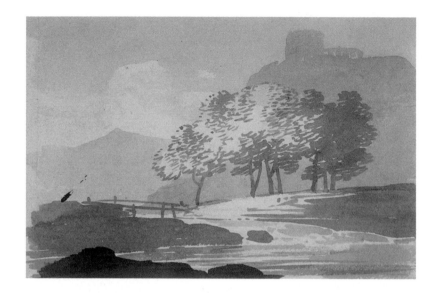

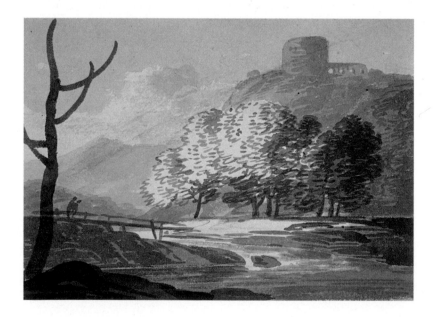

If you feel daunted by Laporte's Progression, perhaps you might care to try this similar exercise by William Payne. Here we have the first two stages, and the colour guides necessary to the production of a finished watercolour à la Payne. Originally they appear to have been on one large sheet, but unfortunately some previous owner, whose eye was clogged by the prospect of a profit, has removed the final stage or stages and sold them separately. Payne's Grey, which naturally forms the basis of much of his work, consists of a mixture of Alizarin Crimson, Lamp Black, Prussian Blue and Ultramarine. Also illustrated here are two further Paynes, showing how the same basic shape can be turned into either a round or a square tower. These too are in grey and blue washes.

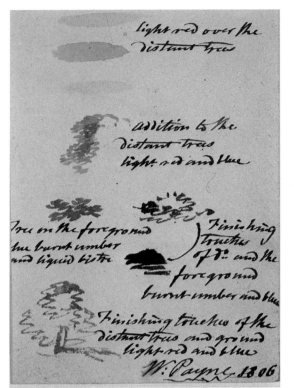

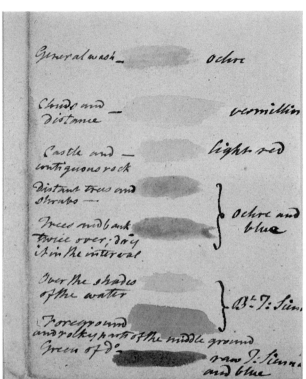

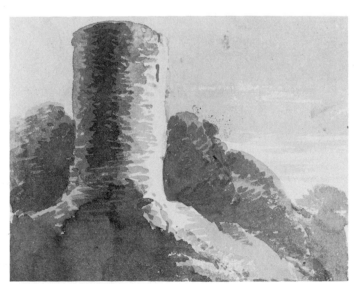

(W. Drummond)

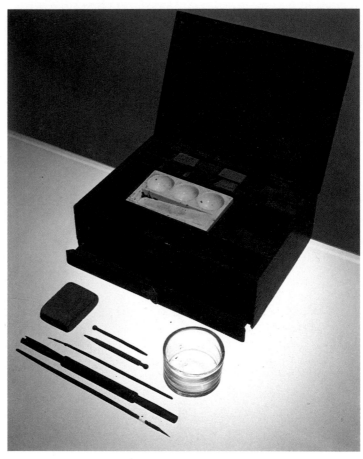

An Ackermann watercolour box of about 1835. In front of it (from the bottom) are a crowquill brush, portcrayon, lark brush, silverpoint and scratcher — which also secures the drawer. They are flanked by an India rubber and a water glass. The box itself also has compartments for brushes, mixing trays and paints, and among the latter can be seen Ackermann's own with the Royal coat of arms, and Lechertier Barbe's with the portcullis. Such boxes can be dated by the details on the trade labels. This one is at the bottom of the brush compartment.

there were numerous specialist watercolourmen in business, some of whom, such as Reeves, flourish today. The basic equipment was cheap, compact and easily portable, and by 1800 practical mahogany paint boxes were commonplace. For the truly elegant amateur Wedgwood had produced a fine jasperware paint box with stoneware bowls and palettes in 1779. Illustrated above is an Ackermann wooden box of about 1835 complete with many of the original colour cakes in compartments and a drawer, a porcelain mixing tray, a glass bowl for water, brushes, a black lead pencil, a portcrayon, or charcoal holder, and a silver-point which doubles as a lock for the drawer. It is still possible to make effective use of some of the colours.

William and Thomas Reeves, who quarrelled in 1784 and split their business, had received a great silver palette from the Society of Arts three years earlier for what they claimed was the invention of "Superfine Water Colours in Cakes", and they soon had many competitors such as G.F. Blackman of Oxford Street, Ackermann, S. & I. Fuller of the Temple of Fancy, and Thomas Brown of Islington. Later, in the 1830s, came Winsor & Newton's further innovation of moister colours in small individual pans, such as are still used, and in 1853 Rogers' shilling colourbox in japanned tin, which sold eleven million in less than twenty years. Despite all these

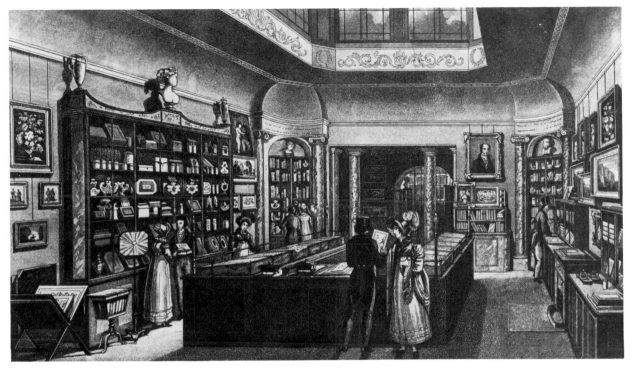

(David Fuller)

A fashionable colourman's shop in about 1820. The lady on the left is buying a watercolour box, and there are more among the objects in the splendid showcase beside her. The frames of the period are clearly shown. They cover the mounts completely, although wash line mounts can be seen in the portfolios.

technical advances many professionals continued to experiment with different ingredients and additives, like John Varley with gin and honey, but the availability of cheap and good quality materials undoubtedly boosted the fashion for watercolour painting among amateurs.

Paul Sandby's unceasing experiments to discover new pigments were a constant source of amusement to his friends, and in 1797 he himself wrote of "a grand discovery I have just made... a few weeks ago I had a French brick for breakfast; the crust was much burnt in the baking. I scraped off the black, and ground it with gum-water; it produced an excellent warm black colour like mummy[1], and bears out with great vigour... The day after this great discovery I had pork and pees-pudding for dinner. I tried some split peas[2] in the evening in a shovel over the fire, and parched them quite black. This also answers well, very dark and warm, not opaque

1 Mummy was exactly what might be expected from the name, a brown bituminous pigment which was originally prepared from the bones and bodily remains of Egyptian mummies which had been embalmed with asphaltum. It was known and used in England from the sixteenth century. While on the subject of necrophilia, Ivory Black was originally made from burnt ivory shavings, but later from animal bones.
2 I have repeated this experiment and the results can be seen on page 35.

like ivory black: you will, I know thank me when you try it, and throw your Indian ink aside.'' Like Varley, Sandby was a great user of gin, and he also produced a fine bistre from the sooty wood of the inside of a hollow tree in Windsor Forest which had been the home of a woodman and his family.

Given this catholic and enquiring attitude to his materials, it is remarkable how well Sandby's pigments have stood the tests of time and light in most cases, and a great compliment to his practical bent. Another artist of the period perpetuated his name through making his own pigments, since Payne's Grey, named after its discoverer the drawing master William Payne, is still on the colourmen's books. It consists of a mixture of Alizarin Crimson, Lamp Black, Prussian Blue and Ultramarine. In 1819 James Roberts, a Sandby follower, wrote that ''Porter is a very good general wash'', and also recommended tobacco steeped in water.

Should you wish to try the experiment of following Laporte's instructions, you might feel that it would make it more complete to grind your own colours. L. Cornelissen & Son, the artists' colourmen of 22, Great Queen Street, Kingsway, London W.C.2, issue a pamphlet of instructions and provide the necessary equipment. In a prefatory note they make the point that in ''comparing the directness and spontaneity of the early watercolourists, Towne and Cotman, to the overworked and shrill colour of the later Victorians, we are forcibly aware of a decline in quality. Many artists and critics attribute this, among other causes, to one of the aspects of the industrial revolution, the mechanisation on a huge scale of artists' materials. It is true that this also gave us beautiful and clear new metallic colours and dyes, but something, artists felt, had been lost. This was the direct tactile contact with the materials, which is only possible when the artist makes his own colours.''

The Introduction of Pigments from 1700

The oldest known pigments which are still in use are Carbon Black, Yellow Ochre, Iron Oxides and Red Ochre, all of which were current in the Neolithic period. The Romans added White Lead, Vermilion, Terreverte and the Madder Lakes, as well as a number which have subsequently sunk into obsolescence such as Tyrian Purple and Dragon's Blood Indigo. The greatest innovations came in the eighteenth and nineteenth centuries. The dates given in the table on page 36 are either those of invention, where known, or of introduction to the colourmen's lists.

Further reading:
R.J. Gettens and G.L. Stout, *Painting Materials,* 1942.
R.D. Harley, *Artists' Pigments, circa 1600-1835,* 1970.
C. Hayes, *The Complete Guide to Painting and Drawing Techniques and Materials,* 1979.

The following samples were taken from old colour cakes in my paintbox (see page 32) when I attempted a painting 'after Turner'. It is impossible to say how much age has altered the effect, and whether the samples would look like this had they been made when the paints were new.

Yellow Ochre, unknown maker, c.1830.

Burnt Sienna, Ackermann, c.1835.

Venetian Red, Ackermann, c.1835.

Vermilion, Ackermann, c.1835.

Curiosity also prompted me to try an experiment with Paul Sandby's split peas (see page 33 for the full recipe): any grittiness is due to insufficient pounding in a kitchen mortar.

Chronology of Colours

1700	Prussian Blue
early 18th C	King's Yellow; Sepia; Bistre
1778	Scheele's Green. The first artificial green pigment in which copper and arsenic were the essential constituents. It was replaced by Emerald Green.
late 18th C	Sepia popularised. Previously Bistre and Indian ink had been most used for washes.
c.1780	Cobalt Green invented, although not much used before the middle of the next century.
1781	Turner's Yellow
1782	Zinc Oxide
1797	Discovery of Chromium
c.1800	Indian Yellow
1802	Cobalt Blue, which was used by Bonington in the '20s.
1809	First printed reference to Chromes.
1814	Emerald Green
1820	Chrome Yellow
c.1824	Artificial Ultramarine
1829	Potter's Pink
1834	Chinese White
1835	Cobalt Green being used on a wider scale
1838	Viridian invented. It was introduced into England in 1862 and popularised by Aaron Penley.
early 1830s	Brilliant Scarlet
after 1846	Cadmiums introduced, having been discovered in 1817.
c.1855	Ultramarine Green marketed commercially.
1856	Mauve Lake
1859	Magenta
1860	Cobalt Violet
1861	Cobalt Yellow (Aureolin), also popularised by Penley.
1862	Chromium Oxide
1868	Nurnberg Violet. This was introduced into England as Manganese Violet in 1890.
1870	Alizarine Lakes
1910	Cadmium Scarlet
1920	Titanium Oxide

Paper

The first known paper mill in England was in operation just outside Hertford near the Stevenage road in the early 1490s, but until the middle of the eighteenth century the best quality English paper was no match for that produced in France, Germany, Holland and Italy. White paper, which was used for drawing and writing, was made

from linen rags, which were by no means always easy to come by, and its manufacture also required pure and clear spring or well water. Until 1772, when Whatman invented his "Contrivance" for making Antiquarian paper — so called from a commission from the Society of Antiquaries — the size of paper that it was possible to produce was determined by the size of mould which it was physically possible for one vatman to handle.

The problem of finding good quality rags, which had led to petitions for the prohibition of exports in 1585 and 1640, was exacerbated in the eighteenth century by wartime interruptions of trade with the Continent. Even so, by 1800 the annual value of imported rags was almost £200,000. In the nineteenth century there was considerable experimenting to discover practical alternatives. Asparagus stalks, jute, turf, leather and many others were tried before, in the second half of the century, esparto grass and wood pulp became the norms.

During the eighteenth century beating engines were introduced into English mills for the reduction of rags to pulp, but to begin with these could not produce as satisfactory papers as the old hand hammering process, since they shredded the fibres too finely, which meant that more size had to be added to the mixture, resulting in a product that was too hard for printing purposes. However, this difficulty was gradually overcome, and from the middle of the century the Hollanders and similar engines greatly increased output. By the 1790s the new invention of bleach was also in general use, and this too greatly improved quality, although, as we shall see, it was not without drawbacks.

Many of the improvements in the manufacture of paper in the second half of the eighteenth century were due to the activities and enterprise of the two James Whatmans, father and son, and the reputation gained by the products of their mills in the Maidstone area, of which the best known was the Turkey Mill. The most important innovation associated with the Whatmans was the production by the father of wove paper from 1756. Previously the moulds or frames on which the pulp was transformed into paper had been made up of parallel wires or chains which resulted in very noticeable watermark-like lines in the finished product, known as laid paper. Whatman introduced fine wire mesh moulds, which by giving more support to the pulp almost eliminated the marks, and produced sheets of a uniform smoothness.

It was not, however, until the late 1770s that wove paper came into general repute and use, thanks to the further improvements and business acumen of the son. The difficulties for an artist wishing to get hold of it in the early days are shown by a letter written by Gainsborough to the publisher Dodsley in November 1767 in the hope of obtaining some:

"I beg you to accept my sincerest thanks for the favour you have done me concerning the paper for drawings. I had set my heart upon getting some of it, as it is so completely what I have long been in search of... I wish, Sir, that one of my Landskips [sic], such as I could make you upon that paper, would prove a sufficient inducement to you to make still further enquiry. I should think my time very well bestowed, however little the value you might with reason set upon it.

"P.S. I am at this moment viewing the difference of that you send and the *Bath*

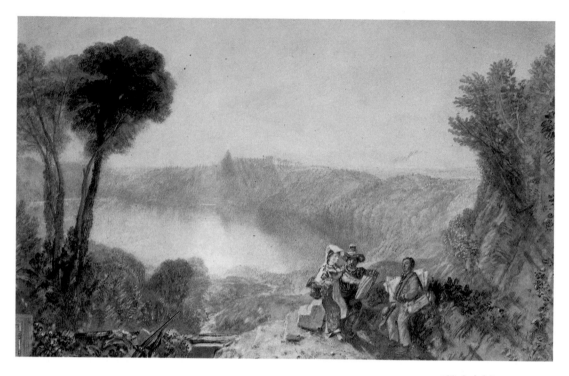

(Christie's)

Joseph Mallord William Turner (1775-1851). This view of Lake Albano in Italy (see detail of the figures on page 29) was painted in about 1828. Despite the early date the colours have remained stable.

Guide, holding them edgewise to the light, and could cry my eyes out not to see those furrows. Upon my honour I would give a guinea a quire for a dozen quires of it.''

From the earliest days of paper making in Britain watermarks and countermarks had been used to identify the type of paper and the manufacturer. The watermark is the larger of the two, and many of the best known were imitated from Continental papers. These include the Strasburg Bend and Lily, the ''Pro Patria'', Britannia and the Posthorn, and they were adopted not to pretend to a Continental original, but to indicate the size of the sheet. The smaller countermark, which was sometimes incorporated into the watermark, gave the initials or name of the manufacturer, and sometimes the name of the mill, the date and the Excise number.

Excise duty was levied on British made paper from 1712, but the known lists of mills and manufacturers run only from 1816 to 1851 for England, 1831 to 1851 for Ireland and 1837 to 1851 for Scotland, the duty being removed in the last year. The mills were numbered according to the alphabetical order of the Excise Collection Area into which they fell. Thus in 1816 for England the Barnstaple Area had numbers 1 to 5, Bath 6 to 21 and so on. As new businesses came into being or old

ones disappeared numbers could be changed or reallotted, and for precise identification of a mill of origin it may be necessary to go to the Excise General Letter for the year in question. The highest number given officially in England was 694 and in Scotland 77, but higher numbers were used by mills for their own purposes of identification, sometimes with a letter or a further number to indicate the vat of origin, and numbers continued to be used in this unofficial way after the ending of the duty.

In 1794 it was provided by Act of Parliament that no drawback of Excise duty was allowable on papers for export except where they had the year date in the sheet, and this regulation remained in force until 1811. However the date 1794 itself cannot be taken as proof positive of manufacture in that year, since the regulation was loosely worded and some manufacturers continued to use the original date mark for several years. Although it was no longer financially necessary, the practice of dating papers did not entirely die out with the regulation. During the nineteenth century it also became more common for the name of the mill to be included in the mark, thus the mark "J. Whatman Turkey Mill" is found in hand made papers produced by the successor firm of Hollingworth Bros. between 1807 and 1859, rather than by the Whatmans themselves, the younger James having sold out in 1794. The 'J Whatman' mark is still used today, and 'Whatman' paper, together with 'Old Creswick' were the two preferred papers of Peter de Wint. The latter was produced by Thomas Creswick, a stationer, pasteboard and paper manufacturer who was established in Islington in 1816. He was presumably the uncle of his namesake the Royal Academician.

As with colours, so with papers, and certain artists continued to seek out the type best suited to their style and technique, even if it was not specifically intended for drawing. Cox's biographer Solly gives an account of his discovery of the rough Scotch paper which became the regular and characteristic surface of his later watercolours: "It was in the year 1836 that Cox first met with the rough Scotch wrapping paper which on trial turned out to be very unabsorbent of colour when used for water-colours, producing a powerful effect. The surface is hard and firm, the paper being made from old linen sailcloth well bleached. Cox obtained the first few sheets by chance at Grosvenor & Chater's, and on showing it to S. & J. Fuller their traveller ascertained, from the Excise mark stamped upon it, 84B, that it was manufactured at a paper mill at Dundee, North Britain. There a ream was ordered for Cox, and it was some time before it could be obtained. On its arrival he was rather surprised to find that it weighed 280 lbs. and cost £11. However his friend Mr. Roberts was willing to share in the purchase, and after some years Cox rather regretted that the quantity ordered had not been larger, as he was never able to obtain the same quality of paper again. . . It gave the texture he required, and suited his peculiar mode of rapid work with a large brush, charged as full as possible with very wet though rich colour. It enabled him to obtain *power* at once. The paper was very thick, not quite white, with here and there little black or brown specks. In the landscape part these specks were of no consequence, but they looked out of place in the sky. On one occasion being asked what he did to get rid of them, he replied, 'Oh!

I just put wings to them, and they fly away as birds!' '' Nowadays rough 'Cox' paper is on the list of every good artist's supplier, but it is unfortunately nothing like the original, being generally a rather nasty shade of pink.

Other artists who insisted on special papers included George Cattermole, who gave his name to a "thick absorbent paper of low tone and warm tint" specially prepared for him by Winsor & Newton, and James Duffield Harding, who invented his own. According to both the *Somerset House Gazette* and *The Gentleman's Magazine* Thomas Girtin had a particular liking for cartridge paper. "Girtin made his drawings, with but few exceptions, on cartridge paper. He chose this material as his aim was to procure a bold and striking chiaroscuro, with splendour of colour, and without attention to detail... The warm tone of the cartridge paper frequently served for the lights without tinting, acquiring additional warmth by being opposed to the cool colour of the azure, and shadow of the clouds." Again, "It is said that the wire-worked cartridge he loved to work on was only to be obtained at a stationer's at Charing Cross, and was folded in quires. As the half sheet was not large enough for his purpose, he had to spread out the sheet, and the crease of the folding being at times more absorbent than the other parts of the paper, a dark blot was caused across the sky, and indeed across the whole picture in many of his works. This defect was at first tolerated on account of the great originality and merit of his works, and gradually gave a higher value to those in which it occurred, being considered a proof of their originality." Incidentally, "his palette was covered with a greater variety of tints than almost any of his contemporaries." Cartridge paper, as the name indicates, was originally used for wrapping cartridges, and it was to play a part in the outbreak of the Indian Mutiny. It was a tough hard paper with a rough surface. The statement as to Girtin's palette shows only how limited were those of his contemporaries. His surviving watercolours indicate that he used only five pigments: Light Red, Yellow Ochre, Burnt Sienna, Monastral Blue and Ivory Black.

One reason for the continued use of eccentric papers by artists was, paradoxically, the actual progress of manufacturing techniques. According to the architect and painter John Woody Papworth: "the progress of science taught the means of adulteration, the use of materials which chemically quarrel with each other and the colours, and the employment of superbly finished machinery which leaves no fibrous texture... In a short period the damage of such operations was felt by Turner, who found that his paper required preparation; and even a quarter of a century had not elapsed before 'old paper' was worth a guinea a sheet to men like Harding."

By the end of the nineteenth century the best drawing papers had come to be regarded by artists in the same light as wine, with vintage and poor years. In 1906 Winsor & Newton advertised stocks of "reliable, well-preserved Paper of the best years" from 1851.

Further Reading:

Hunter, D., *Papermaking, the History and Technique of an Ancient Craft,* 1957
Shorter, A.H., *Paper Making in the British Isles,* 1971
Balston, T., *William Balston,* 1954
Balston, T., *James Whatman Father & Son,* 1957

Names and sizes of Drawing Papers (in inches)

1. Arranged by size

	14 x 9	Half Foolscap	*	27½ x 20½	Super Royal
	15 x 9½	Half Crown		28 x 23	Elephant
	15 x 12½	Post	*	30 x 22	Imperial
	16½ x 13¼	Foolscap		30½ x 19	Double Post
	18 x 12	Half Demy		33 x 21	Double Large Post
	18½ x 12	Half Medium	*	34 x 26	Atlas
	18½ x 14½	Small Post		34 x 27	Portfolio
	20 x 13	Half Royal	*	34½ x 23½	Colombier
	20 x 14½	Half Super Royal		35 x 22½	Double Demy
	20 x 15	Crown		35 x 27	Large Atlas
*	20 x 15½	Demy		40 x 25	Double Royal
	20 x 16	Copy	*	40 x 27	Double Elephant (until 1772 this was the largest size produced in England)
	21 x 16½	Large Post			
	22 x 13¼	Sheet and a Half or Square Foolscap		42 x 28	Grand Eagle
*	22 x 17½	Medium		42 x 33	Quad Large Post
	22½ x 15½	Half Imperial		44 x 30	Double Imperial
*	24 x 19	Royal		48 x 38	Extra Casing
	25 x 15	Sheet and a Half Demy Foolscap	*	53 x 31	Antiquarian
	26½ x 16½	Double Foolscap	*	56 x 40	Extra Antiquarian
	27 x 20	Large Royal	*	72 x 48	Emperor

* These are the papers recommended by Theodore Fielding in his *On Painting in Oil and Water Colours,* 1839. However some of his sizes differ from those now accepted, as: Demy, 20 x 15; Medium, 22 x 17; Super Royal, 27 x 19; Imperial, 30 x 21; Colombier, 34 x 23; Double Elephant, 40 x 26; Antiquarian, 52 x 31; Emperor 68 x 48. He notes that the largest sizes were (and are) chiefly used by artists in teaching. He adds a caution: "Drawing papers are sometimes of an extraordinary degree of whiteness; these may be suspected of having had a superabundance of acid used in the bleaching, and the draughtsman had better sacrifice a small matter in the extreme purity of colour, than run the risk of having the whole work ruined by any remains of acid." He quotes an instance in which acid in the paper had turned all the blues and greens in a drawing to reds after about three or four months. Browns remained much the same, and reds became more red. This sorry state could also be brought about by the use of alum in the paste used for mounting drawings. It seems likely that this is the cause of the pink tinge which is all that remains of so many of de Wint's skies, rather than the actions of light and damp.

2. Arranged alphabetically

Antiquarian	53 x 31		Double Foolscap	26½ x 16½
Extra Antiquarian	56 x 40		Grand Eagle	42 x 28
Atlas	34 x 26		Imperial	30 x 22
Large Atlas	35 x 27		Half Imperial	22½ x 15½
Colombier	34½ x 23½		Double Imperial	44 x 30
Copy	20 x 16		Medium	22 x 17½
Crown	20 x 15		Half Medium	18½ x 12
Half Crown	15 x 9½		Portfolio	34 x 27
Demy	20 x 15½		Post	15 x 12½
Half Demy	18 x 12		Small Post	18½ x 14½
Sheet and a Half Demy Foolscap	25 x 15		Large Post	21 x 16½
Double Demy	35 x 22½		Double Large Post	33 x 21
Elephant	28 x 23		Quad Large Post	42 x 33
Double Elephant	40 x 27		Double Post	30½ x 19
Emperor	72 x 48		Royal	24 x 19
Extra Casing	48 x 38		Half Royal	20 x 13
Foolscap	16½ x 13¼		Double Royal	40 x 25
Half Foolscap	14 x 9		Large Royal	27 x 20
Sheet and a half or Square Foolscap	22 x 13¼		Super Royal	27½ x 20½
			Half Super Royal	20 x 14½

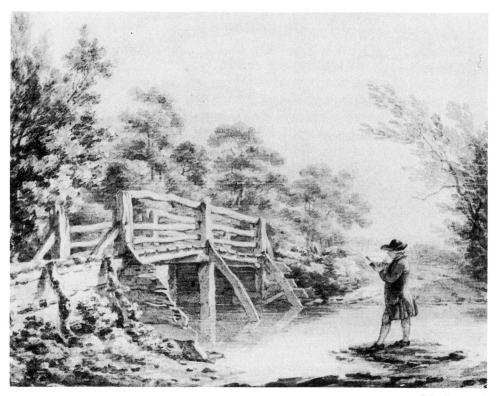

(M. Gregory)

In 1771 Thomas Hearne and that great patron Sir George Beaumont visited Henstead in Suffolk. This informal sketch by Hearne in pencil, grey and brown washes, probably shows Beaumont sketching. He has the very minimum equipment, a sketchbook and portcrayon. The collectors' mark in the bottom right hand corner should be noted and borne in mind: it is that of William Esdaile, whose collection was particularly strong in Gainsborough drawings. You cannot, however, assume that any Gainsborough-like drawing with the Esdaile stamp is necessarily a Gainsborough, since he also owned imitations by Gainsborough's friend George Frost.

Brushes and Pens

"No Artists' brushes have ever been made from the hair of camels, which is quite unsuitable for the purpose. The name, camel-hair, introduced about the year 1800, by whom it is unknown, has always been misleading to the general public, though those engaged in the trade have always understood camel-hair to mean the hair from the tail of the squirrel." Thus Messrs. Reeves in 1929. Other terms which actually denoted grades of squirrel, or in some cases, mink, were Siberian, and Red and Brown Sable. But, "We have known dealers apply the word Siberian hair to dog hair, and Finest Camel to quite useless brushes made from pony clippings."

The basic form of the watercolour brush or pencil, before the introduction of

wooden handles with metal ferrules towards the end of the nineteenth century, was a shaped tuft of hair inserted into one end of a quill. To the other end a wooden handle might be added. The size of brush was denoted by the type of quill employed, ranging down from Large Eagle, through varieties of Swan, Goose and Duck, to Crow and Lark. Modern brushes run from 12 down to 000.

There have been metal writing, and presumably drawing, instruments since the very beginning of recorded history, but for much of the period of the English watercolour school the common implement of the artist was the quill or split reed, fashioned with a penknife, and the art of cutting a pen was by no means universal. It would be interesting to know the nature of the "drawing pen" bought by Pepys of Mr. Greatorex in October 1660. The real revolution came about in the 1820s with the inventions and improvements of John Mitchell, Joseph Gillott, Sir Josiah Mason and James Perry in Birmingham and Manchester, and by the middle of the next decade steel pens manufactured on an industrial scale were sweeping the world. The pamphlet on the history of steel pens published in 1892 by Perry & Co. proudly announces that the illustrations were engraved "from pen-and-ink sketches executed by Walter Langley with a Perry's No. 25 pen", but as was so often the case with materials, many artists had continued to use their old and tried favourites. Samuel Prout, for instance, was noted for his invariable use of a reed pen in his later watercolours. The effect of this, which is broad and knotty, is very much the same as if he had used a watercolour brush for his outlines.

2. The Social History
Collecting and Fashion

Water soluble pigments are as old as painting and were used by the Chinese, the Assyrians, the Egyptians and in the European Middle Ages. However, the colours used were opaque, the forerunners of gouache, bodycolour and poster paint, rather than the translucent medium which we now call watercolour. The application of bodycolour is in fact more akin to oil painting than to watercolour, in which the whole point is that each layer of paint remains transparent, and that light is reflected not only from the colours themselves, but also from the paper beneath. Obviously in a bodycolour or an oil painting it is only the uppermost surface that reflects. It is probably only for convenience and because of the common base of paper that so many bodycolours are nowadays classed with drawings rather than paintings.

On the whole English artists in the eighteenth and nineteenth centuries held out for purity in watercolour, where their Continental confrères saw no harm in mixing water and bodycolour. Some of the Victorian English, notably Birket Foster, also allowed this, and many Englishmen used opaque white for highlights, especially after the introduction of Chinese White. It must not be forgotten too, that many good men among the earlier English watercolourists, like Sandby, Laporte and Walmsley, also produced pure bodycolours, as did the Italians such as Zuccarelli and Zucchi who worked in England for a number of years at the end of the eighteenth century. It has been truly said that the majority of these bodycolour works look much the same. They should, perhaps, be ranked with the pleasing but often rather unoriginal oil paintings produced by watercolourists such as Cox and de Wint in the middle of the following century.

The first great artist to use pure watercolour in modern terms in Western Europe was Albrecht Dürer, who experimented with the medium for a few years, notably on his first journey to Italy. In doing so he inaugurated the long tradition of studying and portraying landscape for its own sake, rather than as a background for figures or a commentary on a story. This can be seen most clearly in his wonderful *Pond in the Woods* which is now in the British Museum. It was painted between 1495 and 1497, and in its sketchiness it is a superb evocation of atmosphere, concentrating on the colours of the clouds and in sunlight. It would hang quite happily beside a Samuel Palmer or Paul Nash.

The artistic history of the development of the English watercolour school has often been chronicled, and there is little point in covering the ground yet again in a book such as this. However, art history alone cannot answer the question, why England? — if indeed it can ever be answered. A clue may be found in the social history of the period, however, since the tastes and attitudes of collectors and amateurs, who were of course often the same people, and the political and commercial developments of the time often dictated the directions taken by professional artists.

Dürer had soon abandoned the medium, and he had no direct imitators, although a few other German and Flemish painters, such as Altdorfer, the elder Cranach and, more importantly for England, the younger Hans Holbein, did occasionally use water soluble pigments for their sketches and memoranda. In England the first serious demand for tinted drawings came with the increasing sophistication of

44

military affairs during the reign of Henry VIII, and many of the earliest names in the chain of descent of English watercolour painting were in fact Flemish. The careful line drawings lightly washed with watercolour of palaces, castles, harbours and fortifications by men such as Vincent Volpe or Wolf 'the King's Painter', John Luckas, Anthonis van Wyngaerde, who accompanied Philip II to England and returned to Spain in 1561, and George Hoefnagel, not only provide a tenuous link with Continental groups such as the school of Brueghel, but were also the direct forerunners of what was to be seen as a peculiarly English movement.

Thus the first accumulator of watercolours was the English Government, and it is appropriate that the first known English amateur should have been a King. The young Edward VI presumably wandered into one of the Royal 'drawing rooms' and was intrigued enough to copy some of the works which he saw there.

The great Elizabethan sea voyages and the founding of the first English colonies in America naturally gave further employment to topographical artists, and watercolour proved to be the most practical medium for them. Sketch books took up little room, and pigments could be mixed and stored in mussel shells for easy carriage. As a point of nostalgia, despite the introduction of the paint box, some colourmen will still sell pigments, notably gold, in such shells. The immediate inspiration for the employment of artists on expeditions probably came from the Frenchman Jacques le Moyne de Morgues, who had accompanied the Huguenot attempt to found a colony in Florida in 1564 and had settled in London at about the time of the Massacre of St. Bartholomew. There he became a friend of the great nautical historian Richard Hakluyt, Sir Walter Raleigh and Sir Philip Sidney. In 1582 Sir Humphrey Gilbert's expedition to New England was supplied with an artist, Thomas Bavin, who was instructed to make a ''graphic record'' of the coasts, harbours, settlements, unusual happenings, flora and fauna and the habits and customs of the native inhabitants of the country. Two years later Raleigh himself sent out an expedition under the command of Sir Richard Grenville which was accompanied by John White, who had already visited the New World, and later became governor of the Virginia colony.

White, who, tantalisingly, disappears from history again a few years later in Ireland, and probably died at the beginning of 1606, is the first recognisably English watercolourist whose work has come down to us with a firm attribution. His style of drawing, with careful and firm outlines and thick washes from a full palette of colours, is in some ways more akin to that of his spiritual descendants the book illustrators of the early nineteenth century than to the majority of his more immediate successors. However, his work must have had a considerable, if now untraceable, influence in the intervening years, and it is one of some importance in the history of watercolour collecting.

In 1709 in a letter to the Abbé Bignon Sir Hans Sloane wrote that he had had a copy of White's notebook made, in part because he could not buy the original, but partly also because it was almost worn out with the handling of young painters learning their craft. Previously drawings had usually represented the working thoughts of artists, and it was only natural that the first serious collectors should be

fellow painters. In the absence of museums and schools they needed them both to learn and to teach. The drawings of White and his fellows, although they were finished works rather than studies, were valued for the same reasons, and in the collections of the artists of England, the notes of the Old Masters blend gradually with the full and finished watercolours of contemporaries.

The importance of provenance and collectors' marks will be discussed in a later chapter and in the eighteenth and early nineteenth centuries many of these artists' collections passed from one to another of their successors. Sir Peter Lely was one of the first in England, and his stamp, P.L., is often found with P.H.L. for his pupil Prosper Henry Lankrink, who bought much of the collection in the sale after his master's death. From him they might go to the Jonathan Richardsons, father and son, who used copperplate JRs, to Reynolds with Sr IR in a rectangular shape, to Paul Sandby, Richard Cosway, Benjamin West and Sir Thomas Lawrence. A provenance which includes several of these is not only a thrill for the modern collector, but also a guarantee of quality.

There were undoubtedly many more practitioners of watercolour in the seventeenth century than are now known to us, but already two of the most important strands which make up the later English school are clearly visible, the decorative and the topographical. Pure landscape for its own sake hardly existed, with the exceptions of one or two examples by Inigo Jones, made in connection with his work as a designer of Court masques, and a group of watercolours in the British Museum and at Chatsworth, which is associated with the name of van Dyck. The work of Jones, and that of later decorative artists such as Sir James Thornhill, stands midway between the allied but very distinct fields of Old Master drawings and English watercolours. The kinship with the Old Masters can be seen even in the decorative designs of a charming minor painter John Devoto, who used much more colour than either Jones or Thornhill. In fact during much of the seventeenth century the majority of the artists who used pure watercolour, did so to make miniature copies of oil paintings, rather than to create original works.

Much more relevant to the mainstream of the art was the emergence of the

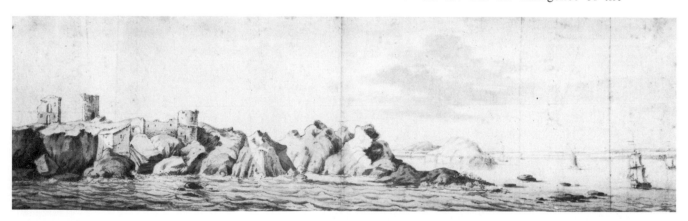

A typical panoramic view in wash by Francis Place. (Sotheby's)

antiquary and the growing interest in recording the monuments and curiosities of the country, although topographical works for the most part remained utilitarian, and, if one may say so of bird's eye panoramas, rather pedestrian in execution. However, already in the reign of Elizabeth the travelling scholar John Norden and the Herald William Smith had decorated their manuscript descriptions of the various antiquities of the country with small and sometimes naîve watercolours. The great outbreak of antiquarianism came at about the time of the Restoration, and was a manifestation of the spirit of universal enquiry which is typified by Sir Christopher Wren and that great printmaker Prince Rupert. Occasional drawings by the latter exist, incidentally, but I know of none in colour. It was not just in London and around the Royal Society that such men congregated, or even in the University cities, but also in centres such as York, where a group known as the 'York Virtuosi' formed around Francis Place. Place came of the Durham gentry, and he was sent to the Temple to study law, but he left both London and thoughts of a legal practice on the outbreak of the Great Plague in 1665. While there, however, he must presumably have met the Bohemian painter Wenceslaus Hollar, who had first come to England with the Earl of Arundel in 1637 and had returned after the Civil War in 1652. Although Place declared that he was "never his disciple nor anybody else's, which was my misfortune" he seems to have meant this only in the sense that he took no formal lessons from Hollar, since his drawing style is so largely based upon that of his professional friend.

In York the circle around Place included the glass painter Henry Gyles and the amateurs William Lodge, who had visited Italy, John Lambert, the son of the Cromwellian General and Sir Ralph Coll of Brancepeth Castle, and his collection of works by others included ink and wash drawings by Thomas Manby (1633-95), another of the earliest English artists to sketch the ruins and landscape of Italy. There were also examples by the Dutchman Thomas Wyck, who settled in England after the Restoration and drew harbour scenes and landscapes in grey wash, and drawings by Francis Barlow, whose studies of birds and animals were etched by Place. Place himself made many sketching tours of Great Britain and visited Ireland. While his style is based on that of Hollar, he was sometimes able to use a greater freedom and imagination, since he was working for his own pleasure and that of his friends, rather than to satisfy the demands of print publishers.

A particularly satisfying connection between the Place circle and a similar, if slightly later and looser group in Edinburgh, is provided by the Gale family of Scruton in Yorkshire, three of whose members were eminent antiquaries. Roger and Samuel were sons of Thomas Gale, F.R.S., Dean of York, and kinsmen of Samuel Pepys. Their cousin Miles was a close friend of Henry Gyles, and was born at Farnley Hall, which later earned a footnote in art history as the home of Turner's most generous patrons. Roger, perhaps the most eminent of the three, was a close friend and correspondent of Sir John Clerk of Penicuik, (1684-1755) the Edinburgh judge, antiquary and amateur draughtsman. Although no drawings by the Gales appear to be recorded, it would be surprising if none existed.

Clerk, at any event, was a prolific artist. He took lessons in Leyden from one of

the Mieris family, probably Willem, although he later recorded it as Francis, in order the better to appreciate what he saw on his Grand Tour. In 1741 he appended a note to a group of views among his papers: "These following Draughts are a few of many hundreds that have been given away or lost since I returned from my travels in 1699. They are very incorrect from the number I used sometimes to make in a day." His house at Penicuik was a centre for the virtuosi of Scotland, such as his first cousin William Aikman, who became a professional painter and moved to London, and Allan Ramsay the poet and father of the painter. At least two of his own seven sons were amateurs, the youngest, John Clerk of Eldin, being the brother-in-law of Robert Adam and a friend of Paul Sandby who encouraged him to etch.

Of course the drawings of men such as these would have been little known and have had little influence outside their own circles of aquaintence, wide though these undoubtedly were, but it is well worth emphasising the ties of blood and friendship between the various groups of antiquaries and amateur and professional topographical painters, because their equivalents can be traced throughout the next century and a half, and they provide one of the most fundamental reasons for the extraordinary popularity of watercolour in Britain.

This antiquarian enthusiasm blended almost imperceptibly with the renewed bout of overseas exploration in the middle decades of the eighteenth century, the first tours to record the ruins of Greece and Rome being sponsored by the Society of Antiquaries and the Society of Dilettanti, and the later voyages to the South Seas being accompanied by professional artists who were commissioned by men of wide-ranging scientific and antiquarian interests such as Sir Joseph Banks. Towards the end of the century the taste for the exotic was mined and minted by the Daniells and others in India and South Africa, and the first embassies to China gave the opportunity to men of the calibre of Julius Caesar Ibbetson and William Alexander to expand the horizons of their art. For all these travelling artists watercolour was the most convenient medium, and the development of the process of aquatint, which was introduced into England by the Hon. Charles Greville and his protégé Paul Sandby, provided the ideal partner for the propagation of their work.

An allied form of patronage which resurfaced at this time was that of the government, through the encouragement of military draughtsmanship. The careers of the brothers Thomas and Paul Sandby virtually began in the drawing room of the Tower of London, Thomas then serving as a draughtsman to the Duke of Cumberland in Flanders and in Scotland during the '45 Rebellion. Paul joined him in 1746 to work on the military survey of the Highlands, remaining in Scotland until 1751. The Duke continued to act as patron to the brothers, and this connection no doubt helped Paul to obtain the post of drawing master at the Royal Military Academy, Woolwich, which he held from 1768 to 1796. He must have been a particularly good and inspiring teacher, since his military pupils produced many excellent 'Sandby' views of parts of the world which he would only have read about. Many such pupils, too, became not only competent amateur watercolourists, but also enthusiastic collectors and patrons. A pre-eminent example is Field Marshal the Hon. William Harcourt, later third Earl Harcourt, who with his brother and sister

were pupils and friends of Sandby, and who made himself a considerable force in the world of art patronage.

In the early part of the eighteenth century the taste of the aristocracy, as far as the employment of native artists was concerned, ran only to portraits of themselves and their property, however, a number of factors combined to make them look upon the growing numbers of watercolour painters with favour. Two of them have already been indicated. The enthusiasm for antiquarian pursuits affected the aristocracy and gentry as well as the professional classes, and an ability to draw became part of the cultural equipment of the enlightened man. At the same time the fact that military and naval officers were being taught to use watercolours for professional reasons led their civilian relatives to take an interest for pleasure. Watercolours too were ideal for turning into prints, and views of seats and parks were popular. The great age of country house building might be on the wane by the middle of the century, but landscaping was at its height, and many of the greatest artists in this sphere including 'Capability' Brown and Humphrey Repton produced finished watercolours as aids in their work, which might well be retained by the owners of the parks. It was at this time too that ladies began to try their skill. As early as 1621 a

(Christie's)

This watercolour by John Nixon shows the stout figure of Captain Francis Grose heading his last antiquarian tour in 1791. A day or two later he died suddenly at the house of Horace Hone in Dublin. The other figures are likely to include Nixon himself, Thomas Cocking and Daniel Charles Grose. Nixon is best known for his caricatures and was very much an amateur. However, there are very impressive views by him at Carisbrooke Castle in the Isle of Wight, and this scene, Ireland's Eye and Lambay from the top of Howth Head, is instantly recognisable. His caricatures were said by contemporaries to be very lifelike.

A South-East View of the Inside of the Ruins of Caister-Hall in Norfolk, anciently the Seat of Sir John Fastolf Knight of the Garter — This Drawing taken & executed by Francis Grose Esqr. F.A.S. in 1778. was exhibited at the Royal Academy in 1776 & afterwards by him presented to Mr. Fenn.

(Christie's)

This drawing by Francis Grose has been fully inscribed, presumably by the Mr. Fenn to whom he gave it. The drawing and colouring are thin and tentative, but then accuracy rather than artistic merit was his principal aim. The bouncy drawing of the trees is perhaps a characteristic, a well as the cut-out appearance of the figures. A feature that this composition shares with the two following illustrations is a carefully outlined tree in full leaf at the left hand end of the buildings.

writer had recommended limning as a particularly suitable pursuit for gentlemen, since watercolours would not ruin their elaborate clothes as would oil paints, and this was equally true for the ladies of the following century. Drawing was a gentle, as well as genteel, occupation for them.

Drawings and watercolours also came to play their part in the social life of the cultured country house. For the most part they were kept in portfolios, to be discussed and admired of an evening as an alternative to music making or games of cards. The need to cater for the sensibility of this market helps to explain the idealisation and romanticism of so much of late eighteenth century watercolour painting. The artistic philosophy of the Picturesque, which was expounded in the writings of Uvedale Price and the Rev. William Gilpin — who was the very recognisable original for Combe and Rowlandson's Dr. Syntax — gave a spurious dignity to drawing as a pastime for the empty-headed. While Gilpin himself, and some of his more able acolytes, were serious enough, a dictum such as: 'We must ever recollect that nature is most defective in composition; and *must* be a little

assisted. Her ideas are too vast for picturesque use, without the restraint of rules,' could easily provide a cover and an excuse for the deficiencies of the incompetent.

As it affected watercolour painting the cult of the Picturesque was a natural sequel to the antiquarian enthusiasm, but like so many sequels it had lost much of the strength of the original. What had been serious and scientific became a social grace. However, at the end of the eighteenth century there were still professional antiquaries of the older school, such as Captain Francis Grose and Thomas Pennant, who were assiduous, if also convivial, travellers and scholars. Grose had been trained at William Shipley's well-known Drawing School, but he was no great draughtsman; Pennant, one assumes, was simply no draughtsman. In any event each of them employed a 'drawing man-servant' who accompanied them on their tours, along with like minded amateurs, such as the topographer and caricaturist John Nixon and Grose's nephew Daniel Charles (see illustration page 49). In Grose's case the servant was Thomas Cocking, and it is virtually impossible to tell the drawings of man and master one from the other. Pennant employed Moses Griffith, who is described by Williams as a "real primitive, a sort of untaught rustic Sandby", which is only a little unfair. Beating a similar path around the antiquities of Britain was the professional artist Thomas Hearne, who should not be confused with the earlier antiquary of the same name, who was not an artist. Hearne's style may be said to be Sandby without the ultimate sparkle. He is a gentle and

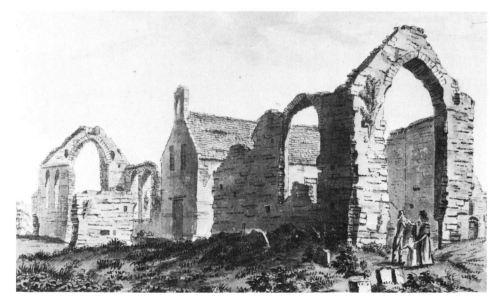

(Royal Irish Academy)

In his Sporting Anecdotes *Pierce Egan wrote: "The Captain had a funny fellow by the name of Tom Cocking, one after his own heart, as an amanuensis, and who was also a draughtsman of considerable merit," but on the evidence of this drawing of Drogheda Abbey his figures are even weaker than those of his master. On the other hand the shading of the buildings is much superior, as is his grasp of the eighteenth century conventions of composition, in the differencing of the fore and middle grounds and the distance of sky.*

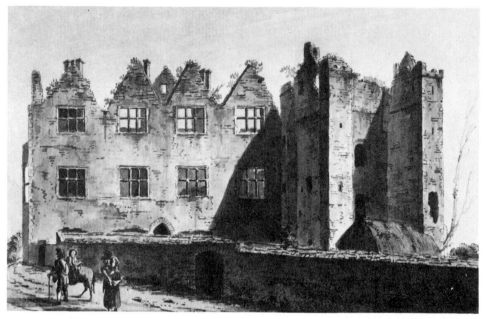

(D. Snelgrove)

This drawing was made by D.C. Grose in 1792 to complete his uncle's unfinished Antiquities of Ireland. *It is faithful to the manner as well as the intention. The figures are really very poor, but his handling of the complicated perspective is deft. D.C. Grose continued to produce Irish subjects until his death in 1838.*

(Sotheby's)

Moses Griffith, the "drawing man-servant" to Thomas Pennant, was the best of the antiquarian set. He had a rudimentary feeling for composition, and his figures are often lively, if rarely elegant. He shares a thinness of penline with Grose. This drawing was signed and dated 1776 on the original mount and it came from Pennant's own collection which was sold off in 1938.

unadventurous painter, but he had a lasting importance in that he was a favourite of Dr. Thomas Monro, and thus played a considerable part in the artistic education and development of the young Girtin and Turner.

Monro was the third in a line of doctors who specialised in insanity — one of his patients was George III and another John Robert Cozens — and the profession was carried on by at least two more generations. He was educated at Harrow, where he may have studied with John Inigo Spilsbury, a worthy if unoriginal watercolourist, moved on to Oxford and John Baptist Malchair, and was a friend and disciple of Gainsborough, whose drawing manner he imitated. His real importance to the development of the English school, however, is as a collector and a patron of young artists, rather than as a performer. His 'Academy' marks the end of the period when watercolour painters were, so to speak, taken up by the aristocracy and gentry, and the beginning of that in which they established their own meritocracy. From this point the relationship between patron and painter changed, as did the attitudes of collectors.

From about 1793 or 1794 Monro invited young artists to come to his house in the Adelphi of a winter's evening to copy drawings from his extensive collection, paying them a small sum and supper for their work. His neighbour and fellow enthusiast John Henderson did likewise, and their most famous students were Girtin and Turner, who are said to have collaborated, Girtin drawing outlines, and Turner tinting and colouring them. It is often well-nigh impossible to tell the exact authorship of a Monro School drawing, and other great, or at least good, men of the future who benefited from his generosity included Louis Francia, Thomas Richard Underwood, Paul Sandby Munn, George Shepherd, Joshua Cristall, Henry Edridge, John Sell Cotman, John and Cornelius Varley, Peter de Wint, John Linnell, William Alexander and William Henry Hunt.

The obvious difference between Monro and earlier patrons and enthusiasts was that here was an amateur who surrounded himself with professionals, rather than a professional who attracted a circle of amateur imitators.

With the foundation of the Royal Academy in 1768 the oil painters of Britain, especially if they painted portraits, had won for themselves a recognised and respectable place in a hierarchical society; they were no longer mere tradesmen, but, if they achieved any success, members of a distinct caste. As with any newly privileged group, they had no wish to see their hard-won status shared by others, in this case mere drawing masters, and many of them endeavoured to maintain a division between the high art of the oil painting and its frivolous poor relation the tinted drawing or watercolour. When exhibited at the Academy, a watercolour was inevitably 'skied' and had little chance of attracting notice, and since individual watercolour painters were discovering that there was a ready market for their work, it was inevitable that they should eventually attempt to form their own body.

On November 30, 1804, at the Stratford Coffee-house in Oxford Street William Frederick Wells, Samuel Shelley, William Henry Pyne, Robert Hills, Nicholas Pocock, Francis Nicholson, John and Cornelius Varley and William Sawrey Gilpin formed themselves into the Society of Painters in Water-Colours, although,

according to Pyne, some of them had felt that the use of the word 'Painters' was presumptuous. Five months later, after the addition of a further six artists, George Barret, Joshua Cristall, John Glover, William Havell, James Holworthy and Stephen Francis Rigaud, they opened their first exhibition to the public. The catalogue carried the following prefatory announcement: "The utility of an Exhibition in forwarding the Fine Arts arises, not only from the advantage of public criticisms, but also from the opportunity it gives to the artist of comparing his own works with those of his contemporaries in the same walk. To embrace these points in their fullest extent is the object of the present Exhibition; which, consisting of Water-Colour Pictures only, must, from that circumstance, give to them a better arrangement, and a fairer ground of appreciation, than when mixed with Pictures in Oil. Should the lovers of the Art, viewing it in this light, favour it with their patronage, it will become an Annual Exhibition of Pictures in Water Colours." They did, and it did, surviving, sometimes precariously, until the present day.

The previous decade had perhaps been the most important in the whole history of the art in Britain. As has been increasingly apparent in the twentieth century, it does not take long for the best artists to exploit all the possibilities of a new philosophy or style and to feel the need to express themselves in still newer ways. At the same time there will be others less adventurous and enquiring who will continue to mine old seams in increasingly repetitive and unoriginal work. In the 1980s, when subdivisions of medium hardly matter any longer, we see just such a process of transition between a worn out insistence on abstract art and whatever is to succceed it — which seems to be a great leap backwards in the Pre-Raphaelite manner to a base in the old values of realism. Watercolour painting in the 1790s had reached such a crisis, since there was little more which could be developed from the Sandby tradition of the tinted drawing.

By 1794 Girtin and Turner had come under the wing of Dr. Monro. They had already virtually mastered the traditional methods of their masters Edward Dayes and Thomas Malton, and the introduction to the work of Munro's favourite John Robert Cozens, perhaps the most significant and forward looking British artist of the eighteenth century, must have proved a catalyst. Cozens is a painter of moods and dreams and poetry, and his landscapes, whether on the coasts of Italy, in the Alps or even in Greenwich Park, border on the realms of Faery. His art is very far from the topographic 'portraiture of places', and equally removed from the Arcadian vision of the Claudians.

Girtin and Turner, like most of their professional contemporaries, began by colouring prints and copying the work of established masters. Girtin also made tours with yet another perambulating antiquary, James Moore, and produced plates for Walker's *Copper Plate Magazine,* one of the first of a type of publication which was to have a great influence over the next decades. Turner also toured Britain extensively, at the same time setting himself the task of mastering the techniques of his predecessors as completely and rapidly as possible. His early work is remarkable in the fidelity of his copies to the originals, and for the speed with which he mastered and abandoned successive styles. It is very often almost impossible to tell an early

Turner from a Dayes — although the latter was Girtin's, rather than his, master — or in another mood, an early Turner from a Hearne or a Cozens. Girtin on the other hand made what he copied his own. Unlike Turner, too, Girtin was prodigal with what he had learned, happily passing his methods to friends and pupils. At this period Turner did have a few pupils, such as the competent amateur William Blake of Newhouse in Glamorgan, but he was by nature secretive and unwilling to impart his knowledge, and he soon gave up the uncongenial task.

Although it is easy to overexaggerate the isolation of Great Britain during the Revolutionary and Napoleonic Wars — which naturally gave a great boost to the Sandby school of military topographers — certainly many artists were forced to draw upon native resources more than at other times. On the rare occasions when it was possible to travel freely, as at the Peace of Amiens and during the First Restoration, as many cultured people as could find the means flocked to Paris and the Continent, but for the best part of twenty-five years the British School had to develop in virtual isolation, and it was indeed fortunate that it was healthy enough to endure this experience without becoming irredeemably provincial and old fashioned. One important outside influence which did reach Britain in the early days of the Wars must be mentioned, however, as it was to have a considerable effect on the patterns of nineteenth century connoisseurship and collecting.

The fashion among the British aristrocracy and the rich collectors of the eighteenth century had been largely for Italian and French masters, leavened with contemporary and native portraits of houses and their owners. The sale of a number of the great French artistocratic collections, most notably that of the Duc d'Orleans, during the Revolution, brought Dutch landscape painting to the attention of British connoisseurs, and encouraged them to patronise their own landscape painters.

A further encouragement at the beginning of the nineteenth century was the discovery, against all received wisdom, that contemporary works could be valuable in monetary terms. Previously collectors and patrons had been activated by altruistic, aesthetic and short-term motives only, since it was held that such things would increase in value only after two or three generations, if ever. However, the sales of several eighteenth century collections around 1800 produced indubitable profits, thus gradually injecting a financial element into collecting and patronage.

Given Girtin's more open nature, it is not surprising that he, rather than Turner, was the focus of the first of the sketching clubs which became such a feature of nineteenth century artistic life. 'The Brothers' apparently first met in May 1799, and they were different in kind from earlier groups, since sketching and drawing was their *raison d'être,* rather than one among several scholarly and artistic activities. The society, which consisted mainly of professionals but also included dedicated amateurs, would meet one evening a month and work at the same subject for two hours. As at Dr. Monro's there would be beer and cheese, and the resulting sketches became the property of the host for the evening. Turner is said to have refused membership because of this last provision. The first members were Francois Louis Thomas Francia, who may have been the originator of the scheme, Girtin, Robert Ker Porter, George Samuel, and the amateurs or part-time professionals John

Charles Denham, Thomas Giles Worthington and Thomas Richard Underwood. These were shortly joined by John Sell Cotman, who became the moving spirit of the circle after the death of Girtin, Augustus Wall Callcott and Paul Sandby Munn. The original group seems to have faded away after about 1804, despite the further addition of Joshua Cristall and John Varley, but a successor society emerged in 1808, which included some of the same members, but centred on the brothers John James and Alfred Chalon. This was to continue its activities, and to attract many of the most distinguished watercolour painters, until 1851.

Many of the members of these sketching clubs also became stalwart members of the 'Old' Watercolour Society, as it became known to distinguish it from its rivals the Associated Artists in Water Colours (1808-12) and the 'New' Society, founded in 1831. These professional societies, which insisted on "moral character" as well as "professional reputation", were intended not only to make money for their members, but also to enhance their social standing, as had the Royal Academy for oil painters, and in this they met with considerable success. At the same time there was a growing social diversity among collectors.

Occasionally in the eighteenth century aristocrats had accepted watercolour painters into their circle of friends, even though they may have first come to the families as drawing masters. Examples are Paul Sandby and the Harcourts and Grevilles, Girtin at Harewood and Alexander Cozens with William Beckford, although Beckford still took Cozens' son on the Grand Tour very much as one of his suite. As the nineteenth century progressed this more equal relationship between patron and protégé became more common. Turner at Farnley Hall and Cotman at Brandsby were very much the honoured and familiar guests of the Fawkes and Cholmely families, and although one cannot generalise from the behaviour of Lord Egremont at Petworth, there again Turner was welcomed as a friend rather than an employee.

The Napoleonic, like any other war, produced its crop of new rich, and a number of them proved to be serious patrons and far-sighted collectors of contemporary art. They did not automatically turn to the Old Masters as had the older aristocracy which was part of a wider international culture, and indeed some of them may have been put off by the large numbers of forgeries to be seen in the aristocratic collections. They preferred to deal directly with their contemporaries, who often shared the same social background. The new collector and patron is typified by that remarkably generous figure William Wells of Redleaf in Kent, a retired Deptford shipbuilder, and an innovative landscape gardener, whose own gardener was by chance a namesake, and became the father of H.G. Wells. He kept more or less open house for his favourite artists, showering them with commissions and with hospitality. For a number of years the young Edward William Cooke would spend some two months each summer at Redleaf, and when he became engaged, Wells paid for his fianceé to stay at a nearby hotel so that she could visit him as a surprise. For a wedding present he gave the couple two Turner watercolours.

Another very useful source of income for watercolourists in the 1820s and '30s was the publishing fashion for landscape 'Annuals', which provided not only fees

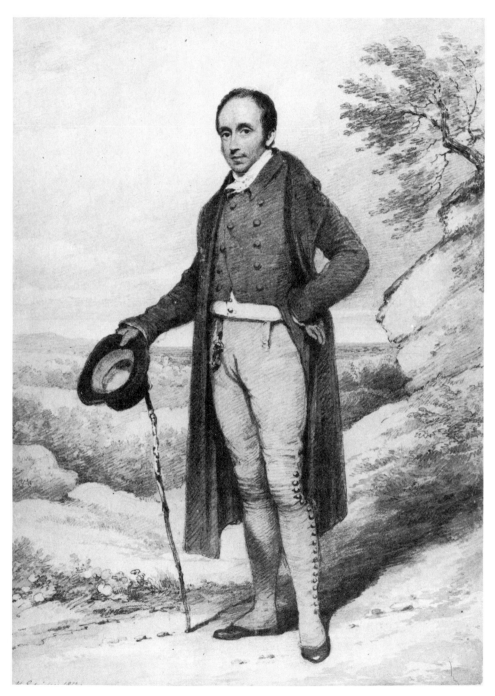

(Christie's)

A portrait of the great patron and collector William Wells of Redleaf in Kent by Henry Edridge.

but also advertisements. Financially the nineteenth century was an excellent time for painters, and in real terms the prices paid for the work of the better watercolourists during their own lifetimes and shortly afterwards have probably never been equalled.

As early as 1818 or 1819 the great collector John Allnutt of Clapham paid Frederick Nash £125 for a large interior of Westminster Abbey with monks, and when Allnutt's executors held a sale of the collection in 1863, it produced some of the highest prices then recorded. It is an excellent thing to find the name of Allnutt in the provenance of a nineteenth century watercolour; other reassuring names are J. Heugh (sales 1874 and 1878), W. Leaf (sale 1875) and W. Quilter. There were two sales from the collection of William Quilter of Norwood, in 1875 and 1889. In the first unprecedented prices were paid, or apparently paid, for the works of many near contemporaries, in particular Cox, but it marked the collapsing point of the current boom, and many of the lots were in fact bought in. One, however, may be quoted as an illustration of the rise in prices over a period of thirty or forty years. A large Cox *Hayfield* which had been sold at the O.W.S. for £50 and later bought by Quilter for £500, made £2,950 in 1875. The 1889 sale, on the other hand, contained many of the works which had supposedly been sold on the previous occasion, and for the most part prices were lower.

For much of the nineteenth century the majority of collectors were uninterested in the work of the earlier men. Even Girtin had little appeal. In the Wells of Redleaf sale in 1857 his *Morpeth Bridge,* which is said to be his last work, went to a dealer at a mere 31 gns. In 1881 it sold for 110 gns., and in 1933, another period of low prices it made 310 gns. Of this watercolour his biographers write that "this work being in magnificent condition, the original strength of the colour can be savoured as but seldom in Girtin's late drawings." On its latest sale-room appearance, as part of the Newall Collection in 1979 it made a well-deserved £70,000.

The subjects and styles of mid and late nineteenth century watercolours reflect very accurately the predominance of the new prosperous middle classes among the collecting public. Tourism in a modern sense, rather than Grand Tourism or antiquarian ramblings, became common and ensured the popularity of views of Snowdonia and the Highlands. Cox had many successors at Bettws-y-Coed, and in Scotland Turner and the young J.F. Lewis were followed with profit by Turner of Oxford and William Andrews Nesfield. The Gothic charms of the old Continental towns were exploited in a similar way by Samuel Prout and Thomas Colman Dibdin. Both romantic nature and the quaintly old had an immense appeal to people who had increasingly to live in modern industrial cities.

This can be seen even more clearly at the end of the century in the cottage garden school headed by Birket Foster and Helen Allingham. Their charming confections of the dappled lanes of Surrey and Berkshire were avidly sought after by a society which did not wish to admit its urbanisation. The very fact that Surrey was being built over made a rustic presentation of it even more attractive to the early commuters who were themselves ensuring its destruction.

The same need to turn back to an idealised country past and a simpler time of

elegance assured the success of the neo-Stuart and eighteenth century costume painters and Regency revivalists such as the Cattermoles, the Buckleys, George Goodwin Kilburne and Henry Killingworth Johnson, although to a modern eye many of them are at their best when portraying contemporary life and scenes à la Tissot. This need continues today and explains why so many townees who have never sat a horse are eager buyers of hunting prints, paintings and watercolours.

The true aristocratic amateurs, like Hercules Brabazon, were unaffected by this taste for sugar in style and subject, since they had no need to consider buying fashions. Brabazon was an avid disciple of Turner's impressionism, and he was

The frontispiece for the albums in which the Haldimand Collection was originally bound. It is fascinating in many ways. Not only does it show the comparative esteem in which the various artists were held by their contemporaries, with Glover in the place of honour, but it also shows us how good a painter such as its author James Prinsep could be, although he is virtually unknown to modern experts.

lucky in that he was only persuaded to exhibit his work very late in life when professional artistic fashion had caught up with him. Thus he is something of a bridge between the great men of the early part of the nineteenth century and the new dynamism of the new schools of its end and the early twentieth, notably the Glasgow Boys and their fellow Scots.

The taste for collecting watercolours, like the habit of amateur painting, tends to run in families. Norman D. Newall of Newbrough in Northumberland, inherited a small group of works by the earlier watercolourists from his grandfather Robert Stirling Newall, together with a larger number of fine things by Alfred William Hunt, who had been a friend and protégé of the grandfather. During the 1920s, '30s and '40s the younger Newall greatly added to the collection, concentrating particularly on J.R. Cozens, T.S. Boys and John Scarlett Davis, who was so little appreciated in 1945 that a large parcel of his drawings could be had for £34. Newall died in 1952, but the collection was not dispersed until after the death of his widow, by which time, even in real terms, its monetary value had increased immensely.

Newall was lucky to be born at the right time, and to have the money to buy the few things that were comparatively expensive should he want them. But during this period of neglect from the 1930s to the '50s, other magnificent collections were built up on enviably small sums. For the few who were interested these were the palmy days of collecting, and it must have been a joy and an excitement to accompany Iolo Williams or Professor Jack Isaacs on a lunchtime trawl of the Charing Cross Road. At that time the Victorians were even more unfashionable than their predecessors, but since the late 1960s it has been difficult to find any area of the English school that is without its admirers, and by 1980 the Victorians were once again more expensive than the earlier men in general terms, although of course individual works by Turner, Cozens and Girtin were still at the top of the financial league.

A unique collection which must find a place in any notes on the subject is that formed by the painter George Fennel Robson for Mrs. George Haldimand between 1826 and 1828, and consisted of 101 watercolours by the best practitioners of the time. They were first exhibited in unsuitable and elaborate gold frames and then mounted in three albums. Later they were grouped in twos and threes in austere brown frames. As well as the obvious names the collection included examples by many excellent artists who are now almost forgotten — such as Frederick, a fifth Fielding brother. After the death of Mrs. Haldimand the collection was sold as one lot in June 1861 to Agnew at £1,500. If ever there was a case for a collection to be bought for the nation and preserved together, this was it, but sadly it has recently been sold piecemeal.

3. Autres Temps, Autres Moeurs

Here we have a group of watercolours of the same subject, Durham Cathedral, executed between about 1799 and 1895. They illustrate some of the many different responses possible to the same challenge in the nineteenth century: (colour) Thomas Girtin, 1799; George Fennel Robson, c.1827; John Chessel Buckler, c.1830; George Fennel Robson, c.1830; Henry Barlow Carter, 1842; Alfred William Hunt, 1876; John Varley, yr., 1889; James Burrell Smith, 1890; Frederick George Cotman, 1891; Richard Henry Wright, 1895; and (colour) Thomas Shotter Boys, 1830. A Brabazon is shown as a complete contrast.

Thomas Girtin (1775-1801) (Whitworth A.G., Manchester)

Girtin's composition is as proud and assertive as a coronation fanfare of trumpets. It is also taken directly from the romantic Italian work of J.R. Cozens — we could easily be looking up the volcanic sides of Lake Albano to Castel Gandolfo. It is a splendid image which set an impossible standard for most of the artists who were to attempt the same subject over the next century.

George Fennel Robson (1788-1833)　　　　　　　　　　　(Christie's)

Robson's first view is one of a series he made for *Picturesque Views of the English Cities,* which was published in 1828. Several of them were in the Newall Collection. They show no great originality of composition, and in each case the viewpoint is much the same. This one looks rather unfinished, and was probably a preparatory version. Although these watercolours centre on the various Cathedrals, the title of the work obviously made it necessary at least to indicate other features of the Cities, with a consequent loss of potential dramatic effects.

John Chessel Buckler (1793-1894) (Christie's)

Buckler was an old fashioned purveyor of portraits of places, working in a style perfected by his father at the end of the eighteenth century. This is an unusually dramatic work for him, but then it is the most obvious viewpoint to take when painting Durham, and it is the composition rather than the conventional handling which provides the drama. The careful outlines and limited palette of stone colours and greens for the massed, woolly foliage betray not only his eighteenth century inspiration, but also the professional architect that he was. Luckily his practice took up much of his time, since he was a very prolific painter, and as he lived to be more than 100, he might otherwise have left us almost every building in Britain in the same worthy manner.

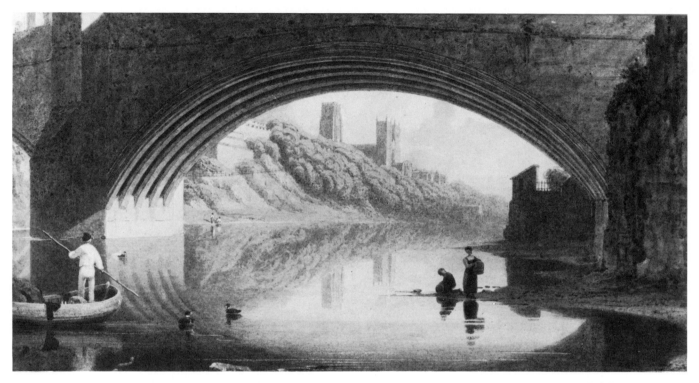

George Fennel Robson 1788-1833 (Christie's)

In this return to the subject Robson has done it greater justice. The use of the bridge
to frame the actual subject was a favourite with Varley, from whom Robson may
have taken it, and it was later adopted for oil paintings by Clarkson Stanfield's son
George. It is very effective here, and gives the watercolour a greater interest than the
unadventurous technique might have merited.

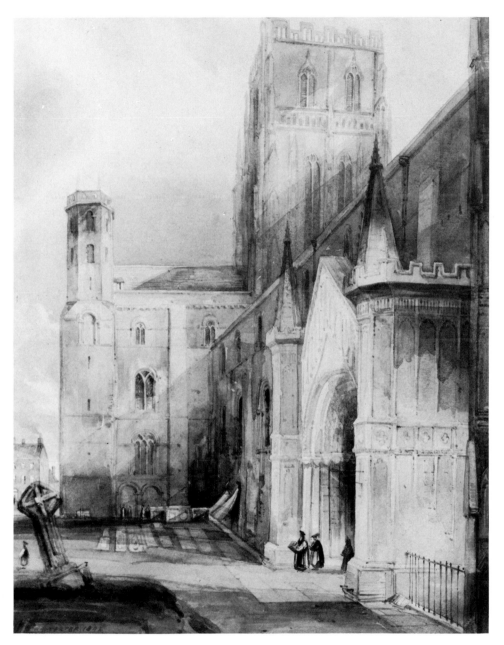

Henry Barlow Carter 1803-1867 (Christie's)

The Turner follower Henry Barlow Carter is best known for his wide views of
Scarborough from the sea and other subjects on the Yorkshire coast. Here, a little
unexpectedly, he has gone to the opposite extreme, closing right in rather than
taking a broad sweep. He shows a firm grasp of architectural forms and a good
feeling for light, although the latter is often undermined in his work by too great a
reliance on yellow-greens.

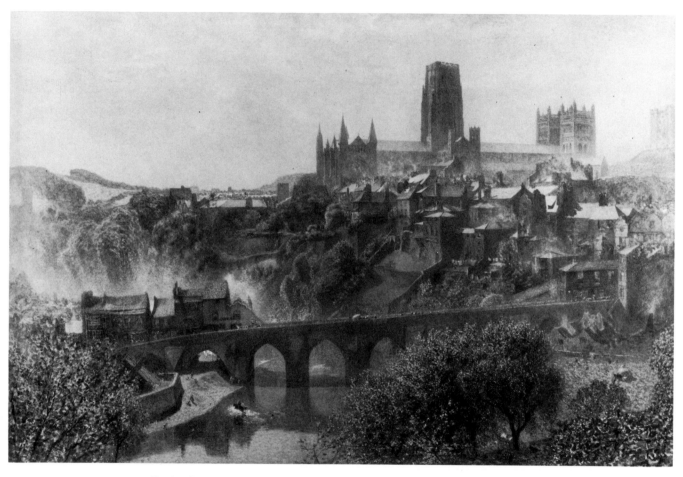

Alfred William Hunt (1830-1896) (Christie's)

At his best A.W. Hunt was one of the strongest of the Victorians, and his best was often produced for the Newall family, his friends and patrons, as here for William Newall, uncle of the main collector. He has taken one of the standard viewpoints, but he has not used the undoubted mist and smoke as an excuse to avoid going into detail. He uses a thick and rich paint surface, with much scraping, scratching and stopping out. Here it works very well, and produces a splendid effect of solidity.

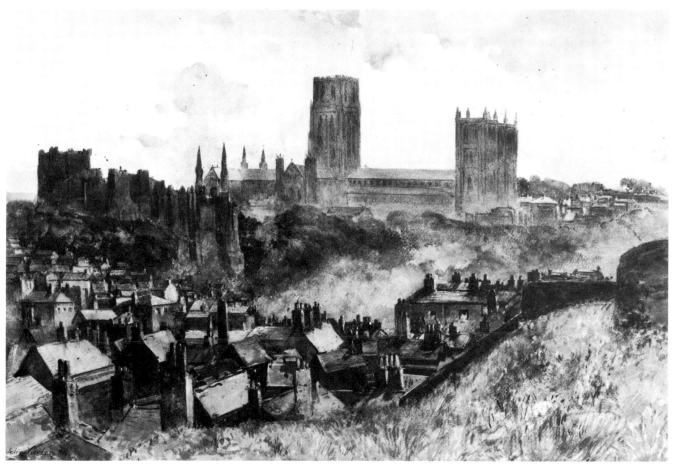

John Varley, yr. (1850-1933) (Sotheby's)

By the end of the century because Buckler, Robson, Hunt and almost everyone else had painted Durham either from or from across the river, painters had to find new viewpoints. It must be admitted that few match up to the cliché. The younger Varley (the first John's grandson) seems to have realised this and to have found more to interest him in the roofs of the town in the foreground than in the Cathedral itself. The splashy style used here was popular with watercolourists from this period up to the 1930s — although by then it was itself dated.

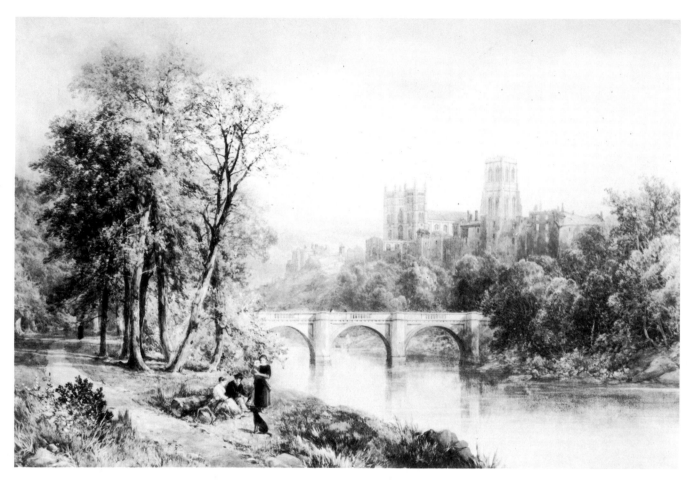

James Burrell Smith 1822-1897 (Sotheby's)

J.B. Smith was nearing the end of his career when he painted this, and although executed a year after the Varley, the style and viewpoint are more typical of the middle decades of the century. Smith was a pupil of the elder T.M. Richardson, and his style is a rather insipid version of that of the Richardson clan. He uses clear, light greens and stippling for foliage, and although the peace of the river is unbroken at this point, his nickname of "Waterfall" Smith indicates his preferred subject matter.

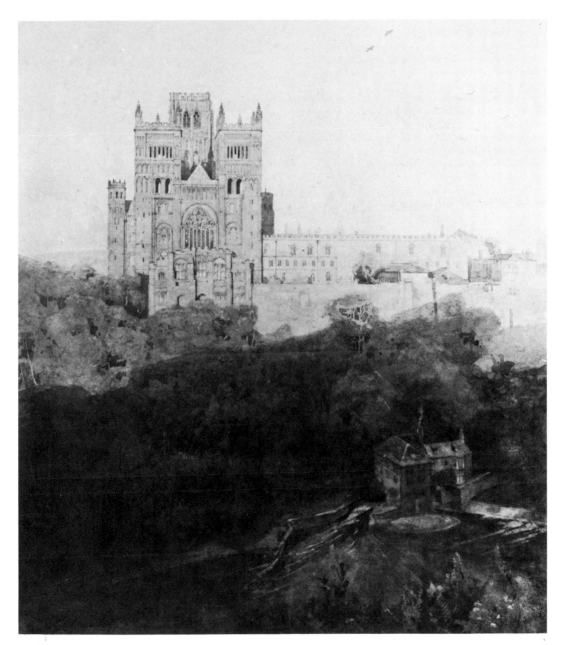

Frederick George Cotman 1850-1897 (C. Chrestien)

Cotman (nephew of J.S.) has boldly gone for the full frontal, and it pays off magnificently. His colouring is reminiscent of both his uncle, and on this occasion his cousin J.J. Note too the scraping and stopping out. This is quite the most powerful of the later views, one reason for its success being that he has eliminated such inessentials as the neighbouring houses — which gives all the more effect to the weir house below.

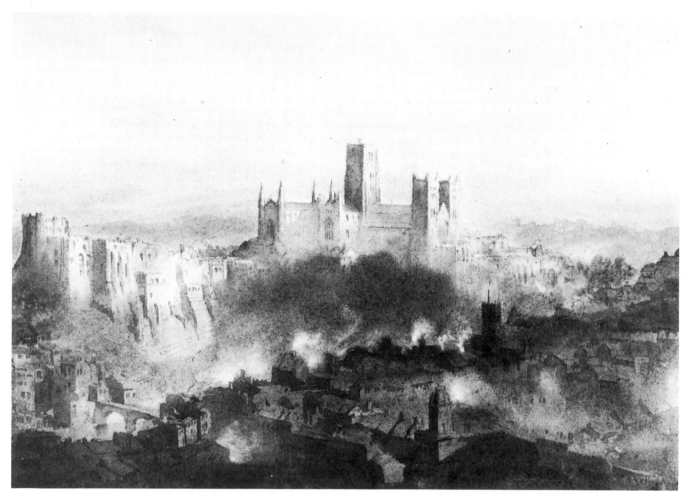

Richard Henry Wright (1857-1930) (Sotheby's)

Wright began, a few years before this, in the free and splashy manner in which he was to continue until the Twenties. He has taken the North West aspect and has attempted to infuse drama by making Cathedral and Castle rise from a misty and miniaturised foreground. It is a gallant attempt, but does not entirely succeed.

Hercules Brabazon Brabazon (1821-1906)

All these artists were working for an often conservative public. This did not apply to Hercules Brabazon Brabazon and here we have a complete change of style as well as scene. The dashing and self-grown Impressionism of the Great Amateur could hardly be in greater contrast to much of the professional work of his time. While many professionals could produce sketches in this manner, most, with obvious exceptions like Turner, returned to realism in finished pictures. Brabazon was mostly working for his own pleasure, and that of his 'hareem' of travelling companions, and so could do as he pleased.

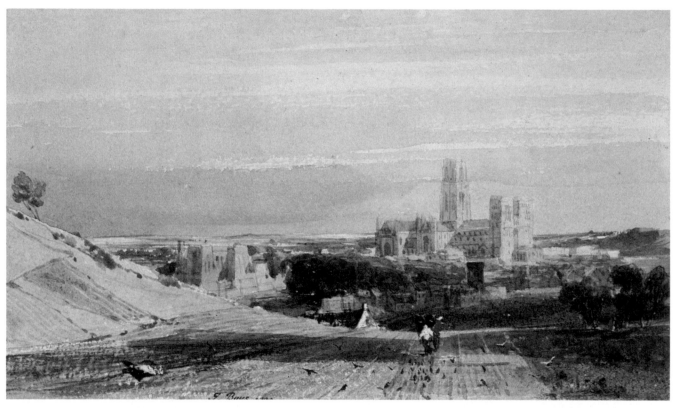

Thomas Shotter Boys (1803-1874) (Christie's)

Although the subject here is English, this is very much Boys in his French manner, as would be expected from the date of 1830. Despite the tricks of dragging and scraping, there is always a lightness to Boys' washes.

4. Learning to See

The essential attributes of the good collector are physical, and need physical training. The greatest, naturally enough, is the eye, which must be developed by the constant study of the best, and the equally constant awareness of the worst. It must be linked to an excellent visual memory, which again needs constant exercise. It is not enough, and indeed it can be positively dangerous, to know that you have seen something of the sort somewhere before; you must be able to recall exactly what and where, in as much detail as possible. An 'eye' is very much a matter of mental self-discipline, a refusal to be carried away by what might be the truth before all the available evidence has been sifted and assessed. An eye should make no allowance for luck, although it may be the means of exploiting a turn of luck to the full. A natural and untutored eye, like perfect pitch, is a rare gift, but most people can develop a reliable one if they are prepared to work hard at it. Admittedly there are some unfortunates who can never do so, but this is largely because they start off with an unjustified and overweaning self-confidence.

Less common than a good eye is a sure feel. It is unnecessary to explain this to a connoisseur of bronzes or of porcelain, but not everyone realises that it can also exist among the admirers of paintings, or indeed anything beautiful. Despite the intervention of frame, glass and mount some people are aware of an acute physical tingle when they handle a painting of real quality, even if they are unable to say at once what it is. I have often found that the first instictive feeling through the hands, whether good or bad, is correct, despite logical second thoughts to the contrary. Obviously, however, it would be most unwise to rely on this alone, without the most rigorous testing, if ever. 'Feel' even more than 'eye' is likely to lead astray the half-knowledgeable. Unfortunate, it is more difficult to acquire a feel by training than it is an eye, since touching is so often discouraged.

The mental process by which an expert first assesses a watercolour is largely subconscious, and very fast, which makes it difficult to analyse to any great degree. However, some, or all, of the following questions should be answered automatically. Is it in fact a watercolour, rather than some form of reproduction or print? Is it signed? If so, do I believe the signature? What date is it? Is it a grey ground drawing, and thus probably eighteenth century or a later amateur working in the old fashioned style? Is there bodycolour or white heightening? Is this of an eighteenth century or a High Victorian type? Are there any stylistic 'signatures' which point to a particular artist, and if so are they in fact his, rather than imitations by a pupil? If it is a topographical work or a portrait, do I know anything about the subject or the sitter?

If this questioning comes up with no more than a rough date of execution, what sort of painter am I looking for? A good one on a good or a bad day? A competent hack? A pleasing amateur? Someone entirely incompetent, but whose subject-matter is interesting enough to override artistic considerations? Is it a view of a place of which prints were likely to have been made? Or one which was visited by very few painters? At the same time the brain will also be assessing the condition of the paint and paper, and deciding whether cleaning would improve it, or whether it has already been restored to lifelessness.

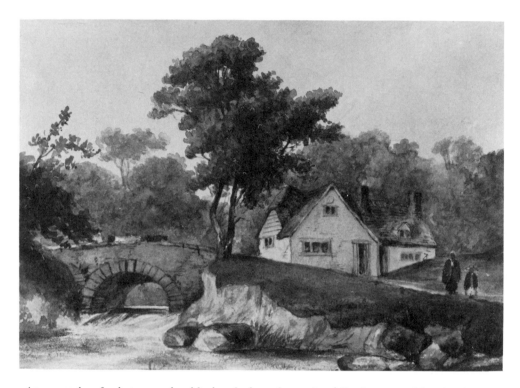

An example of what you should already have learned to dismiss out of hand. This is a charming amateur production, and while pleasant enough it should detain you no longer. However, just pause over the figures and see if you could persuade yourself that they were by a professional.

With experience, approximate dating to within a decade or so should soon become fairly natural to you, with one or two provisos. The sketches of an artist working for his own pleasure may well have a more modern feel than his finished or exhibition work. As in every other art there have been stylistic revivals from time to time, and these may confuse at first glance. The majority of amateurs, however, distinguished, tend not to progress greatly from the style learnt in youth. Thus in the 1840s a man could still be producing work in a manner assimilated from a Varley or a Laporte in the early years of the century.

This said, almost the first considerations of someone offered a picture, provided its immediate quality attracts, should not be aesthetic or instinctive, but practical and forensic. The first action of the professional is to look at the back. Even if a watercolour has been recently reframed, a sensitive dealer or collector should have transferred any information from the old frame to the new. Whether old or new the back may well tell you many things which the painting itself cannot. There may be no signature or date on the front, but there may well be an artist's label on the reverse, giving details of the artist, his address, and possibly of a dated exhibition. There may be one or more stencilled numbers and letters, indicating that it has been through the hands of Christie's, or, more ominously, there may be indications of the

The back of a watercolour which was reframed, presumably after its visit to Manchester. This is what should happen: the artist's label and all other information has been transferred to the new backing.

An Agnew label. The stock numbers can be checked back to about 1890. The firm was founded in Manchester in 1817, and it moved to London in the 1860s, settling in Bond Street in 1878. At times in the nineteenth century there were also branches in Liverpool and New York. This label alone may not be of great use, since it may only indicate that the work has been framed by the firm.

removal of such a stock number. Sadly, Christie's are the only auctioneers to use stencils, which make it possible at least in theory to trace any framed painting which has been handled by them. There may also be chalk indications of a sale date and lot number, but without the short cut of a stencil, this could involve a long search around the likely auction houses. The mark left by an oblong sticky label about one inch in length may indicate a Sotheby sale.

If previous owners have been in any way conscientious the back may also carry

details of provenance, and a sensible collector will carry mental lists of which names add to the stature of a watercolour, and which detract.

It might be assumed that auctioneers and dealers would automatically study the backs of frames, but such is not always the case, especially among the former, and even when they have done so they may well misinterpret what they see. Some years ago I remember noticing an excellent, if not particularly original, and rather dirty late eighteenth century watercolour of a country house in a London sale room. The catalogue gave the artist as W*. Turner, indicating that the auctioneers did not know a Christian name for the artist. On the back, however, there was an engraving made from the drawing, which it also ascribed to W. Turner. Unfortunately I had already seen a leading and very thorough dealer studying it both front and back, and I knew that there was no chance of adding a genuine J.M.W. Turner, who signed in this manner at the beginning of his career, to my collection.

On another occasion in the country an excess of caution led me to miss the opportunity offered by the back of a frame. The watercolour, once again dirty, but not particularly faded, was of a church, which from its combination of a thatched roof and flint dash with a round tower must have been East Anglian, and it was unsigned. The style was unfamiliar, but the quality undoubtedly high. On the back was the trade label of John Thirtle, who was not only one of the best watercolourists of the Norwich School, but also frame-maker to his confrères. Lacking confidence in the combination of quality and label, I dropped out of the bidding too early to defeat the local ring, a decision which I regretted some weeks later in the house of a descendant of John Sell Cotman, where I saw what was virtually the pair to my watercolour, once again in a frame made by Thirtle, who was Cotman's brother-in-law. The unfamiliarity of the style was due to the fact that these dated from the brief period when Cotman was moving from the influence of Girtin to the discovery of his own mature manner.

Thus framers' labels and also dealers' labels, which may also carry a stock number, can well be aids to the search for an attribution.

Until recently a further reassuring, if not particularly informative, feature of many old frames was the faintly pencilled hanging instruction such as 'to right of Drawing Room fireplace'. This gave an indirect corroboration to claims of long and continuous family ownership. Alas, this together with some old labels, inscriptions and boards, has now entered the repertoire of the forger. Of the older dealers' labels those which inspire most confidence include Agnew, Vokins, Palser and the Walker Galleries.

At the very least, the state of the backing will tell you whether the watercolour has been taken out of its frame recently. It should be the automatic practice of every auctioneer's cataloguer to remove a drawing or watercolour from its frame, but such is not always the case, which can be to the advantage of the buyer, but equally to his dismay. Naturally, any dealer wishing to remain long in business will have everything out to examine the mount and the back of the paper. In any case you should always try to see a watercolour out of its frame before buying it.

Many artists signed only on the back. Others, who never signed at all, inscribed

the reverse in a characteristic hand and these inscriptions must become as familiar to the collector as styles and signatures. An eighteenth century mount prepared, and perhaps signed, by the artist himself, may be concealed beneath a modern successor. Beneath the mount or on the reverse there may be a collector's stamped mark. Although fewer collectors of English watercolours than of Old Master drawings and prints had or have their own stamps, some of the best of them did, and such evidence of provenance can add greatly to the value of a drawing. Among those which the collector should carry in mind are the stamps of Paul Sandby, Joshua Reynolds, Thomas Lawrence, the Second Earl of Warwick, William Esdaile and Dr. Percy. They, and most others, can be found in Fritz Lugt's great directory. One or two others, of course, should be taken as a warning. The late Canon Smythe, Archdeacon of Lewes, for instance, certainly had many good things in his collection, but some of his attributions have been scouted by more recent connoisseurs. Other encouraging collections which may be mentioned on backing labels include Wells, Munro of Novar, Iolo Williams, Sir L. Duke, Oppé, Professor J. Isaacs, Haldimand, Dangar and Newall.

The paper, too, can have its story to tell. Some account of the eighteenth century developments in paper making associated with the Whatmans has been given in Chapter I. Details of the countermarks and watermarks used by them can be found in Thomas Balston's *James Whatman, Father and Son,* 1957. Interestingly, Balston knew of only one paper, used for a watercolour of a rowing match at Richmond by Robert Cleveley which is now in the Victoria & Albert Museum, which bore the countermark "J. Whatman Turkey Mill 1792". No other actual Whatman paper

(Ashmolean)

A splendid example of an inscription on the reverse of a drawing by the Oxford drawing master and musician John Baptist Malchair. His is one of the hands which a collector of the period should learn to recognise.

(M. Gregory)

Another of the great reverse inscribers was John White Abbott, the pupil and friend of Francis Towne. The back of every drawing should be examined, but it is particularly important with any Towne school subject, since the back may well prove it to be a White Abbott.

(Christie's)

A good example of a Constable inscription. If in good condition it is sometimes difficult to date a Constable watercolour sketch immediately, because the dashing freedom can suggest a later period. It is as well to have an example such as this at hand to help in sorting out his work from that of his family and other imitators.

mark seems to have included either a date or "Turkey Mill", although both were and are used frequently by the Whatmans' successors.

Dated watermarks can of course be an invaluable aid in the detection of forgery and fraud. Around 1970 Christie's offered a spirited pen and wash drawing which carried a 'Wm. Blake' signature and a date. Unfortunately this date was two years prior to that in the watermark, and the drawing, a perfectly good Fuseli, suffered in the eyes of the market as a result. Watermarks can give a *terminus ad quem,* in this way, but they can be relied on for little more, since, as we have seen, many artists would continue to use stocks of an old preferred paper for many years.

Further details of both British and Dutch watermarks can be found in W.A. Churchill's *Watermarks in Paper* which was published in 1935. Despite its age this still provides a starting point for research.

The most common form of mount in the eighteenth century consisted of a simple border, either on the same paper as the actual watercolour, or a backing sheet, with several washed or pen and ink lines. Since watercolours were generally kept in portfolios there was less need for the modern window mount which is better suited to framing. The wash lines, which are generally broader than the modern equivalents and in the same tones as the watercolour, do however, give it added depth. Occasionally watercolours, like prints, were stuck directly on to walls, and

these might well have been varnished over, with the borders giving the illusion of frames. Naturally these watercolours, where they have survived at all, are but poor shadows of themselves, however lovely they must have looked when first pasted up.

A particularly good instance of the importance of looking beyond the frame and beneath the mount is provided by some of the portraits of John Downman (1750-1824). Portraits, naturally, were intended for hanging, and in many cases the name at least of the sitter will be inscribed on the front. However, Downman's characteristic oval mounts are often laid on to the surface of the watercolour, and in some cases they cover the artist's personal comments on his subject. In some cases, too, he actually applied the colours for his faces to the back of the paper to give a softer and more delicate effect.

On the whole Downman kept his most pertinent and extended comments for the copies of his commissions which he made in personal sketch books, but if lucky you might uncover something like one of the following: "Robert Fourth Duke of Ancaster, 1779. Died suddenly this year. This copy was enlarged from a miniature, and done under the particular directions of his friend, Mr. Weston, and much approved, of which I made two." Or again: "The Rev. William Way, of Glympston Park, 1817. He played at backgammon from Wednesday morning till Saturday night.' Sometimes there is a touch of acerbity as "never was quiet for a moment", or "pretty, but knew it a deal *too* well". With immense luck you could come across a Georgette Heyer-like synopsis of eighteenth century fashionable life such as the following: "Devonshire House, 1784. Original study for a whole length with Lady Elizabeth Foster. The Prince of Wales came there; present also Lady Duncannon, who, in play, followed him with a chair to sit, which he declined. A French prelate was introduced, who kissed the inside of Lady Elizabeth Foster's hand; and when gone the Prince noticed the odd action with much humour. Presently Blanchard was announced, having just descended from his balloon."

Incidentally, Downman's biographer reports a rumour that he had suffered the attentions of a press gang and served two years in the Navy. Downman was an excellent, if very occasional, landscape painter, and if true this story might provide an explanation for some otherwise unattributable group of scenes of shipboard life which might turn up dating from 1775-77.

This last raises another point for the collector in search of a collection. Never dismiss the uncharacteristic, but equally always treat it with caution. Just because an artist is well known for working in one style or manner, it is not safe to assume that he never experimented with another, although such examples will need a greater weight of evidence to establish the attribution. In this case, unless you are particularly eminent, eye and personal conviction are not necessarily enough. Some years ago in a country fair I bought two small watercolours which, had the one not been initialled and dated on the mount, and the other faintly initialled in the subject, would never have carried conviction as being by Thomas Colman Dibdin (1810-93), whose subject matter is usually the picturesque towns of Northern France and Germany, and whose style falls between the middle manner of William Callow and the maturity of Samuel Prout. These were a very eighteenth century view in

Kensington Gardens and a loose sketch of the Camden Hill waterworks, which could almost have been one of Linnell's Bayswater studies. They were, in fact, particularly early works, dating from the days when Dibdin was still a Post Office clerk, rather than a professional artist, and had yet to find his own style.

Subject matter can be equally deceptive. At much the same time in a London exhibition I saw a finished watercolour catalogued merely as English School, which I was convinced was by the Scottish watercolour painter and landscape gardener James Giles (1801-70). The style was right, and so were the details of the elaborate garden in the foreground. However, Giles normally signed his work and this was unsigned, and the view was based on that of the Great Sugarloaf in the County Dublin from the gardens of Powerscourt, although the details were wrong, and Giles almost certainly never visited Ireland. A grand-daughter, who was still alive, was able to confirm that he had never been there, but added that he had worked for Lord Powerscourt in the 1840s preparing a scheme for the remodelling of the great gardens. It is rather a relief that his plans were not carried out, but nonetheless intriguing to see what might well have been.

The caveat, of course, is that a theory is no more than that until it is backed up with proof. The art world is filled to tedium and madness with fanatics who believe that they own some great or significant work, which all the benighted souls who call themselves experts know to be rubbish.

Learning to See — A few characteristics

(Ashmolean) (Christie's)

An example of Sir James Thornhill's use of a cross to indicate facial features. He usually drew, as here, in brown ink and wash. The cross cannot, alas, be taken as proof positive of his authorship, since it was adopted by at least Thomas Carwitham among his followers in the decorative field.

Francesco Zuccarelli, who worked in Britain for five years in the 1740s and between 1752 and 1768, was one of the best of the eighteenth century bodycolourmen. He sometimes signed with a crossed Z or FZ monogram, but on other occasions, as here, he included a characteristic gourd in the composition instead of a signature.

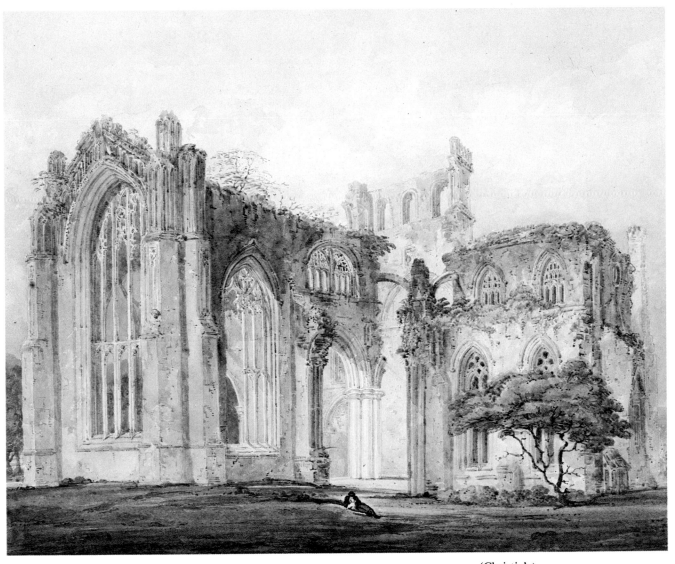

(Christie's)

Thomas Girtin (1775-1801). Here we have an exercise in the Dayes/early Turner manner (see page 138). The figure, in particular is close to Dayes. Perhaps the squiggly lines of the bushes on top of the wall might be taken as an identifying mannerism.

George Chinnery (1774-1852) (M. Gregory)

Three British watercolourists are particularly noted for the use of shorthand on their sketches. The cross makes a frequent appearance in Chinnery's version (left). Note also the heads of his figures, which are far better proportioned than those of some of his talented pupils and imitators such as Dr. Watson. James Ward's monogram (below) is really a signature, since all the letters of the name are present. For this reason it is not safe to assume that anything so signed is datable to after his election as R.A. in 1811. It was such a satisfactory combination that he often put it in when going back over earlier work. Hills' shorthand and subject-matter (opposite) can be very similar, so study the two.

James Ward (1769-1859) (Sotheby's)

Robert Hills (1769-1844) (Albany Gallery)

Joseph Mallord William Turner (1775-1851)　　　　　　　(Christie's)

A vignette of Smailholme Tower, which was made as an illustration to Scott's Border Minstrelsy. *It is dated 1827, and the composition and colouring are typical of Turner's work for books. The provenance includes not only Scott's publisher, but also Munro of Novar, the great mid-nineteenth century collector, who is not to be confused with Dr. Monro.*

84

Subject and Date

If you are unable to attribute a drawing to a specific artist on stylistic grounds, you may well be able to date it pretty accurately from the subject matter, and this is often largely a matter of common sense and simple research. Over the centuries the features of buildings and landscapes have changed, and many obvious changes are clearly recorded. For instance, the number of piers in a view of the sea front at Brighton can provide a useful beginning. If there is no pier at all, the painting dates from before October 1822, when the first piles were sunk for the Chain Pier. This was built on the suspension bridge principle, and it stood alone until the more sturdy West Pier was opened in October 1866. The Chain Pier was finally destroyed in the great storm of December 1896, and if you have a view of it which includes the ghostly skeleton of another construction, this must have been painted between the end of 1891, when the Palace Pier was begun, and that night. The Palace Pier was only opened in 1899, and its simple structure was elaborated with the addition of further pavilions and a central theatre over the next fifteen years.

(M. Gregory)

James Holland was a great man for annotating his sketches with details of time, tide, place and colour. This example includes his simple monogram — between 'Sep' and '1837'. This is sometimes used on finished work as well as sketches, and it can easily be overlooked among the details of masonry or paving stones.

In the same way, a drawing of York Minster which shows a small beacon turret on the top of the central tower, must date from between 1666 and 1803, or at least be intended to represent a view of that period. A short time in a local library should be able to establish many such features for you.

In interiors the details of furniture may help, and in portraits and figure subjects there are many obvious clues in clothes and accessories. For example, the M-cut lapel was in vogue for mens' coats between about 1805 and 1815, and after about that date the old straight walking cane gave way to the modern round or cross handled walking stick. Large and elaborate muffs for the ladies may indicate a date of between 1785 and 1795. Swords were going out of fashion in the 1740s, but if your subject is a musician, a sword probably indicates a later date, since it was the badge of a soloist at the annual Handel Commemoration Concerts, which were held from 1784. There are many books on the history of clothing and fashion. A good starting point is the series of *Handbooks on English Costume* by C.W. and P. Cunnington, published by Faber & Faber.

If you can come up with nothing yourself, but feel that the matter is worth

pursuing, there are a number of professional picture researchers who will undertake the task for you, and who may well provide you with evidence for an attribution.

A Few more Dates to provoke Thought:

Balloons: First ascension of a Montgolfier balloon at Paris, 1783. First deaths, 1785 in an attempt to cross the Channel.

Bridges: Westminster, the first in London after old London Bridge, completed after twelve years in the building, 1750. The first large iron bridge, at Ironbridge on the Severn, 1779. The first large chain suspension bridge in Britain, the Menai, 1825.

Canals: The Bridgewater, begun 1758. Several smaller projects were carried out earlier, but this inaugurated thirty years of intensive construction.

Railways: Wooden 'tram-ways' go back to the middle of the seventeenth century; the first iron rails were at Whitehaven in 1738. The Stockton and Darlington line of 'Rocket' fame was opened in 1825, and the first extensive railway line was the Liverpool and Manchester, opened in 1830. A name to remember in connection with railways is J.C. Bourne, after whose drawings many prints were made. Others are I. (or J.) Shaw and A.B. Clayton.

Steam Vessels: The first passage on the Forth and Clyde Canal, 1789, and on the Thames, 1801. First commercially used on the Clyde, 1812, on the Thames, 1815, and in Ireland, 1820. By 1850 there were more than 1,000 in the United Kingdom.

(Andrew Wyld)

William Marlow (1740-1813). The Thames at Richmond. Water and bodycolour 12⅝ x 25¾ins. Here we may have a warning against too much cleverness in this sort of research. It appears to date from before the building of Richmond Bridge in 1774. However, it is tightly linked to a group of Marlow works of 1800-1. Thus it seems to be a watercolour which was based on a sketch made some thirty years before.

5. Of Men and Manners

Since one can neither paint each leaf, nor just lay in a flat mass, one of the most useful stylistic details in the attribution of watercolours, and eighteenth century examples in particular, is the rendering of trees of foliage. Most artists evolved their own symbols and shorthand methods, and these can be as recognisable as signatures — although, as always, beware of imitations.

William Taverner (1703-1772) (Christie's)

William Taverner was a very professional amateur, and his obituary in *The Gentleman's Magazine* called him "one of the best landscape-painters England ever produced". Despite his stylised approach to his subjects, he had a definite feeling for trees. The elegant example to the right of this detail has branches which are very much as they might be in nature. The other trees are also observed, if simplified. The dappling of a darker tone, or white heightening, on to a lighter first wash is typical of him. The overall lighting in his work, incidentally, is generally soft in effect. According to Williams his method of suggesting foliage was by means "of a flat wash of grey, grey-green, or yellow-green, incised diagonally at the edges with broad strokes of a darker colour, thus creating a very pretty dappled effect".

William Marlow (1740-1813) (Sotheby's)

William Marlow, on the other hand, preferred more dramatic contrasts of light and shadow. This little bush is tough, wiry and convincing. It shows a greater emphasis on outline than the Taverner example, and it too employs dark washes on light, although they are not dappled. The foreground branches come close to the loopy technique which was strongly in vogue a little later in the century, but they are also dangerously similar to the ripples on the water beyond them.

Jonathan Skelton shows little real feeling for the ways in which trees actually grow. This is a pity since he uses a lot of them, but his concern is more with intorted and artistic writhings than with convincing construction. His penwork does not mean very much, but he does give a nice sense of solidity by using two or three tones to build up massed foliage.

William Pars (1742-1782) (Christie's)

This detail is taken from an Irish view of Pars' middle to late period; naturally when dealing with architectural subjects, as earlier in Greece and later in Rome, he is more stylised and exact. Here we see trefoils and quatrefoils for the leaves of the near tree — they could almost be flowers. The trees behind are merely indicated with the pen and lightly washed. At times there are downward zigzagging lines. In the manner of the time his foregrounds are very much darker than the middlegrounds and distances, and his colouring is often rather tawny.

Jonathan Skelton (c.1735-1759) (Spink and Son)

Samuel Wale (1720-1786) (Christie's)

Samuel Wale was an engraver and one of the most charming of the eighteenth century book illustrators. He was also the first Professor of Perspective at the R.A. Here his delicate pen outlines could easily have become fussy and confused, but they have not. He must have had a feeling for this tree, since it has inspired him to better drawing than was his wont, or than is evident in the figures or the other trees in the background. As is usual with him, this work is in grey wash, and he has achieved a surprising variety of tone with it.

George Barret (1732-1784) (B. Kendall)

Here Barret has produced a portrait of an actual tree, without overloading it with detail. There is perhaps a little too much reliance on crutch-head loops among the branches. The sketch is inscribed ''the stricken tree'', and one can certainly see that it may well have been enjoying its last summer.

The watercolour of a military encampment (right) shows both the strengths and weaknesses of Paul Sandby's draughtsmanship. There is often an element of caricature in his figures, and for the most part they are lively. At times, though, he seems to lose interest, and they can be really rather badly drawn. Here the little boy on the ground at the left and his counterpart to the right both appear to be crippled. On the other hand the boy with the performing dog is a very neat study of childish concentration. The trees are very typical, with slight outlines, and many of the darker tones laid on in wavy zigzag lines. There is no great concern with where the branches are going.

At this point I would proffer a theory, and no more than that, as to the fondness of the Sandby school for a basis of grey on which to lay the local colours. Sandby and his brother Thomas both spent time in the Highlands at the beginning of their careers, Paul remaining in Scotland from 1746 to 1751. As anyone who has travelled

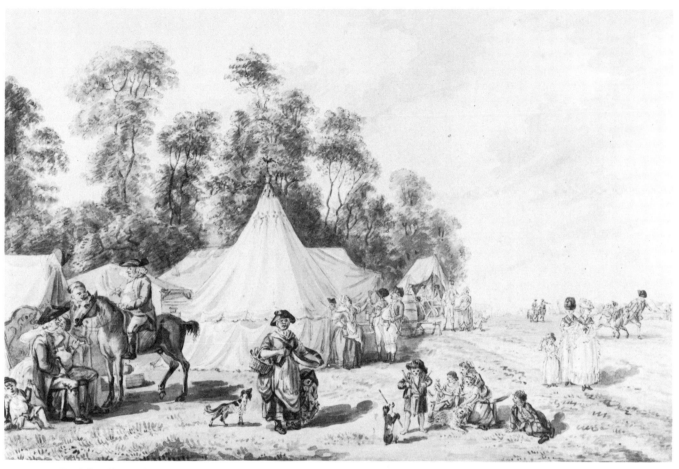

Paul Sandby (1725-1809) (Christie's)

in those parts will know, the colours in the Highlands generally seem to be variations on the theme of grey. Indeed, this is recognised in Gaelic, where the word *glas* is used for both green and grey, and *gorm,* normally a deep blue, can also mean grey or even green. There is a similar ambiguity in *uaine,* which is the modern word for green. It is possible that this experience affected the way in which the Sandbys looked at their world and encouraged them to adopt a convention which was less suited to the brighter South, and still less again to India, where it was taken by Paul's military pupils and later the Daniells.

Paul Sandby (1725-1809) (Christie's)

This detail from a bodycolour shows another Sandby mannerism in foliage drawing: the little dabs and dashes of light and dark to relieve the mass.

The main concern of the antiquarian draughtsman and Sandby follower Thomas Hearne (who should not be confused with his earlier namesake who was an antiquarian tout court) was with buildings and ruins (below); trees and vegetation are merely a necessary setting. He uses little spiky outlines, as in the central bush, and a daintier version of Sandby's zigzag. His feeling for stonework is sure, and where he introduces a small figure or two, they often have a dash of red or some other strong colour as a contrast to his usual muted tones.

Thomas Hearne (1744-1817) (Sotheby's)

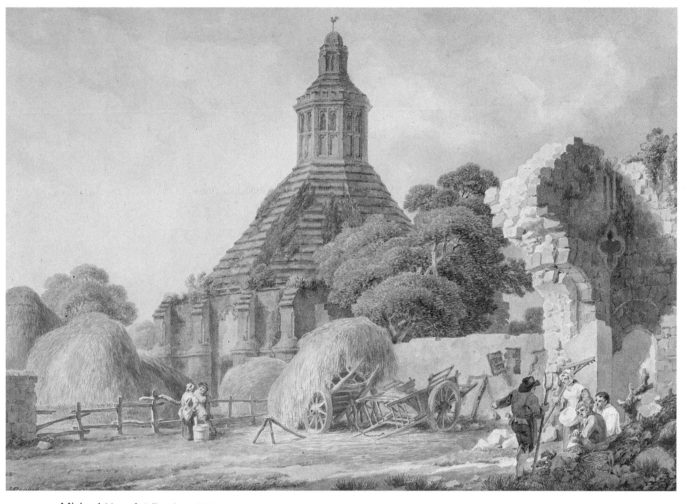

Michael (Angelo) Rooker (1743-1801)

As befits the son of one of the leading engravers of the day, and no mean performer with the graver himself, Rooker is clean and neat in his watercolour work, and has a sure eye for a clear-cut composition. Perhaps as a further result of his training his colours can be rather cold. His signature appears at the bottom left of the picture with its distinctive joined MR.

Michael ''Angelo'' Rooker (1743-1801) (Christie's)

In this further example of Rooker's composition it is instructive to note how he has given each of the foreground group of sheep its distinct character. The signature appears this time on the plank in the right foreground.

George Samuel (d.1823) (A. Wyld)

George Samuel's style falls between those of Sandby and Dayes. The figures are poorly drawn and the wiggly branches and foliage are over-busy. In the nearer trees both the first and second washes are largely made up of zigzags. The outlining here is all brushwork.

James Miller (fl.1773-1791) (Christie's)

James Miller was another follower of Sandby, and his strength, such as it is, is in his buildings, which are usually views of London and Westminster. His figures are often out of scale, and the trees give a furry impression. In this example they are presumably intended for London planes, but one would never know. This is not to say that his work is not charming and full of interest. The sky, too, is very well observed, and the wheeling birds are an excellent touch. This may also have come from Sandby, since few other eighteenth century men seem to have included them.

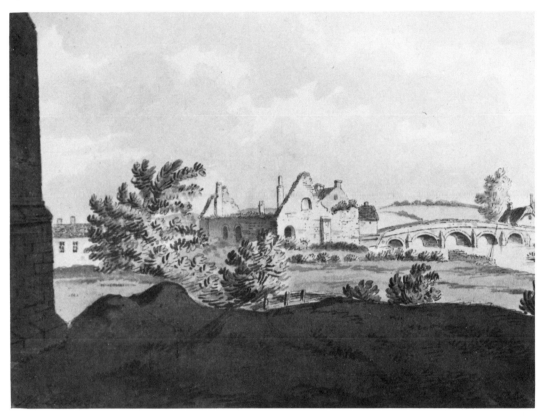

Job Bulman (b.c.1740) (M. Gregory)

The amateur Job Bulman is said to have been a friend of Paul Sandby, and he was certainly a disciple. The first thing to mark in this detail is the signature "N. Pocock", which is a good example of a 'Page Sixteen' fake.* Bulman can often be rather crude in his handling, and here he has given an uncomfortably strong emphasis to the foreground. The perspective and details of the buildings are good here, although they are not always so. His figures can be rather primitive. The bushes are tentative, with the little dashes of darker colouring, but the facility with which he puts these in, sloping both to the left and to the right, makes one wonder whether he was not ambidextrous. Another, if still weaker, Sandby amateur who may be bracketed with him, is the Revd. Michael Tyson.

*See p.185.

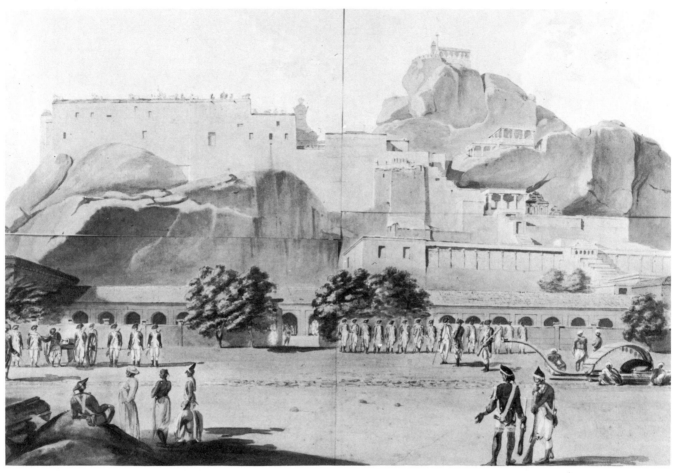

English School (c.1781) (National Army Museum)

It is sad that this 'Sandby of India' has not so far been identified, since he is really very good. Despite the grey ground there is considerable sunny brightness in the colours. This watercolour appears to date from well after Sandby's appointment to Woolwich, and it would be remarkable if the author of it had had no connection with him. The format, on four sheets, and the weaknesses in the figure drawing indicate that it was indeed done in India rather than worked up at home by a professional from an amateur sketch.

Ashford has been called the Irish Sandby: a study of the detail (above right) will show how fair and unfair the description is to both men. The drawing of the trees, especially the fussy pen dashes and outlines, is tentative in the extreme, and yet the willow could just be by Sandby in a slack moment. Ashford's colouring tends to rather gloomy greens.

William Ashford (1746-1824) (Sotheby's)

Chatelain was a conventional draughtsman and engraver of the earlier eighteenth century. This example is in grey and brown washes with much penwork. Note the stippled dashes of wash on the bush to the left and the nice effect of wind in the tree. The drawing has been patched quite sympathetically.

John Baptist Claude Chatelain (1710-1771) (Sotheby's)

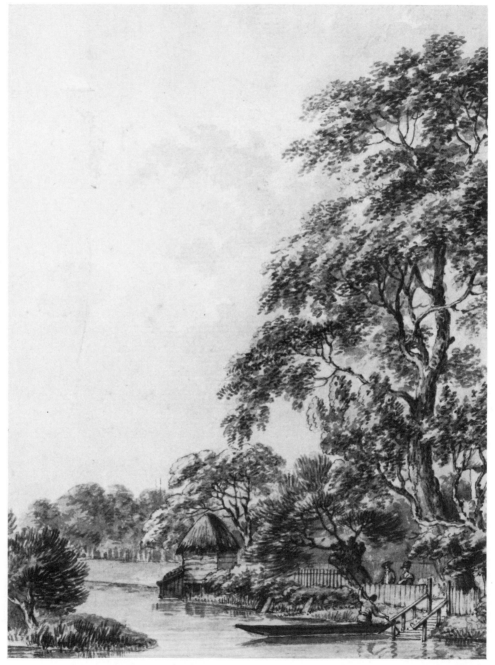

John Alexander Gresse (1741-1794) (Sotheby's)

"Fat Jack Grease" was charming, fashionable, competent and conventional. He uses a combination of restrained penwork and dots, dashes and zigzags in colour. His pollard willow is good, but some of his other trees rather lose themselves.

George Robertson (1748-1788) (Sotheby's)

This detail clearly shows Robertson's use of massed, dark brush strokes for foliage and bark. It makes almost everything look a little like a detail from a fir tree. He also uses the loop convention for branches which was then coming into vogue.

Francis Nicholson (1753-1844) (M. Gregory)

Nicholson's landscape work, as opposed to his town views, often appears to have suffered from fading, leaving a rather woolly residue of yellowish green overlaid with strokes of dark brown. Here he has used the brush alone — note the pleasing japanesque effect of the hollow wash leaves — and there are touches of his stopping out. He too is something of a loop or crutch-head man for branches, and he is perhaps overfond of low curves for brambles and downward dribbly strokes for other vegetation.

These trees (above right) are made up of superimposed tints laid on, light to dark, with the brush. Barber may well have been impressed by his fellow drawing master William Payne, since he uses a number of tricks which are hallmarks of the latter, such as rubbing and dragging and a wiry rendering of foreground foliage. He is competent rather than great, and it is strange to think that his work and teaching provided a starting point for David Cox.

Joseph Barber (1757-1811) (Leger Galleries)

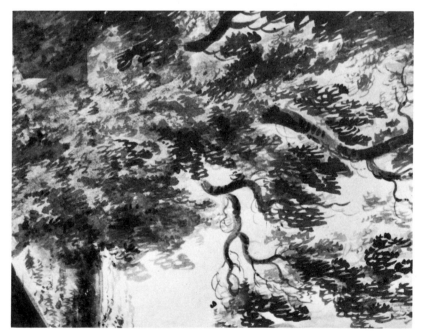

William Anderson (1757-1837) (M. Gregory)

Anderson was primarily a marine painter, and it is tempting to think of his typical mannerisms for rendering foliage and trees as being derived from his observation of ripples and waves. Even the dribbles of creeper on the trunk of the tree could be falling water. The whole thing, in fact is dashing rather than convincing — he is obviously more at home with spars than the original branches, and he too must have known the work of Payne. His landscape work is predominantly green.

John Claude Nattes (c.1765-1822) (C. Chrestien) James Baynes (1766-1837) (Laing A.G. Newcastle)

We now come to two of the drawing masters who make the business of attribution so difficult: Nattes, who exhibited other peoples' drawings under his name, and Baynes, who exhibited his own work under the guise of being his pupils'. Nattes would not appear to have been greatly interested by trees. Firstly he lays in a great dark mass without detail or differentiation, and then he superimposes bodycolour highlights in wriggles and blobs, which have often faded unevenly. His figures and architectural details can be good, although the figures sometimes appear to be afterthoughts.

Baynes is as weak and woolly in his drawing as he seems to have been in his life. His attitude is 'convention demands some trees in this position', rather than 'what is the nature of these particular trees'. He is working from light to dark with stopping out. Varley's description of him as "a poor nervous creature" says it all.

Benjamin Barker of Bath (1776-1838) (Sotheby's)

Barker's colouring is soft, and the same could be said of his drawing. This detail has doubtless suffered from fading, but in any event the effect is rather slapdash. That it may not always have been so is indicated by the presence at the bottom right of the collector's stamp of the second Earl of Warwick.

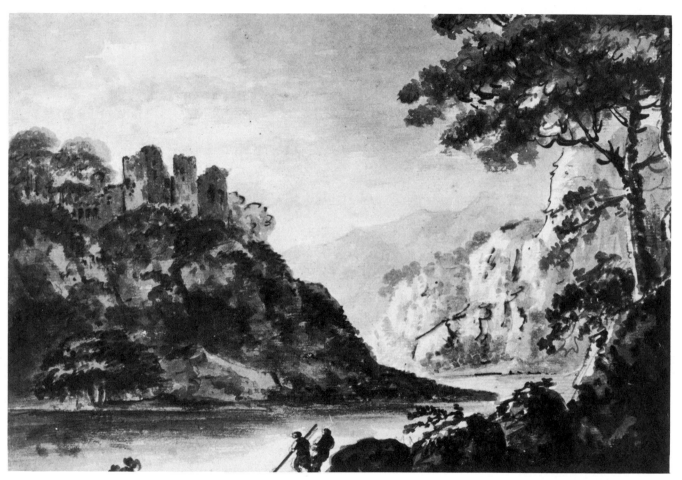

Revd. William Gilpin (1724-1804) (Private Collection)

Between about 1760 and 1850 the Church Artistic (and the Painter turned Cleric) played almost as important a part in providing the strength of the English amateur school as the Military Academys of Draughtsmanship. The sociological reasons are plain enough. The established church of the eighteenth century provided ample time for a civilized and monied man to indulge his hobbies, and equally the profession of drawing master could supply the man of humble origins with the livelihood to procure a living. Here we have an example of the work of the Archpriest of the aesthetic, the Revd. William Gilpin. He was the son of a patron and distinguished amateur, the brother and the uncle of professionals, and although no great or original artist himself he had a wide influence on the cultural climate of his time. He was of course interested not with topography, but with the Picturesque, nature as she should be rather than as she was. His drawings are mostly in pencil or charcoal and brown wash, varnished over on occasion to provide a respectably antique hue. They are not portraits of places, but idealisations. It is a style that was much imitated — often badly — and one that should be kept clearly in mind.

James "Drunken" Robertson (fl.1815-1836) (B. Kendall) Revd. John Gardnor (1729-1808) (D. Snelgrove)

One cannot discuss the Church without reference to the Devil, and so here we have an example by a stylistic disciple of Gilpin, James Robertson, of whom almost nothing is known except his drunkenness. He worked for the most part in monochrome, with heavy brown outlines and lurid patches of highlight. It is a depressing fact that thanks to the 'Page Sixteen' forger,* and other connoisseurs who should know better, his drawings sometimes still pass for those of Cox or Glover. The excuse for the latter misattribution is that Robertson sometimes used a rudimentary split brush technique, but anyone who can honestly confuse the two should never be taken seriously as an 'expert'.

John Gardnor was a very professional drawing master before he took the cloth, and it would be fascinating to know how the conversation went at Blake's wedding, in which he officiated in 1782. In both artistic and religious styles they present such a complete contrast, Blake the mystical enthusiast, and Gardnor, if one may infer from drawing to dogma, the quietist. In artistic terms, at any rate, this drawing shows him as the earlier eighteenth century man, rather in the manner of Chatelain, using gentle outlines, simple washes, and absolutely no emotion. It is a worthy tree.

*See p.185.

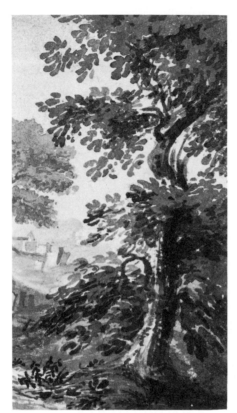

Revd. James Bourne (M. Gregory)
(1773-1854)

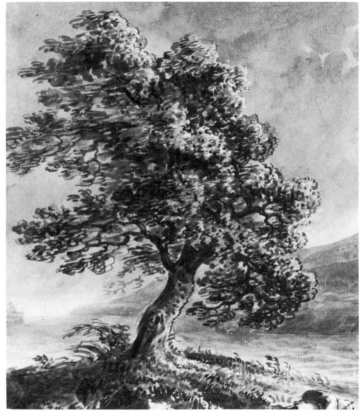

Revd. John Eagles (1783-1855) (Christie's)

Bourne took up his vocation as a man of religion even later in life, having spent most of his career as a mild, uncontentious and not particularly successful drawing master. He was, however, assiduous and prolific, and many examples of his work, usually in grey, brown and blue washes, survive. In style he is perhaps closest to "Drunken" Robertson, although he does not use so much crude outlining, and like him he has sometimes been inexplicably confused with Glover. On the whole he worked on two planes only, a dark foreground of trees and perhaps a stream framing a paler architectural subject — more often than not a church.

Here we have another theorist, rather unambitious and old fashioned like Gilpin in his own style, but as a critic of the work of others, such as Turner, whose statements gave the profession of critic a bad name, John Eagles showed both the strengths and limitations of the clergyman as amateur painter. He was competent enough himself, and a generous patron and encourager of his competent and not particularly adventurous professional friends of the Bristol School. He was not, however, in tune with the future. In his own work there is, perhaps, a nod to the romanticism of J.R. Cozens, but in general it could have been painted by someone who was at his prime at the time of Eagles' birth rather than his maturity. This tree, with its loops and brushed outlines, is very much of the 1780s.

William Payne (c.1760-1830) (M. Gregory)

William Payne was the great master of the technical tricks of the day. A hallmark, naturally enough, is the extensive use of his own 'Payne's Grey'. Here we see not only his characteristic squiggly foliage and curly branches, but also his surprisingly effective flat streaks (in grey of course) for water, as well as two distinct methods of dragging. In the right foreground this is straightforward, with one colour dragged over another with a dry brush. In the central bank of trees, however, the process is reversed. The basic green has been dragged on and then drawn over in grey with the brush. Payne's mannerisms were easy to imitate, and this gave him a great success as a drawing master, although he was by no means an original artist.

La (or Le) Cave has a certain amount in common with Payne, but he is at the same time both weaker and more charming. His drawing is delicate but tentative, and his colours tend to be thin. Here he seems to have tried quite hard with the donkey — but not the dog — and perhaps with the foreground tree, although even there he has not really worked out where the branches are going.

Peter La Cave (fl.1789-1816) (Sotheby's)

I must admit to a certain weakness for Farington's drawings, which is not inappropriate since they are generally rather weak. This example is not nearly as fussy as some, but the outlines are still flat and somehow spinsterish. One the whole he limited himself to blue, or as here grey, wash.

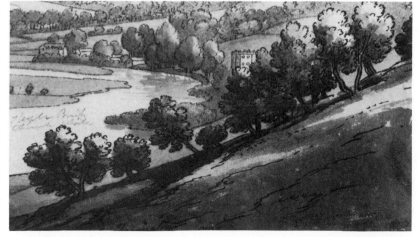

Joseph Farington (1747-1821) (Sotheby's)

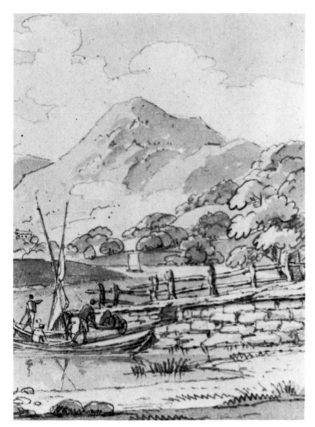

Anthony Devis (1729-1817) (Sotheby's)

Thomas Sunderland (1744-1828) (Sotheby's)

Robert Marris (1750-1827) (C. Chrestien)

When placed next to a Farington the work of the amateur Thomas Sunderland can appear distinctly dashing. It is possible that he was in fact a pupil of Farington, and he certainly took lessons from J.R. Cozens. He too preferred blue and grey washes, although he also used full colour, and he relied heavily on pen or pencil outlines. His perspective is quite good, but he sometimes loses control of scale.

Devis' foliage drawing has been described as resembling bunches of bananas. Another characteristic is providing sheep with long stick-like legs. In a drawing such as this the washes are thin and limited.

Marris was married to a niece of Devis, and the connection is manifest in his style. It is possible too that he had some sort of contact with the Towne school in the West Country. He often signed on the reverse, and it is easy to misread this as "Morris".

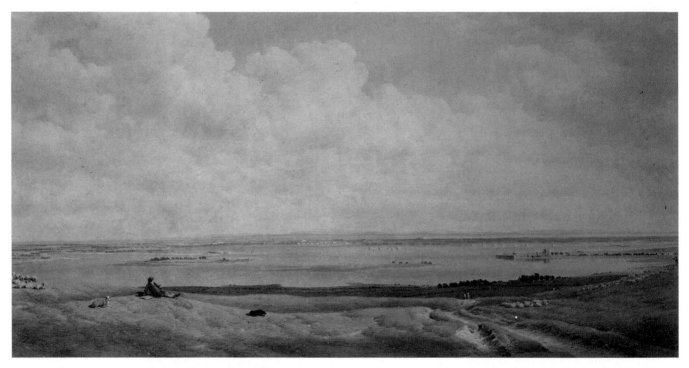

William Turner (1789-1862) (Christie's)

This is one of Turner of Oxford's large panoramic views of the South coast around Portsmouth and the Isle of Wight. The colouring is very typical of him, as are the sheep, which were a favourite ingredient. Sometimes, because of fading, their little black faces and stick legs stand out rather uncomfortably. Turner was a truly excellent draughtsman.

Francis Towne (1740-1816) (Christie's)

It is tempting and pardonable, if not quite accurate, to think of Francis Towne as a painter who stands alone. Certainly he, together with his friends and followers and a small group of fellows, stands aside from the mainstream of the painting of his time. His work can be seen as a foretaste of the twentieth century in the eighteenth. His interest is in composition rather than accurate detail, in the balance of simple shapes rather than the portrayal of picturesque incident. Here we see how he has used the shapes of trunks and branches as fully as possible, without allowing them to be masked by foliage as they would have been in nature. The interlocking geometric planes of the falling water are balanced in the left foreground by the flow of the path. His outlines are firm and uncluttered, and they anchor this complicated composition without overstating it.

Arabella Yeoman (fl.1798-1801) (D. Snelgrove)

Towne's best known pupil is John White Abbott, whose talent is beyond dispute. He must have been an excellent teacher, since he could also extract quite passable work from less promising students such as Arabella Yeoman. However, this example serves largely to underline the strength of the master's own style. The outlines are weak rather than crisp, the trick of the bare tree trunk is obtrusive and there is no sense of geometrical patterns clicking into place. The washes are blobby, rather than bland and assured.

Although in later years their stylistic paths diverged, Towne and "Warwick" Smith produced rather similar work when travelling together in Italy in 1780 and 1781, and this might well be called Smith's best period. He used less outline than his friend, and on occasions he dispensed with the grey ground.

John "Warwick" Smith (1749-1831) (Christie's)

Robert Freebairn arrived in Italy very shortly after the departure of Towne and Smith, and his style has elements in common with that of Towne, although it lacks the originality and mathematical force of composition. One should approach his views with caution, since in some of them the outline is etched.

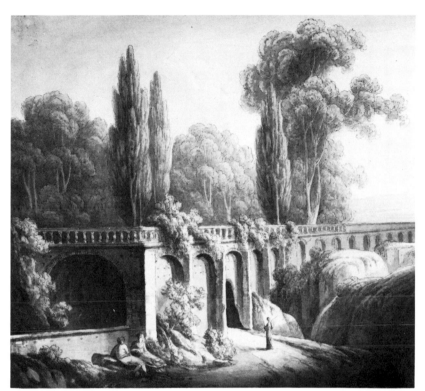

Robert Freebairn (1765-1808) (Sotheby's)

William Day was an amateur who, as far as I know, had no connection with Towne, being rather influenced by his friend John Webber. However I include this detail at this point, because I feel that the styles have a certain kinship, particularly in the use of line and flat planes of wash.

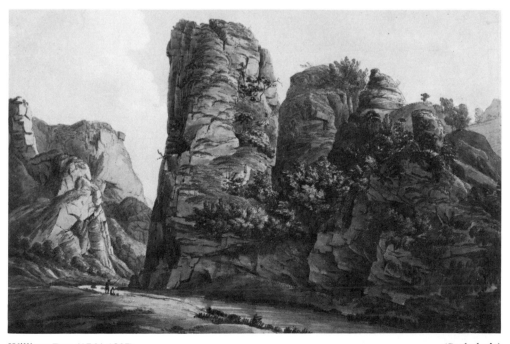

William Day (1764-1807) (Sotheby's)

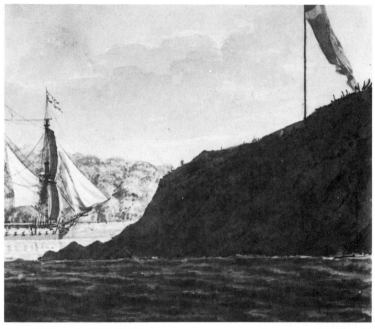

John Webber (c.1750-1793) (Sotheby's)

The treatment of ripples and waves by the marine painters can be as individual and recognisable as that of branches and leaves by their landloving colleagues. Here is a small selection to help focus the eye.

The construction of this drawing is much the same as for a contemporary landscape with the darker foreground and grey base. There appears to be a certain amount of rubbing on the ripples and some penwork for emphasis.

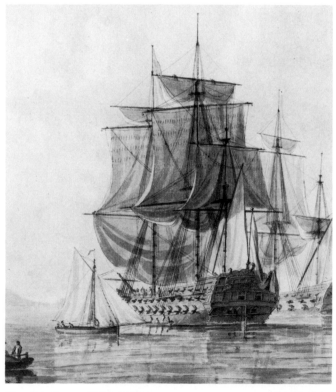

Serres has tried to introduce variety with the bare patches for reflections, but the effect would still be rather flat were it not for his crude use of pen lines on top. The descent of this drawing from the work of the van de Veldes is fairly obvious, but he does not use their formula for scale, whereby the waterline of each vessel is placed at five feet from the horizon.

Dominic Serres (1722-1793) (Sotheby's)

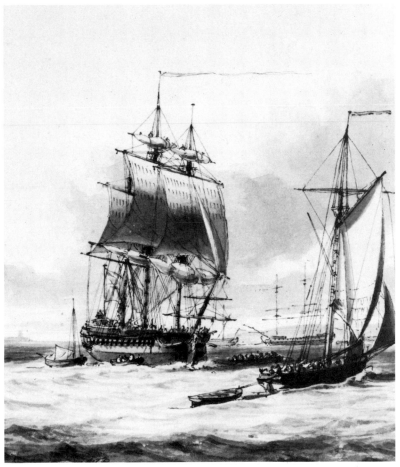

The younger Serres uses harsh penwork on the boats, but there is little on the water itself, except for bow waves and washes. The darker tones on his waves resemble leafy branches blowing in a strong wind.

John Thomas Serres (1759-1825) (Sotheby's)

Atkins liked painting ovals, and he preferred a single ship as the main incident. He often uses orange on the hulls. His ripples are built up from the grey under-wash, and he often signed, as here, on a floating balk or buoy.

Samuel Atkins (fl.1787-1808) (Christie's)

Robert Cleveley (1747-1809) (Sotheby's)

The Cleveley twins, Robert and John, shared the mannerism of drawing water rather as if it was ribbed sand. John was one of Paul Sandby's few professional pupils.

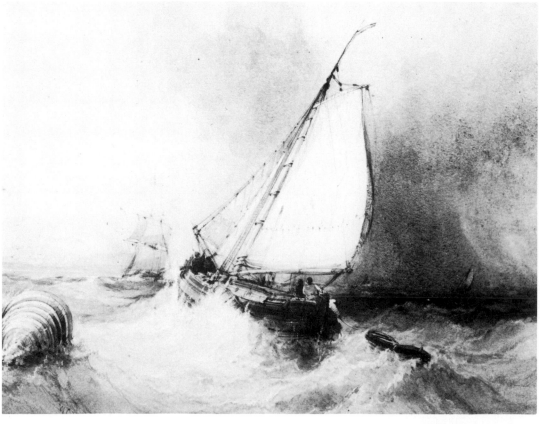

William Callow (1812-1908) (Sotheby's)

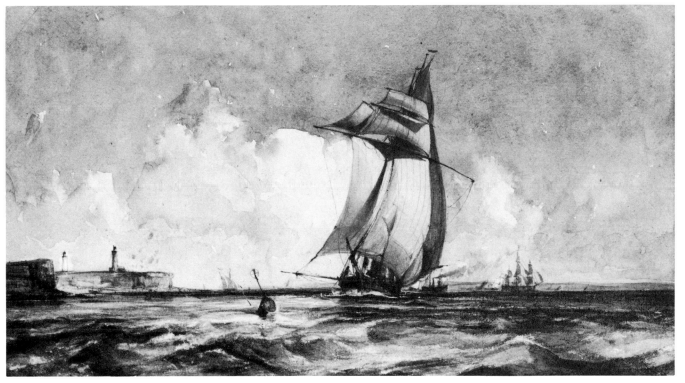

George Chambers (1803-1840) (Sotheby's)

Isn't she lovely? Chambers was a professional sailor and it shows. Sidney Cooper summed him up admirably: "His painting of rough water was truly excellent, and to all water he gave a liquid transparency that I have never seen equalled... his ships are all in motion." The rubbing on the water and the simple washes of the sky are splendidly done. Sometimes, perhaps due to fading or acid in his paper, there is an overeffect of pink in the tones.

The difference in century between the watercolour on the left and the Cleveley detail is obvious. This is a picture rather than a portrait of a vessel — although as almost always in marine painting the details must be accurate. Callow was, among other things, the best of the marine painters among the followers of Bonington and Boys. A typical mannerism of the school, which includes Copley Fielding, John Callow and Charles Bentley, is that the sea darkens towards the horizon, in accordance with nature but in contrast with earlier practice. Callow's waves are dashing in both senses, and he is a great lover of scratching and rubbing for the highlights. As a generalisation one can say that he was a green man, where his brother John preferred blue, but naturally there are exceptions.

The Joy brothers were hacks, if competent ones. Typical mannerisms when working together include a slightly bilious green or light blue for the water, with the ripples scratched on and a strong rubbed reflection from the main ship. The scratched seagulls are also usual. It is hardly necessary to differentiate between the two brothers, but on his own John seems to have liked to take a foreground mudbank with a few figures as his viewpoint, although his figure drawing is poor.

William (1803-1867) and John Cantiloe (1806-1866) Joy
(Sotheby's)

Charles Napier Hemy (1841-1917) (Christie's)

Alfred William Hunt (1830-1896) (Christie's)

A splendid example of late Victorian intensity. Hunt was a friend and protégé of the Newall family, and he did much of his best work such as this, for them. This example is dated 1868. The scraping and scratching give an impression of thickness to the paint surface.

Hemy's work (left) gets more and more Impressionist throughout his career. He loved these little fishing boats and owned one himself. This would also seem to have been his favourite weather. Here he has used a considerable amount of bodycolour, but he was often able to get a very similar effect by leaving bare patches.

You will, I hope, have realised by now that this section is not intended as a comprehensive catalogue of the mannerisms of all the greatest, or even the most common, English watercolourists. Rather its purpose is to indicate the ways in which you should look at things, and the sort of points which you must learn to recognise for yourself. Here then, before we continue with the landscape painters, is a small crowd of strongly contrasted figures.

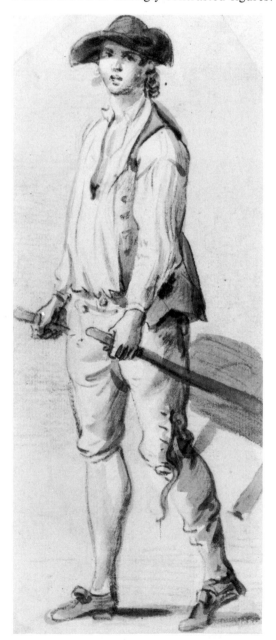

This is a really splendid study, freely and vividly sketched. The hands, so often a giveaway, are well done, but the feet, as so often with Sandby, are feeble — they could be attached to the wrong legs.

Paul Sandby (1725-1809) (Christie's)

Isaac Cruikshank (1756-1811) (Christie's)

In this drawing, for a print published by Laurie & Whittle, the feet do not matter much, and the faces are very well done. The hands, on the other hand, are sloppy in the extreme. By contrast with Rowlandson, whose drawing is always masterly, the line here is poor, and the charm of the work is in the washes.

Dighton's drawing and colouring is described by Williams as "harsh", but for once the great Iolo has missed the point. Dighton is not a charming parlour watercolourist but a strong and effective caricaturist. His firm drawing and strong planes of grey and local colour are ideal for the job. Crude, yes, but ideal for the job. Rowlandson is a great watercolour artist who happened to express himself best with more or less robust satirical subject matter while Dighton is a satirist who happened to work in watercolour. The very harshness of his technique makes it the more effective.

Robert Dighton (1752-1814) (Sotheby's)

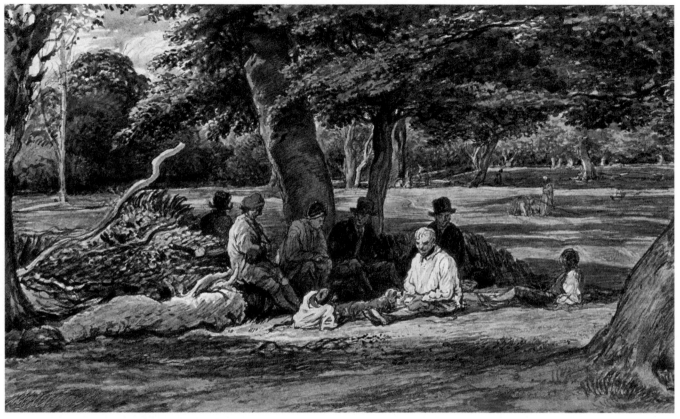

John Linnell (1792-1882) (Christie's)

This is a Haldimand drawing, and despite the finish it shows Linnell's great merits as a sketcher. Its verve is also a refutation of the old claim that he emasculated and held back his son-in-law Samuel Palmer.

Julius Caesar Ibbetson (1759-1817) (M. Gregory)

In contrast with Dighton, Ibbetson is one of the most delicate figure draughtsmen. There is a great deal of work in this little illustration to *The Tempest,* and in lesser hands the result could easily have been a mess. The arrested movement of Ferdinand, who has been spell-bound by Prospero, is particularly well expressed. The blobs of wash for noses and eyes are typical.

William Alexander (1767-1816) (Christie's)

This sketch shows a number of the hallmarks of Alexander's Chinese work, such as the rather square hands, and the nervous washing to indicate folds and creases in cloth. The most common colours are pale blues and yellows.

William Westall (1781-1850) (Christie's)

Like Alexander, Westall travelled in the East, but his feeling for the English countryside, in this case Yorkshire in winter, was sure. His figures are chunky, and the pen or pencil work is well balanced and unassertive. As here, one of his strengths was the ability to convey distance.

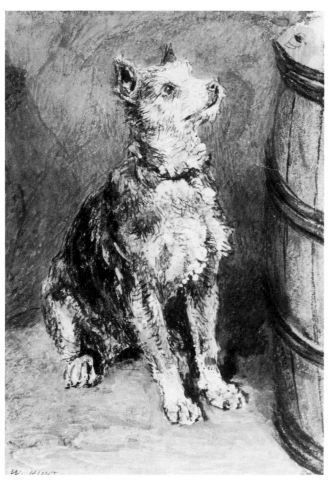

William Henry Hunt (1790-1864) (M. Gregory)

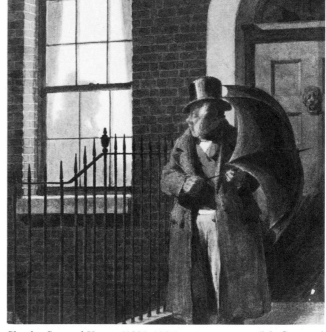

Charles Samuel Keene (1823-1891) (M. Gregory)

This portrait of a dog may appear a simple study at first, but there is a remarkable amount of work in it, which could easily have got out of control. Busy pencil, watercolour and white heightening are all slapped on and dabbled about, but they give an extraordinary feel for the fur and the anatomy beneath. Hunt's earlier landscape work used careful outlines and thin, pale washes. From the 1820s he built up his textures more and more, with much hatching in different colours, and sometimes painting on a ground of white bodycolour to give further luminosity. In this he, together with Landseer and J.F. Lewis, can be seen as an immediate precursor of the Pre-Raphaelites.

There is a fuzziness to some of Keene's rare work in full colour which contrasts not only with Hunt, but also with the clarity of his own penwork. This illustration for Mr. Caudle is a good example: in its suggestion of atmosphere, rather than attention to detail, it points forward to Sickert and the turn of the century. At the same time what little under-drawing there is, is very strong indeed.

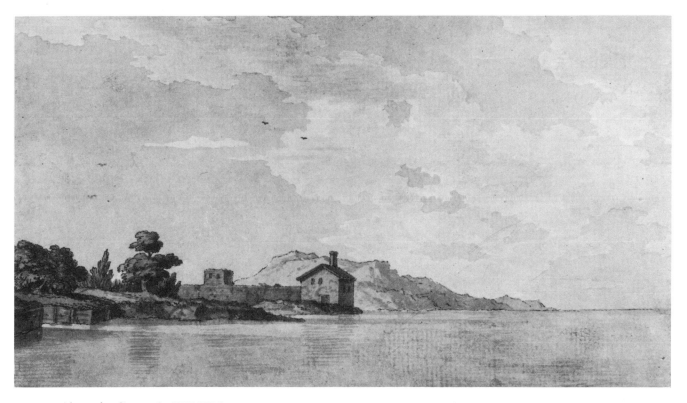

Alexander Cozens (c.1717-1786) (Private Collection)

Let us return now to the mainstream of landscape painting, and to the master of the master. Alexander Cozens is an obscure figure as far as his personality is concerned. Much of what we know of him too is untrustworthy, since it comes from the writings of that fanciful genius William Beckford. With the Duchess of Hamilton, Cozens was probably Beckford's closest intimate, and in a letter of 1783 Beckford describes him as "creeping about like a domestic Animal — t'would be no bad scheme to cut a little cat's door for him in the great Portals of the Saloon." Another often unreliable source, Henry Angelo, who had been at Eton when Cozens was teaching there, informs us that his discipline was lax, but this is made the more likely by the termination of his previous employment at Christ's Hospital. He had been appointed in 1749 at a salary of £50 per annum, but four years later a complaint was made that some five of his pupils were making no progress, and when there was a second complaint in 1754 he resigned at once without taking the opportunity of fighting his case before the governors. He was at Eton from about 1763, and it is probable that standards were less stringent there than at Christ's Hospital, where many of the boys needed to be able to draw for the sake of their future apprenticeships, while at Eton it was more of a civilized pastime. As Ralph Grey of Backworth in Northumberland wrote to his son: "you judged well in taking the opportunity of having a few lessons from the new drawing master whom you think better than the other." Even so there was enough work in the 1780s for an

assistant, the younger Richard Cooper, to be employed.

In dealing with his more talented pupils, and in his private practice, Cozens does in fact seem to have been an inspiring teacher. The unfair and inaccurate attacks made on his style and methods in later years by Angelo and William Henry Pyne in the *Somerset House Gazette* are in fact testimonials to his popularity and influence. Naturally, it was his controversial use of the blot which earned him their greatest contempt and the nicknames of "Blotmaster-General to the Town" and "Sir Dirty Didget". The "Blottesque" system was ridiculed as a quack method of getting passable results out of students with the least amount of effort, but in fact effort and imagination were necessary, and Cozens saw it as more likely to inspire latent talent than endless copying, whether of the master or nature. The blot itself, as described in his *A New Method of Assisting the Invention in Drawing Original Compositions of Landscape,* which appeared in about 1785, was not an entirely haphazard scumble of ink on a paper (still less of colours on a china plate as his detractors claimed), since the first essential was to "posses your mind strongly with a subject" and then "with the swiftest hand make all possible variety of shapes and strokes upon your paper, confining the disposition of the whole to the general subject in your mind. In doing this, care must be taken to avoid giving the blot the appearance of what the painters call Effect". A tracing could then be made of selected and striking features from the blot, and this, rather than the blot itself, would be the basis of a finished drawing.

Quackery or no, the system had a respectable pedigree, being suggested by a remark of Leonardo da Vinci, and undoubtedly it proved very popular among amateurs. Pyne dismisses it as a means of filling the empty heads of fashionable ladies at Bath for an hour or two — although there is no hard evidence that Cozens ever taught there — but a truer picture of Cozens' worth as a teacher may be found in a letter to Beckford from Mrs. Harcourt, the wife of the future Field Marshal.

"I rejoice Cozens is with you. I hope that you will restore him to such health by good air and the pleasure he will enjoy in being with you, that I shall have his society some hours of every week in London for many years to come. Tell him I am six hours of every day following his instructions. I would give him half I am worth if he could give me his genius also". Mrs. Harcourt herself became no mean painter, exhibiting at the Royal Academy in 1785 and 1786 and earning the praise of Horace Walpole. In the sale of Cozens' effects her husband bought twenty-three drawings and two paintings. Here we illustrate not a blot, but one of his romantic grey wash Italian scenes, because it leads directly to his greatest pupil, his son John Robert Cozens.

His art is a perfect blend of simplicity of technique and sophistication of concept. It might, perhaps, be fair to think of him as the Mozart of the school, to Sandby's Haydn, Bonington's Schubert and Turner's Beethoven. I cannot immediately think of an equivalent for Girtin. A favourite theme is the contrast between the massiveness of mountain and the transient delicacy of smoke, mist and cloud. Here the little town is crushed between the crags and the sea. Cozens favours a silvery-grey, greens and blues, and there is little outlining, usually in pencil. Sometimes at this period he used darker zigzag lines on nearer foliage.

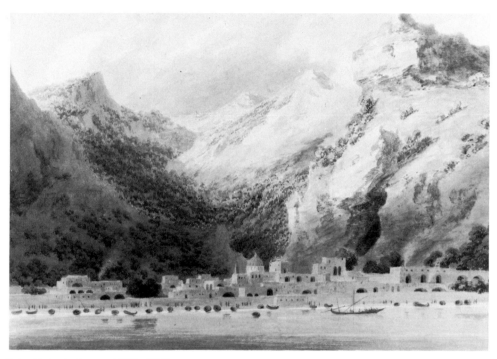

John Robert Cozens (1752-1797) (Christie's)

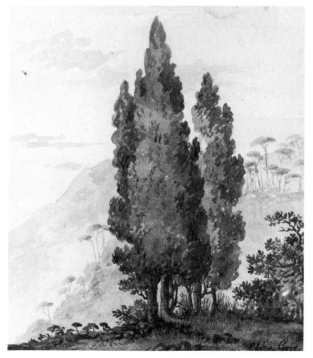

Eliza was the elder daughter of Charles Gore, and they met Cozens during his first visit to Italy. Cozens worked up some of Gore's drawings of Sicily, and no doubt also advised Eliza and her younger sister Hannah Anne, who married Earl Cowper in Florence in 1775. This drawing is in sepia wash, but otherwise very much in the Cozens manner. His leaf drawing, however, is much more delicate.

Eliza Gore (M. Gregory)

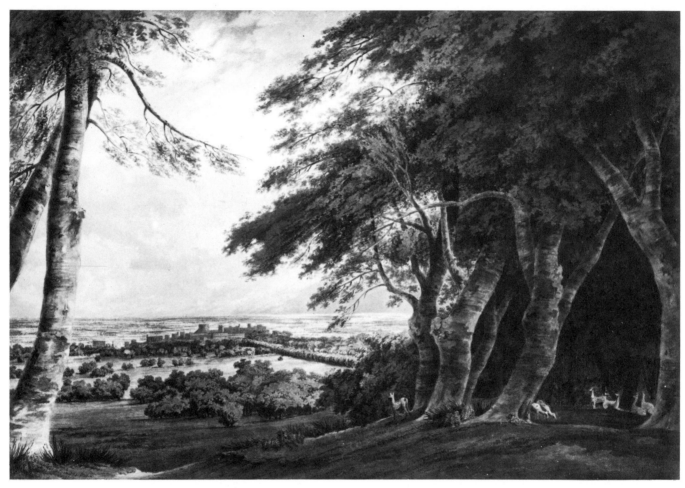

Juliet Ann Roberts (Sotheby's)

This watercolour by Cozens' daughter Juliet Ann Roberts is a copy of one of her father's compositions, but it shows her to have been no mean performer. She has got the distance and the sky very well, and the trees, which could have been a mess, are very well controlled. The bark on the trunks is particularly impressive.

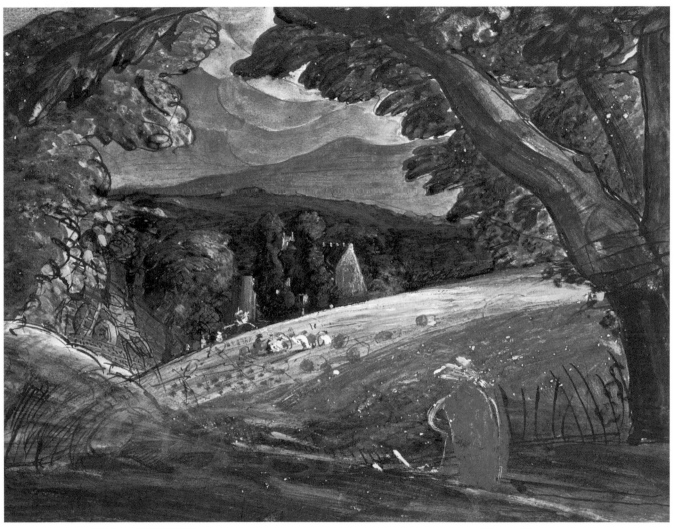

Samuel Palmer (1805-1881) (Christie's)

Palmer at his most lurid. The thick oiliness of the washes combines with the rapid sketchy drawing to give this sort of work its intensity and power.

English School (c.1795) (M. Gregory)

This watercolour (like that on page 132) is also a copy of a Cozens composition. He painted at least six versions of the view, but this is not another of them. It is good, but the trees are too vague and cotton-woolly. It would be interesting to know who the author was.

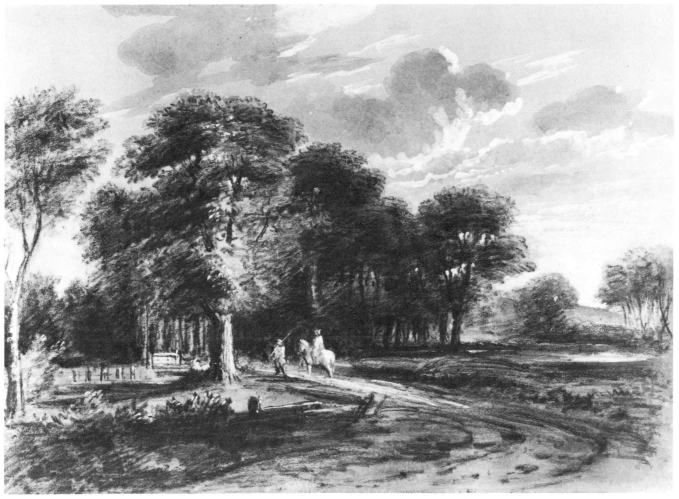

Dr. Thomas Monro (1759-1833) (Ashmolean Museum)

A detail from a typical Monro 'imagining' in the Gainsborough manner. It is in charcoal, brown wash and white on blue paper. There is not often much colour, and they are neither original nor Great Art — but few amateurs would be ashamed to have produced such things. It is very much to Monro's credit that he understood the limitations of his own preferred style and did not try to foist it on his Academy.

Alexander Monro (1802-1844) (Sotheby's)

The youngest of Monro's sons, Alexander, was not particularly original either, but unlike his father he worked in pure watercolour. In this example the drawing is done with the brush and the squiggles and dashes have a rather nervous effect. It is possible that the lines of small dashes instead of outlines on the trees and bushes might be a hallmark.

Henry Edridge (1769-1821) (M. Gregory)

My first thought on looking at this was to doubt the signature and date, since although it is thoroughly competent and has certain crudenesses, notably in the foreground, which make it likely that it is the work of a young man, it would indicate a remarkable precocity in a thirteen or fourteen year old. The answer, of course is that it is a copy, of plate XXV of the first volume of the *Antiquities of Great Britain,* showing Kelso Abbey. This was drawn by Thomas Hearne in 1778 and published two years later. Even so it is a commendable achievement.

Edward Dayes (1763-1804) (Christie's)

"Edridge very rapidly developed from student to exemplar, and his work together with that of Hearne and Cozens, was copied by the younger generation of Monro artists. Here in the young Turner we have an example of the style at its best. Its antiquarian origins are obvious in the thin, pale, blotchy washes which give the feeling of old stone. There are the little dashes and dribbles which appear in Alexander Monro's work, but they are better controlled. The signature is on the foreground gravestone. 'W.' or 'William' Turner is usual at this early stage of his career."

Since I wrote the foregoing words, I have learnt that despite the inscription, this watercolour has now been ascribed by the current authority to Edward Dayes, whose work was copied by Turner both of his own volition and as a task at Dr. Monro's. Certainly the figure looks more like Dayes. From the aesthetic point of view it must surely be better to have a good example of the work of a man at the height of his powers, rather than one of a student struggling to release his genius.

When weighed in the financial balance, however, there is no comparison. The youthful Turner is a bankable commodity; the mature Dayes, where he can be confused with the acolyte, is not. I can only advise the owners of Dayes-Turner works such as this to be proud and ignore the temporary whims of fashion. Each example must ultimately be judged on its own merits. That Dayes was shortly to die an embittered suicide, and that Turner was to be recognised as one of the world's greatest artists at a later stage in his career, must not be allowed to prevent your eye from perceiving whether what is in front of you is a good drawing on its own terms or whether it is not.

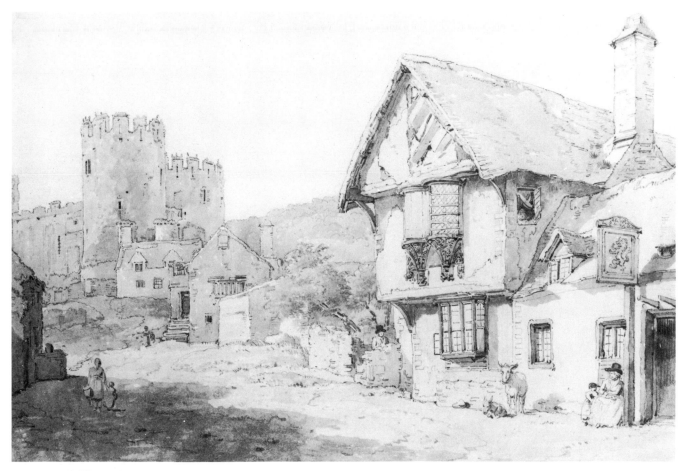

William Alexander (1767-1816) (W. Drummond)

William Alexander was older and more experienced an artist than either Turner or even Edridge when he too benefited from Monro's generosity. This drawing is a looser and later variation of the style, and it is very similar to Cotman's Welsh sketches of 1802.

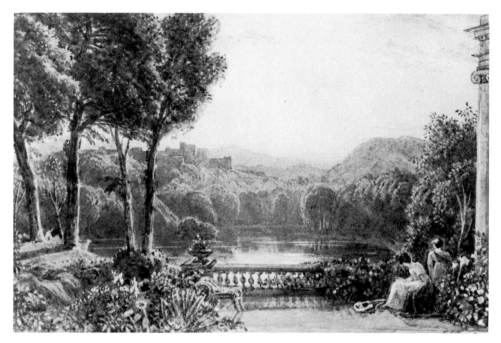

George Barret, yr. (1767-1842) (Christie's)

Turner, quite consciously, set himself the task of overmastering the Old Masters; many of his contemporaries were happy enough to follow in the paths which had already been mapped by their great predecessors, notably Claude, Poussin and Wilson. Here we have three versions of very much the same thing. When Tennyson wrote of "a land in which it seemed always afternoon" he might well have had a Claudian watercolour by the younger George Barret propped up on his desk (above). No sound comes across his miniature Nemi, no wind ruffles the woolly trees and flowers — "There is no joy but calm!" The woolliness, incidentally, comes from too much stippling and stopping. Finch does very much the same thing, but with a sense of morning, and sometimes, as here (opposite above), too much gum arabic for the good of his paint surface. His trees are more airy and delicate than those of Barret. Other Claudians included William Marshall Craig, usually on a small scale and with even more stippling than the others, and sometimes Cristall. Cox also tried this manner on occasion, but there is a more earthy feel to his attempts. John Varley was generally more interested in composition than in exact topography, and it was natural that he too should have his Claudian moments. However, except in his early Monro days, when he was very close to Girtin and then Cotman, he is always himself. He loves the tricks, the scraping, scratching and stopping out. His trees show no great concern with nature, and his foliage drawing, with elegant branches and luscious leaves, is of the eighteenth century. His peasant women and children are the most intimidating bruisers, and his cows would win few prizes. This example (opposite below) dated 1815 is supposed to be in Wales, but might as well show the Campagna.

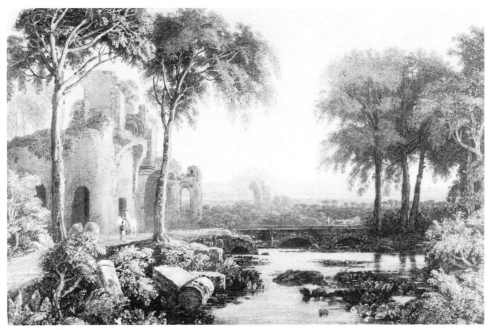

Francis Oliver Finch (1802-1862) (Christie's)

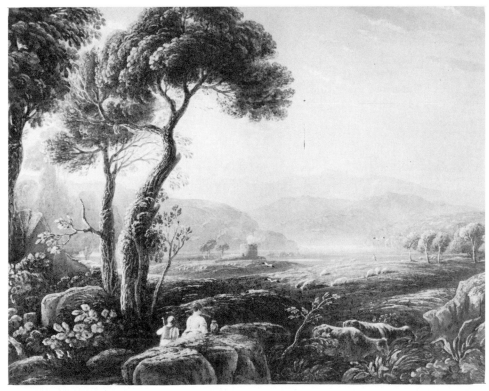

John Varley (1778-1842) (Christie's)

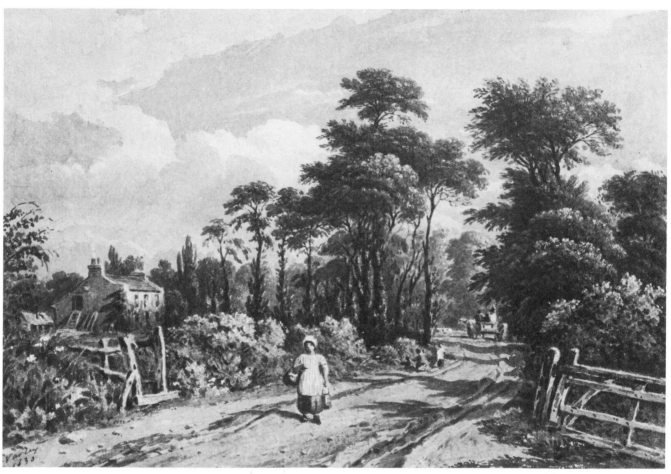

John Varley (1778-1842) (M. Gregory)

Here we have Varley in 1830. He is using the same techniques as in the previous example, but not bothering with a classical veneer for an English subject.

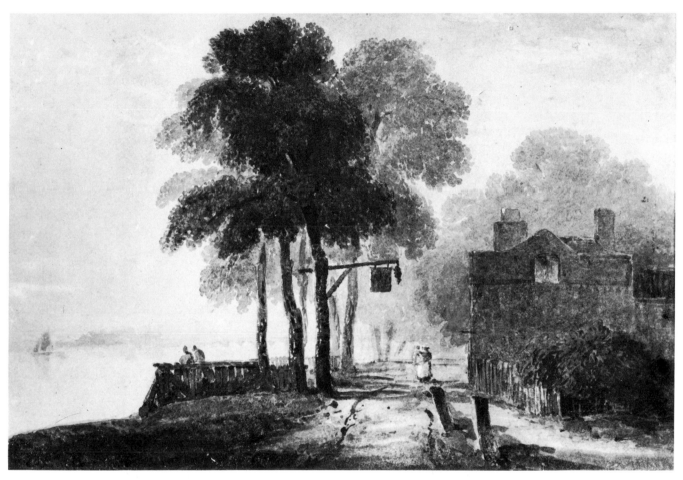

David Cox (1783-1859) (M. Gregory)

Cox was always willing to learn from others, and in about 1809 he took some lessons from Varley. One of Varley's great virtues as a teacher was that he did not try to suppress originality in his pupils if it existed. For a demonstration of this, see the opposite side of the same pub as he drew it, which is illustrated in my *Dictionary of British Watercolour Artists,* Volume II.

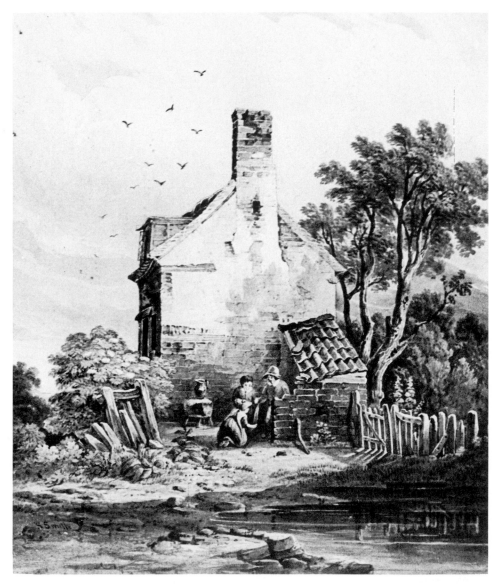

Samuel Smith (fl.1790-1840) (Private Collection)

Those who had no great originality could also benefit, since the mechanical elements of Varley's style were fairly easy to master, even if the spirit was more elusive. Smith is a very obscure figure, a decorator who was working for the Worcester Porcelain manufactory from about 1790 to 1840. He exhibited paintings and drawings in London and Birmingham from 1811 to 1838. It is not possible to say whether he took lessons from Varley, or merely copied his drawings. There is a harshness and crudity here which would not be evident in the original.

Robert Hills (1769-1844) (Christie's)

An example of the stippling mannerism of Robert Hills. It is very close to that used by Birket Foster later in the century, and it gives an impression of both haziness and solidity. In this mood Hills' favourite colour is a warm light green. In his snow scenes he could do remarkable things by leaving the paper untouched.

The ending of the Revolutionary and Napoleonic Wars in 1815 led to a temporary loss of direction in French painting. The neoclassicism of the Imperial establishment was no longer politically and socially appropriate, and there was no obvious alternative native tradition ready to replace it. In England, however, the comparative isolation of the wars had produced a flourishing and self-confident school of artists who were now ready to export their vision. Naturally, too, the British public were eager to obtain views and prints of the Continent from which they had been cut off. Thus in the 1820s and '30s numerous English painters worked in Paris for long periods, and the watercolourists in particular had a notable, if as yet under-researched, influence on the ways in which French painting was to develop later in the century. The spearhead of this English cultural invasion was the atelier, or print factory run by Thales and Newton Fielding. Their apprentices, pupils and colleagues included Bonington, Boys, the Callows, and Ambrose Poynter, and less directly they influenced other Englishmen in France such as James Holland.

The best known of the Fielding brothers is Copley, who in fact had least to do

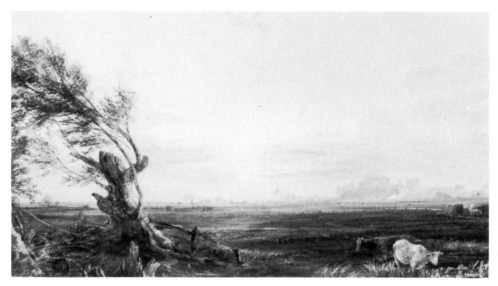

Anthony Vandyke Copley Fielding (1787-1885) (Christie's)

with the Paris end of the family business. In his landscape work he has a number of mannerisms which are easily recognised (see above). He likes to lead into the composition with the ruts of a track. His trees lean elegantly, and there is often one brown one to contrast with others in green. There is a little dragging and stopping out for foreground plants. His hallmark is perhaps an overall smoothness.

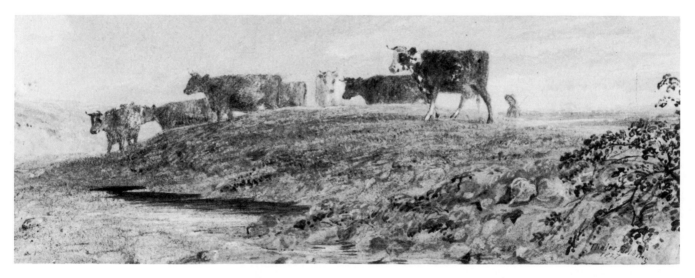

Thales Fielding (1793-1837) (Christie's)

Thales has a rougher and more grainy texture to his surfaces. He too likes to draw a tree or bush in brown, and he also stops out for foreground highlights and contrasts.

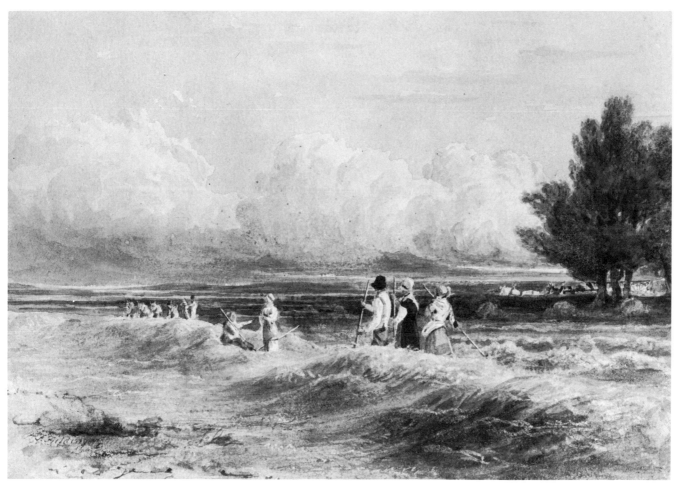

Felix Ferdinand Frederick Raffael Fielding (c.1784-1853) (Christie's)

Frederick is the second and most obscure of the brethren, but he too was no slouch. This Haldimand example is entirely typical of the very few watercolours by him that I have seen. His subject matter is mostly limited to the fields and distant hills of Cumberland, where he must have spent much of his youth, although he lived with the family in London at various dates between 1808 and 1826.

In 1827 he was admitted to Gray's Inn and five years later called to the bar. This, together with his marriage in 1842, to the Hon. Letitia Wodehouse, widow of Sir T.M. Heslerigg, Bt., meant that thereafter he painted only as an amateur. They lived at her town house in Upper Brook Street.

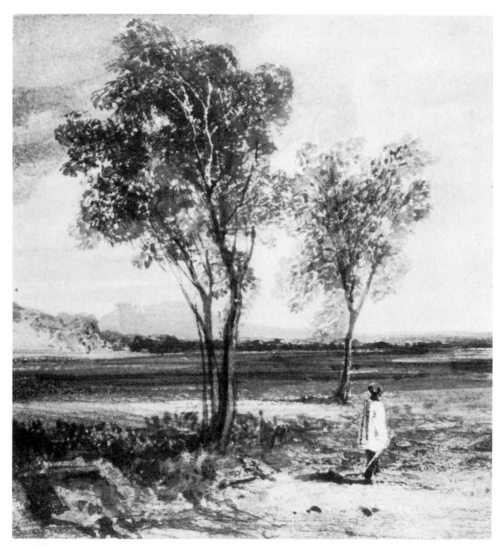

William Callow (1812-1908) (M. Gregory)

Naturally enough many of the elements of the Fieldings' style can be found in the work of the younger artists who associated with them in London and Paris. Here we have an example from a sketch made by William Callow in 1831, when he was on a tour with Boys. At this point the work of the two men is very similar. The airiness of the trees, the scraping, the dragging, the oiliness of texture and the plane of the perspective are all reminiscent of the Fieldings, as is the handling of the figure.

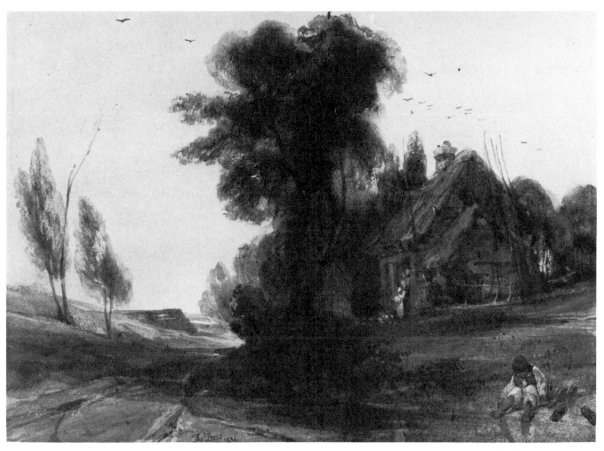

Thomas Shotter Boys (1803-1874) (Christie's)

Five years later Boys displays the style at its most exaggerated. The washes are still smooth but they are built up thickly, sometimes with an admixture of bodycolour. There is much stopping out, and dashing, sketchy drawing with the brush. His trees are very airy indeed. A Fielding rutted track is almost the whole foreground.

A signature of the Bonington-Boys group is the use of finger and thumb prints in the trees. Here is a print by Boys. Perhaps Scotland Yard could help with problems of authenticity?

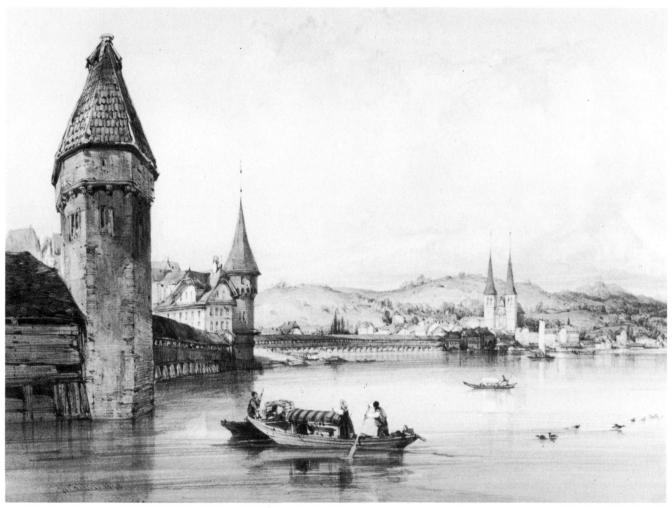

William Callow (1812-1908) (Christie's)

By the end of the 1830s Callow had developed his own mature style. It is strongly linear, with much brush drawing. The outlines are often brown for the nearer objects and blue for the more distant — a convention which was adopted by the painters of Gothic town scenes such as Prout and T.C. Dibdin. The washes are still smooth and oily, particularly for water. Callow's style did not change greatly over the rest of his long career, but it did become looser and rather coarse by comparison with his earlier work.

A highly-finished view of Riva degli Schiavoni, dated 1894, is shown on page 152, a subject to which Callow returned many times after his first visit to Venice in 1840. It shows how little he had forgotten since his early days in Paris with the Fieldings and Boys. The Prout, also shown on page 152, would make a fine companion for the Callow. There is, perhaps, too much detail, but it is fascinating, and although there is a great deal of white heightening, it is still a delicate piece of drawing.

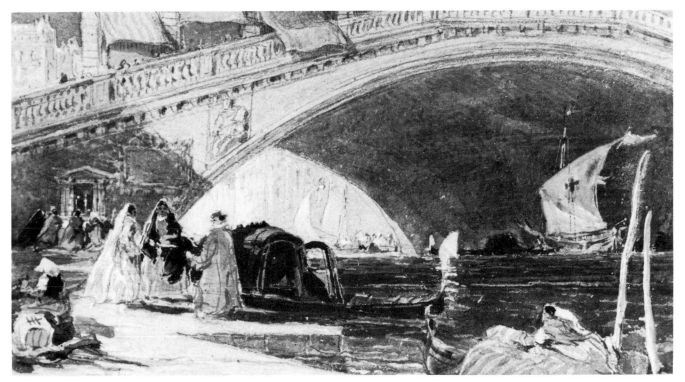

James Holland (1800-1870) (Christie's)

Holland, too, developed away from the style, to a looser one of his own which relied on a sketchy dashingness rather than finish for its effect. In a stylistic sense he is a bridge between the Fieldings and the impressionist maturity of Cox. His casual monogram can be seen here on the bale at the bottom left.

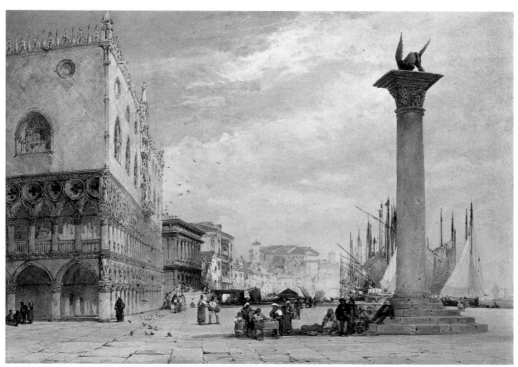

William Callow (1812-1908) (Christie's)

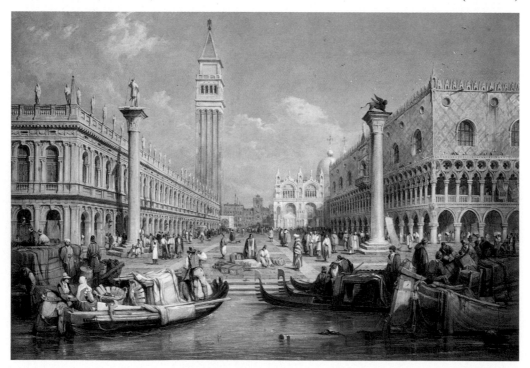

Samuel Prout (1783-1852) (Christie's)

John Glover (1769-1849) (Sotheby's) James Holworthy (1781-1841) (A. Wyld)

Glover is too easily thought of as the inventor of the split-brush technique, whereby a brush is twisted, cut or simply pressed to produce two or more points, thus facilitating the creation of a dappled effect in foliage. In fact others, notably 'Grecian' Williams and James Bourne had already used a similar trick. However, Glover's mannerism is smaller and more mechanical in appearance, and his work should not be confused with theirs — although it still is and by people who should know better. His split-brush effect usually appears very black, an effect that is often exaggerated by the fading of the washes beneath. Many of his greens also seem to have faded to yellow. Since the technique was easy to use he attracted many pupils, and was imitated widely, not least by his family.

Holworthy was one of Glover's earlier and more faithful pupils. His use of split-brush is more tentative, however, and the bulk of his work is in monochrome washes.

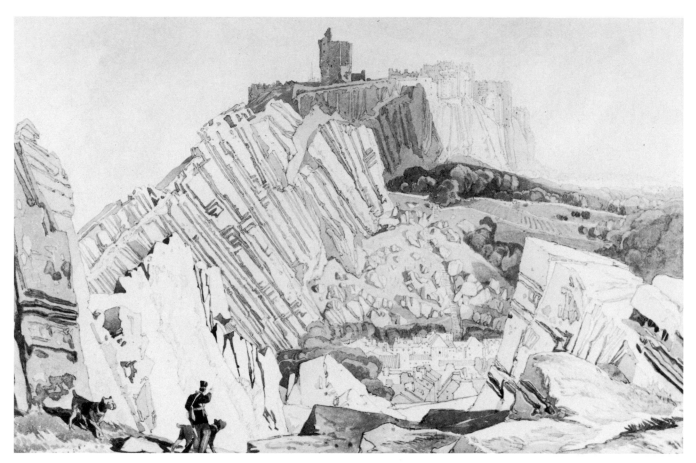

John Sell Cotman (1782-1842) (Christie's)

Line was also of great importance to Cotman, and his laying on of washes paralleled that of the Fielding group, although the results are quite different. At his most original he can be compared to no other artists of his own time and few before or afterwards. In one of his Norman drawings, such as this, he wrenched perspective and scale to serve the purposes of design in a way that had only been attempted by Towne on a professional level and Alexander Cozens and Malchair for their own interest. There is nothing similar in British painting until the 1920s and '30s. Here the foreground figure of the soldier and the dogs tell one the date — just before 1820 — not just because of his uniform, but also because of the chunkiness. Turner or Boys could have drawn these figures, but in their setting they proclaim themselves to be by Cotman. This drawing could be the immediate precursor and companion of the work of the Vorticists Wyndham Lewis and Wadsworth in 1914-16, but it is unlikely that they were even aware of its existence. One of the drawbacks to rebellion is that the rebel almost always has an embarassingly respectable pedigree.

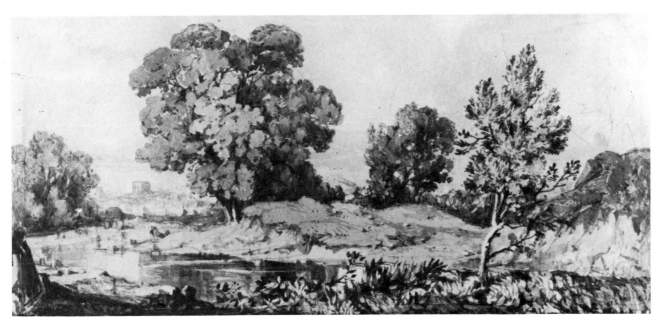

John Joseph Cotman (1814-1878) (Christie's)

J.J. Cotman was the only one of John Sell's children who was strong enough —
or mad enough — to build an individual style. It is not a break with that of his
father, but a variation which will stand on its own. He prefers the broad panorama,
constructed on eighteenth century lines with the distinct fore, middle and
backgrounds. His construction of trees is based on that of John Sell, but with a
more general use of blobby stopping out. His favourite colour is a slightly acid light
green. One feels that he would have been an artist in any case, while Miles Edmund
Cotman, competent painter though he was, would have become a bank manager if
that had been his father's profession. John Joseph, by the by, had a particular
sympathy with muddy clay.

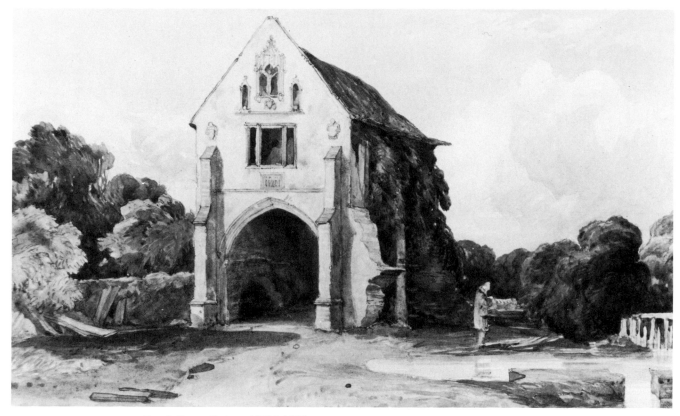

Revd. James Bulwer (1794-1879) (M. Gregory)

James Bulwer could easily have been a professional painter had he not been comfortably off as a clergyman. He is not an original, especially in composition, but neither was he a slavish copyist of his friend and mentor J.S. Cotman. He also had the sense to stick to Cotman's most effective palette of greens and earth colours, rather than to flirt with Turner's least effective style, as Cotman did, all blues and golds with staring red outlines. The construction of his trees is almost pure Cotman, and sometimes it is only the flat, full frontal nature of the composition which tells them apart.

De Wint's tree building is discussed with the colour illustration (see page 161). Here we will merely note some of his favourite compositions. He is particularly fond of the shallow, broad panorama, as in this example (above right) which measures 5¾ins. x 12¼ins. This can be combined with a St. Andrew's Cross formula, which is also used in upright drawings. He likes to give prominence to the sky, and it is unfortunate that this has often faded completely or to a rather dirty pink, perhaps because of acid in the paper. He can be fairly impressionistic, as in these figures, especially towards the end of his career. Signatures and initials should be treated with great suspicion, although, annoyingly, there are a very few which seem to be genuine.

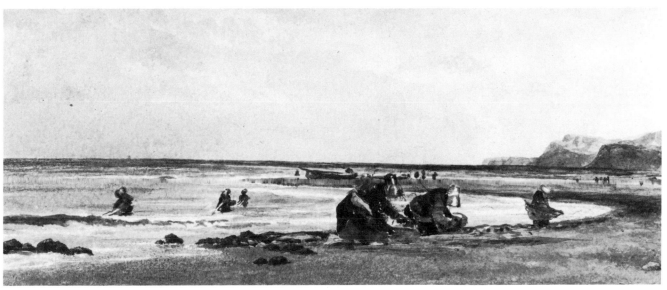

Peter de Wint (1784-1849) (Christie's)

As far as I know all de Wint's pupils were amateurs. However, he was a good and
successful teacher, and he had a large practice. While it would not be true to say that
the best work of a pupil could never be mistaken for a less than perfect example of
the master, it is usually fairly easy to tell them apart. Here, and on the following two
pages we have three of them. In some ways the best of them is the first, Fanny Blake,
of whom little is known except that she was painting between 1812 and 1850. This is
a little more tentative than an actual de Wint, but she has rendered the water well
and followed him closely in the building up of the masses of trees with washes of
blues and greens. On the whole this is a credit to both master and pupil.

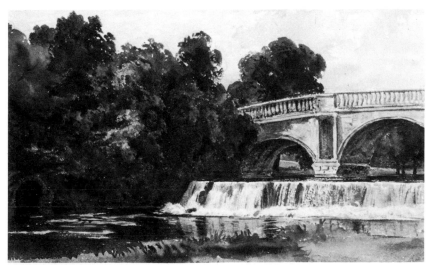

Fanny Blake (D. Snelgrove)

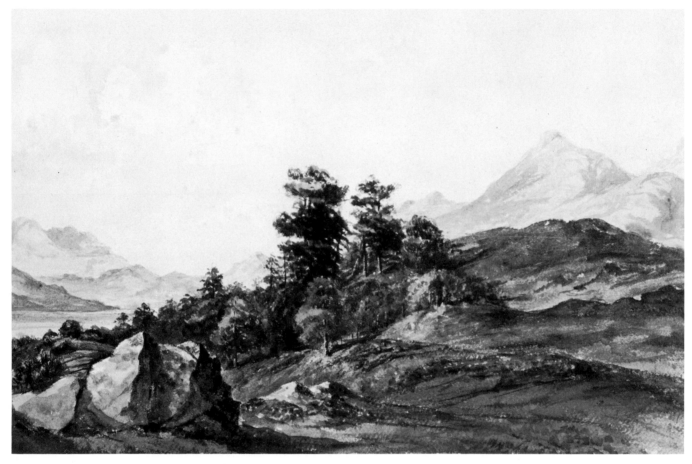

Lord Montagu William Graham (1807-1878) (M. Gregory)

This example by Lord William Graham is on coarse-grained Whatman paper dated 1845. The washes of the trees are a little untidy, and de Wint himself would probably have injected a little more interest into the foreground. There is evidence of both scraping and a split-brush technique.

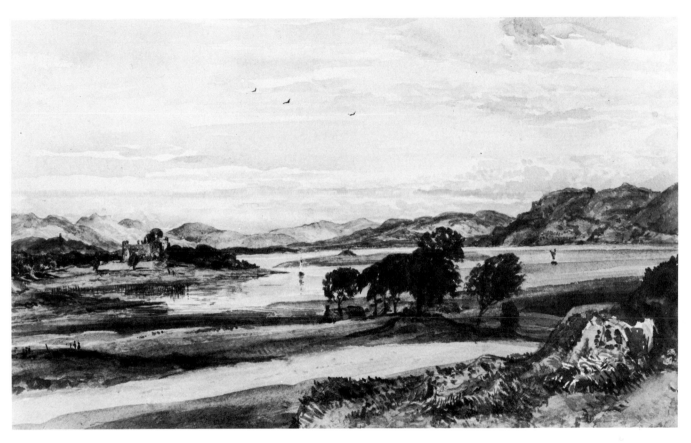

John Moyer Heathcote (1800-1890) (M. Gregory)

Heathcote's drawing is not perfect, but he has mastered the difficult problems of perspective and distance which this composition set him. His paper seems smoother than those commonly used by de Wint, and this difference may account for the preservation of the sky. Few of the pupils seem to have signed, but there are often inscriptions on old mounts and backing papers. When reframing, these should be preserved or at least transcribed.

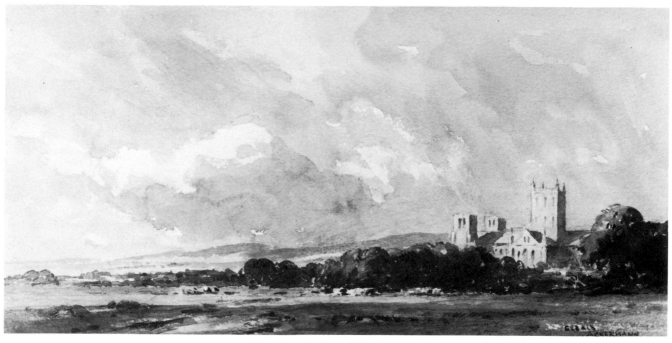

Gerald Ackermann (b.1876) (Christie's)

Obviously, Ackermann was not a pupil of de Wint, but equally evident is the stylistic descent. The trees are made up on the same principles, and the panoramic composition has also been adopted as a favourite.

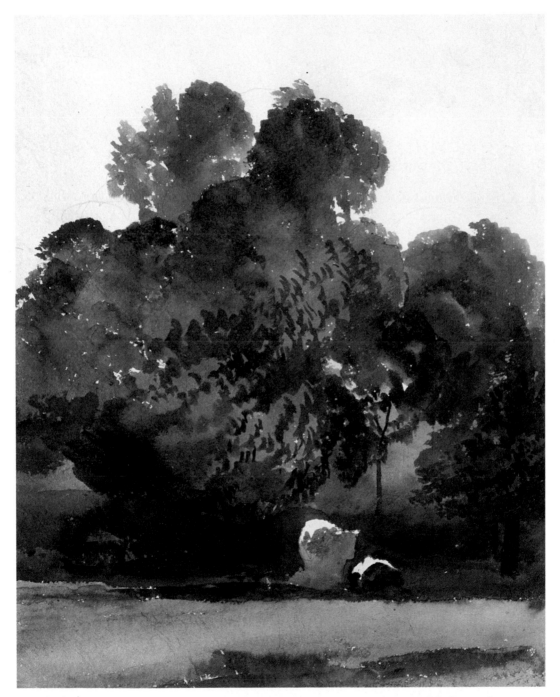

Peter de Wint (1784-1849) (M. Gregory)

This simple study shows the way in which de Wint built up his trees with layers of green and blue washes. A little red is also often used. The sandy ochre of the foreground is also a favourite.

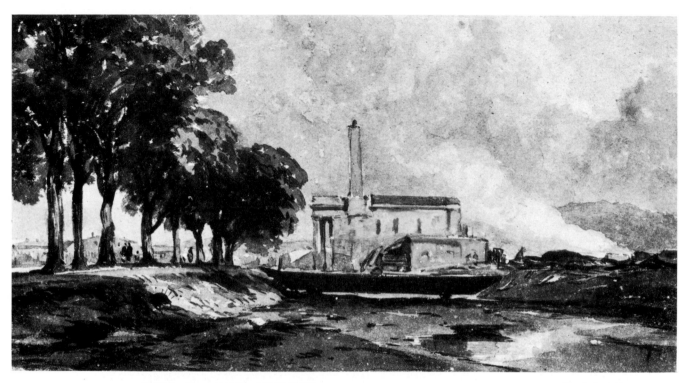

William James Muller (1812-1845) (Sotheby's)

Muller provides a stylistic bridge between de Wint and Cox. He was ambidextrous, but apparently used only the left for painting and the right for writing. At times, however, the slope of his hatching makes one wonder whether both hands had not been employed. The backward slope of the writing should be kept in mind, also the habit of reversing the first two initials. He used bodycolour and sometimes tinted paper, which is usually fairly coarse.

(M. Gregory)

David Cox (1783-1859) (Christie's)

The basic construction of a Cox tree, in this case an ash, shows that he was uninterested in scrupulous detail, at any rate in foliage. However, this sketch is very much of an actual tree, and the wind is there too.

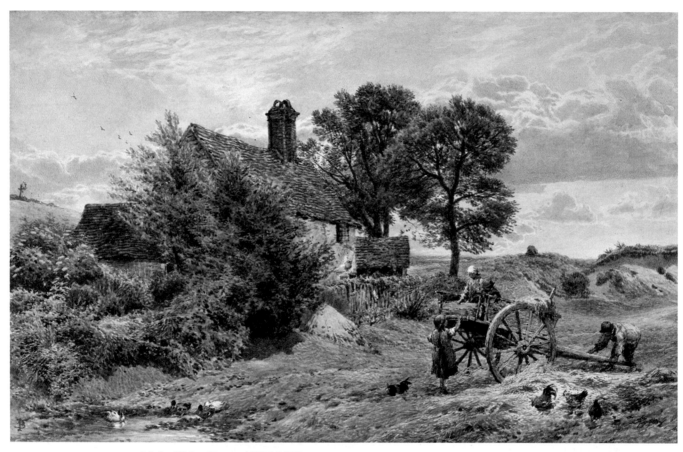

Myles Birket Foster (1825-1899) (Christie's)

The Foster stipple (see also page 178) is much in evidence — at times as in the chickens it is almost impressionist. He was a good painter of skies. Sometimes instead of the monogram there is a B.F. studio stamp.

David Cox (1783-1859) (Christie's)

The same Cox technique (see page 163) displayed in a late, finished watercolour. The tough texture of the Cox paper can be seen here, also the free charcoal or pencil drawing which is left to blend in with the watercolour washes.

William Bennett (1811-1871) (Maidstone Museum)

It would be surprising if Bennett had not been a pupil of Cox, since his work is a slightly crude version of what Cox was doing in the later 1830s and the 1840s. The dappled trees, apparent speediness of execution and the way in which the paper is allowed to break through the paint, are all Cox mannerisms.

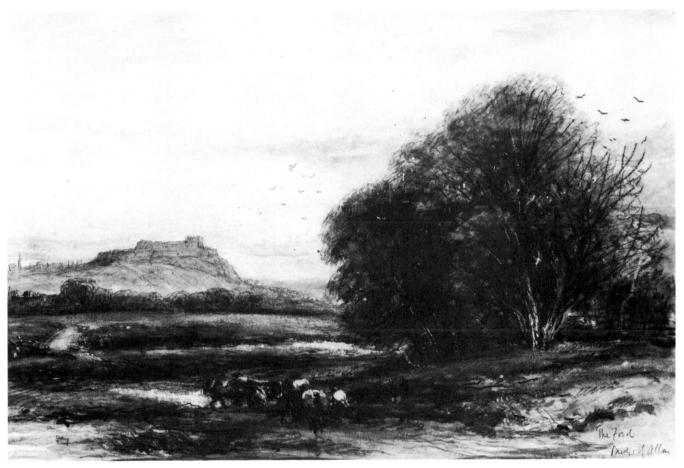

James Orrock (1829-1919) (Sotheby's)

James Orrock, Thomas Collier and Claude Hayes, together with E.M. Wimperis on a good day, are the best of the Cox descendants, rather than pupils. Although technically an amateur, Orrock was as professional as his friends. It might be fair to say, though, that most of his works are coloured drawings, rather than watercolours, since there is so much pencil and charcoal drawing underneath. He is a white heightener.

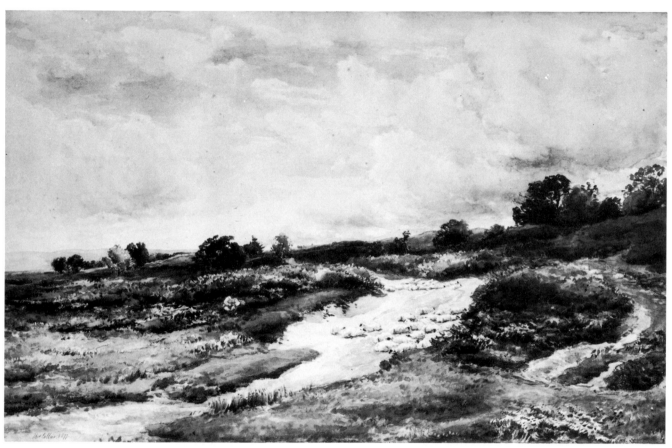

Thomas Collier (1840-1891) (Sotheby's)

Collier's subject matter could be considered dull, which is no doubt the reason that he is not generally accorded the pre-eminent position given him by Martin Hardie. Except in the sky he paints rather less wind than Cox.

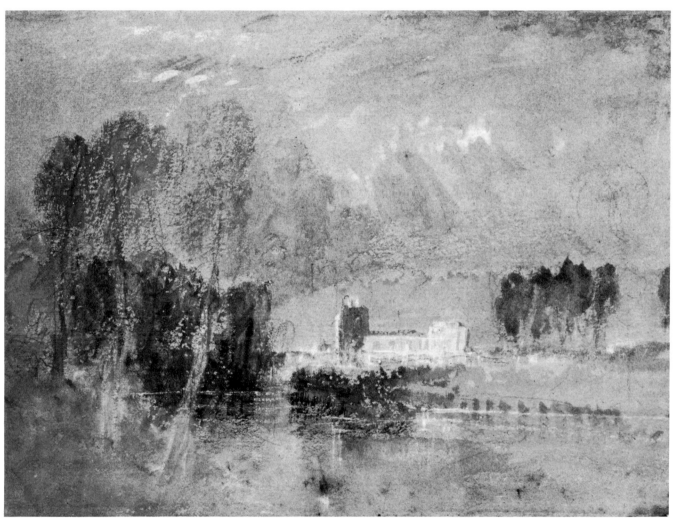

Joseph Mallord William Turner (1775-1851) (Christie's)

There is little point in attempting to chronicle the development of Turner's style here. Enough books have already been devoted to the subject. However, it is sometimes easy to overlook his followers, so with a glance at one of his less formal and most impressionist sketches, here we have four of them, on the following pages, "Alphabet" Bond, H.B. Carter, Jacomb-Hood and Albert Goodwin.

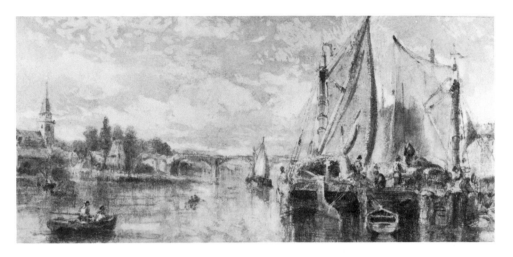

William Joseph J.C. Bond (1833-1926) (Sotheby's)

"Alphabet" Bond moved to Turner from the Pre-Raphaelites. His favourite subjects were coasts and rivers. On occasions he actually copied Turner, as did George Weatherill of Whitby.

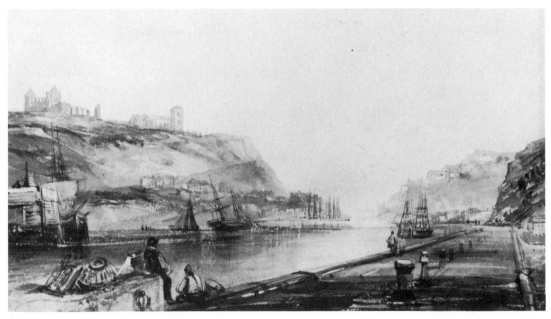

Henry Barlow Carter (1803-1867) (Christie's)

Weatherill's Scarborough neighbour H.B. Carter drew his inspiration from an earlier stage in Turner's work, and the influence of Bonington is perhaps also discernible. There is a great deal of yellow and brown in his work and he was a great one for scratching out.

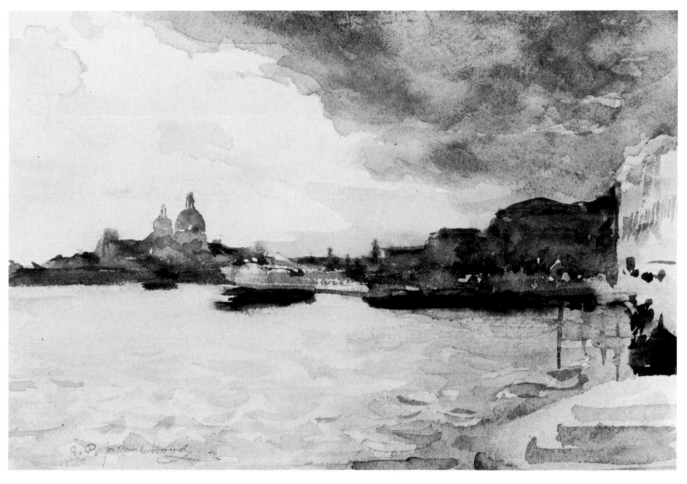

George Percy Jacomb-Hood (1857-1929) (M. Gregory)

It is sometimes assumed that H.B. Brabazon stands alone as an impressionist follower of Turner. This is untrue, and it could be financially dangerous. In fact Brabazon often travelled with two or three other amateurs, including the Leigh-Smith sisters, and they would all paint the same views in very much the same manner. Here we have a Turner-Brabazon subject by a different painter again. Another pitfall for Brabazon buyers could be the early work of the still active Hugh Boycott Brown, whose signature and style are very similar.

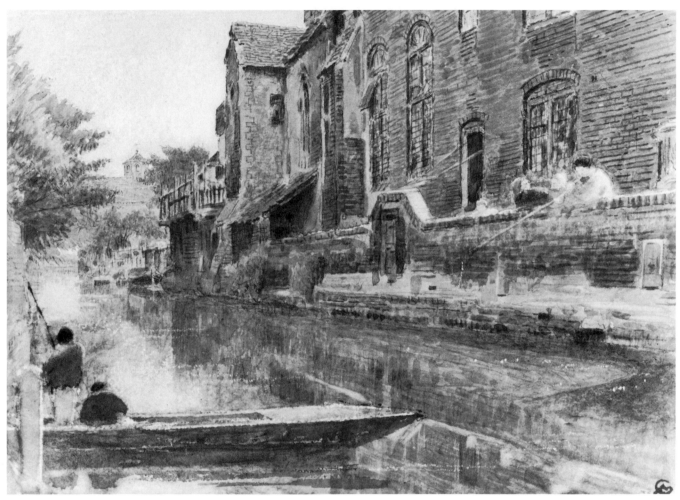

Albert Goodwin (1845-1932) (Christie's)

Turner's influence was transmitted to Goodwin by Ruskin, and it eventually produced a highly idiosyncratic style. There is much rubbing and scrubbing, and the pen drawing is often put in last. The monogram should be noted as a common alternative to a full signature and inscription. Goodwin had a justified passion for reflections.

Octavius Oakley (1800-1867) (Christie's)

We must return briefly to figures, and the Victorian obsession with peasant children. In the middle years of the century peasants were usually clean, pretty and quite mature like Oakley's fortune teller. Note the white heightening here and in the following examples and remember that Chinese White has now taken a firm hold.

John Frederick Tayler (1802-1889) (Christie's)

Tayler deals with a lady, but his peasants would be as elegant. His drawing of horses and other animals is very good, and he can even make a costume subject appealing without winsomeness.

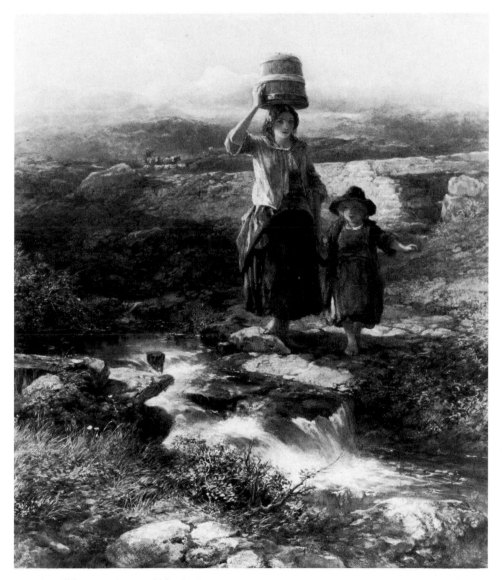

Francis William Topham (1808-1871) (Christie's)

This has almost as smooth a finish to it as the last two, despite the bodycolour which has been mixed in. This is perhaps surprising in view of the artist's methods: "He put on colour and took off colour, rubbed and scrubbed, sponged out, repainted, washed, plastered and spluttered his drawings about in a sort of frenzied way", according to J.J. Jenkins.

William Stephen Coleman (1829-1904) (Sotheby's)

Birket Foster, might you say? Close, but not quite. Coleman is a very varied painter, and in this mood it was inevitable that he should often have acquired a BF monogram. There is a slight coarseness which is absent from Foster's work, and the delicate stippling is also absent.

Walter William May (1831-1896) (Bourne Gallery)

Another example of much the same. A great deal of bodycolour has been mixed in here, which has coarsened the figures in particular.

John Henry Mole (1814-1886) (Christie's)

These figures are really very good for Mole; they are often the weakest part of his work. They are, however, always chubby, clean and well turned-out. There is a thick smoothness to the flesh tones.

(Christie's)

Three more of Mole's children, showing his usual weak roundness.

Myles Birket Foster (1825-1899) (Christie's)

At last the real thing: a Foster child with stippled cheeks, small eyes and long nose. The thick outlining, the background and the fish could all come from a Turner vignette. The thing to remember when deciding whether a Foster is genuine or not is that the man could draw.

Robert Walker Macbeth (1848-1910) (Christie's)

Like his fellow *Graphic* illustrator E.J. Gregory, Macbeth liked painting fairly specific figures against a more impressionistic background. When overdone this gives a rather out of focus effect.

6. Fakes and Frauds

It is probably true to say that the majority of fakes and frauds among English watercolours did not start as conscious forgeries. Rather they are copies, essays by pupils or works 'in the manner of', which in the course of time have been promoted beyond their deserts. Optimistic attributions have often become received certainties after a generation or so. Drawings which began life honestly labelled in a portfolio as the student efforts of so and so, have subsequently been framed up and given to the teacher.

However, forgery has been with us almost as long as art itself, and already by the second half of the eighteenth century forgers were bulking out the *oeuvres* of the more successful watercolour masters. A number of instances are given by Roget, one of the more striking concerning Francis Nicholson and an actor named William Tayleure, to whom he had given lessons while in Yorkshire. Some time later, when Nicholson had returned to London, the rumour spread in Yorkshire that he had taken to drink. On investigation the source of the slander turned out to be Tayleure, who was selling his own work in frames marked with Nicholson's name and using this story to excuse any weaknesses and imperfections.

Nicholson was also instrumental, with John Varley, in exposing another

A watercolour of St. Paul's Cathedral and Blackfriars Bridge by Francis Nicholson. Much of the outline is etched, giving a thinner, blacker, and more finicky line than would have been possible with the quills or reed pens of the period. The difference between the two can be seen in the foreground group, which has been suggested by etching and elaborated with a pen and the brush. The details of the bridge also show both types of line.

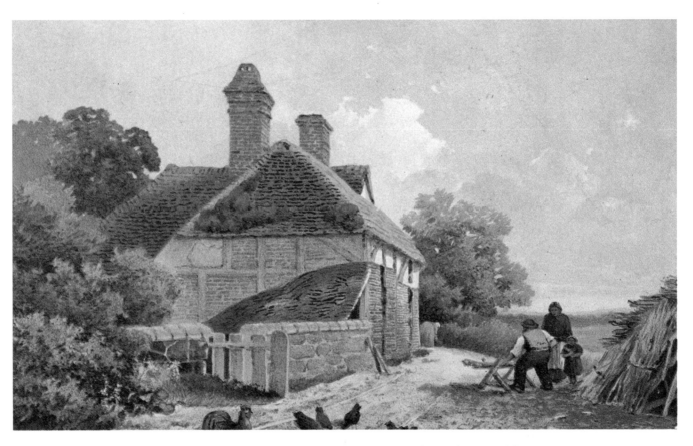

Chromolithographs: Look at the sewage-brown outlines, which are often rather out of focus. Note the limited and unsubtle range of colours. The paper looks like a grainy photograph (see pages 183-4), and the whole thing smells of a reproduction. If you are taken in by one of these — despite Birket Foster — you must reconsider your choice of hobby.

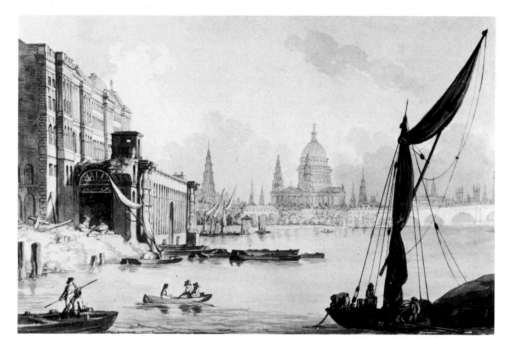

This view of St. Paul's is based on one by Nicholson, but the viewpoint has been moved so as to include the front of Somerset House. Although a ruler may have been used for some of the architectural lines, they do not seem to have been etched. Etching usually gives a blacker line than penwork, which tends to have gone brown. The artist here is Thomas Rowlandson working in a restrained manner. The figures are typical of him in this mood, as are the brush indications of reflections and ripples, and the thicker brush outlines on the barge and rowing boat to the right. This drawing was in the Newall Collection, and had been bought from the sale of that of Victor Reinaecker in 1923, which provided many good things for the few who were interested in those days.

contemporary fraud, whose after-effects are no doubt still with us. Various premiums and prizes were given to amateurs by the Society of Arts, but since the judges were drawing masters to a man, it was obviously in the interests of each to see that his own pupils were the winners. Naturally, many of them would work up their pupils' efforts, or even provide them with finished drawings to sign and submit. By exposing the activities of one popular drawing master, James Baynes, in this line, Nicholson and Varley persuaded the Society to tighten up the terms of entry and examination.

At least this sort of fraud can with the passage of time, be said to be of some benefit to the collector, since what purports to a scrawl by the dabbling Lady Amelia Amateur may in fact be a pleasant enough thing by whoever was her teacher. However, the reverse can be true of some of Cotman's drawings, rather than

watercolours. One of his schemes of teaching, known as his Circulating Library, was to leave drawings with his pupils to be copied. This meant that he could obtain a small income — of a guinea for so many weeks — from many more pupils than would have been possible had they been coming to him for regular lessons at a set fee. However, it necessitated a greater number of drawings than he could himself produce, and he used his children as a sort of factory to supply them, often signing the results himself so that the pupils would not feel cheated. Some of the pupils' drawings too have acquired Cotman signatures either actually from him or from later admirers. The highest recorded number on a circulating library copy is about 10,000, so if each of 15 pupils made two copies...

Another successful drawing master who relied on faithful copying was William Turner of Oxford. I have seen copies by his pupils Caroline and Richard Jenkyns which are almost impossible to tell from the originals even when placed side by side. Luckily these two signed or initialled their versions, but others may not have been so scrupulous.

Some artists might almost be described as forgers of their own work. Samuel Bough for instance, often dated his late work 1857 — he died in 1878 — on the grounds that it was "said to be my best period". David Cox was hugely faked, both during his lifetime and later, and many forgeries will be found to bear the date 1845, which was the period in his work that was most to the taste of his nineteenth century admirers. The younger David Cox, by the way, seems to have been generally meticulous in differentiating his signature with a "jnr", but for a short period after the death of the father in 1859 he appears to have dropped it, and this could lead to confusion and disappointment.

Perhaps the most faked English artists of all were Myles Birket Foster and Thomas Sidney Cooper. Again in many cases, watercolours 'in the manner of' did not start as deliberate fakes. Both artists enjoyed immense popularity, and their often repetitive subject matter attracted many professional and semi-professional imitators, some of whom are illustrated here. These have often had the original signatures erased and a Birket Foster monogram or a Cooper signature substituted. The true Foster fakes should be easy enough to spot, but a remarkable number still deceive the gullible. He was, from the technical point of view, a very good painter indeed, as was recognised by such an unexpected critic as Sickert, and for the most part his forgers were not. Their work is usually thin and flat, and few of them attempt the intense pointilliste technique for the rendering of flesh which is characteristic of his finished work, although not of many of his sketches and studies. Feet are almost as difficult to draw as hands, and in many of the fake Fosters the little girls appear to be wearing theirs on the wrong legs.

By the end of their careers — Cooper died in 1902, just missing his centenary, and Foster in 1899 — so many dubious works were being brought to them that both took to charging a guinea per authentication or condemnation. The reason that these two painters suffered more than most stems from the introduction of the process of chromolithography. Their original work had become expensive, since by 1900 a good Foster could cost £500, and these reproductions, which aimed to render the

A pseudo Birket Foster.

colours as faithfully as possible, were widely popular in the last quarter of the century. In 1874 a set of twelve large "Gems" of Birket Foster was published, and there were many subsequent issues of single works both large and small. Chromo-lithographs can easily deceive at first sight, and Foster himself was once taken in by one on display in a shop window, but they do not stand up to close inspection. The surface is poppled, as in photographic paper (see colour illustration page 181), and the outlines in particular, in a rather sickly brown, betray their mechanical origin. Once you have become aware of them and have studied a few, you should be able to spot one at five paces, but not everyone can, and even today they are still sometimes to be seen on offer as originals.

However it was not just the reproductions themselves which caused the trouble, but also the watercolour copies which were made from them by the unscrupulous. This explains both the flatness of so many of them and their lack of finish, which had already been lost in the mechanical process of reproduction. On a fake Foster the best feature is often the monogram. He even tried to copyright this, but naturally the move made little impression on the forgers.

A frequent problem is the fake signature attached to what may or may not be a perfectly pleasant watercolour. Perhaps the most common group of these is the work of a London dealer of the first half of this century, who can be called for

convenience the "Page Sixteen Forger", since Williams discusses his opus on that page of his book. He must certainly have had a gullible clientele, since the writing is always much the same, and he made no attempt to approximate to the known signatures of the artists concerned. Generally his are written in a round even copybook hand and are too large to carry conviction. The drawings themselves often have very little to do with the style of the artist to whom they are given, although the true author may well be obvious enough. Thus one frequently finds monochrome drawings by the pleasant and accomplished amateur Thomas Sunderland, who lived and largely worked in the Lake District, 'signed' Paul Sandby or Paul Sandby Munn.

This forger's favourite products were Sandby, Munn, Richard Wilson, Thomas Stothard, Nicholas Pocock, Copley Fielding, David Cox, Henry William Bunbury, James Gillray and George Moutard Woodward. He also seems to have kindly signed a number of genuine topographical views by the Buck brothers, when they had carelessly omitted to do so themselves. His method of working was to buy up parcels of unframed drawings and to set to work on them largely at random. Naturally enough there are often perfectly respectable drawings by perfectly reputable artists lurking beneath the aliases. Fellow sufferers with Sunderland include John Glover, who also became Munn, and the disreputable drawing master James 'Drunken' Robertson, whose individual but dull and repetitive work inexplicably became Cox.

Should you come across a drawing with one of these signatures, it is worth looking at it carefully. It may well prove to be a good buy, although in 9.9 cases out of ten not at the 'signature' price. A similar item, although the signature was the work of a different forger, surfaced in a London sale some years ago, and takes us back to Birket Foster. It was a large and well painted woodland scene, marred only by a dubious BF monogram. Here the forger had failed to notice that the work was elsewhere already discreetly signed by another reputable if rather less expensive artist. In the event the monogram put off many potential bidders, although it could have been removed quite easily, and the buyer probably had a bargain. Another oddity which I saw more recently, was what appeared to be a perfectly acceptable Foster 'signed' David Cox. However it was really something of a double bluff, since the genuine signature of John Syer was still just visible beneath.

Signatures, in short, should not be regarded as hallmarks proving authenticity.

A clear example of a "Page Sixteen" signature on a perfectly good drawing by the amateur artist Thomas Sunderland. Sandby's own signature is smaller and less flamboyant.

Even when not actual forgeries they may be honest inscriptions or attributions wrongly added at a later date. They must be subjected to the same dispassionate scrutiny as the drawings themselves.

As in Victorian times, English watercolours are now expensive enough to make serious forgery once again financially worth while. For the last few years a fairly competent group of fakes, which appears to emanate from the Portobello market, has been working its way upwards through serious sales and into good collections. Recently I noticed one of them in the home of a respected and experienced dealer. The products of this forger include Rowlandsons, Fosters and Boningtons. The paper is often out of period, and the inks and colours have a dried out look to them, as if they had been blotted immediately.

One other form of print or reproduction may be mentioned here, although it is not in fact a forgery but an original work. This is the watercolour 'with etched outline'. In the late eighteenth and early nineteenth centuries many good artists such as Sandby, Nicholson (see illustration page 180), Edward Edwards and La Cave used this method to capitalise on the popularity of certain of their compositions. Others, such as Girtin, used soft ground etchngs, sometimes with pencil alterations, and coloured by hand, as stages in the preparation of sets of aquatints. Girtin's best known are for his views of Paris. If your pocket is comparatively short, and you can assure yourself that the colour is original, these are both well worth having, since they tend to be much cheaper than watercolours with autograph outlines. The trap to avoid, of course, is paying a full price for an etched or soft-ground outline.

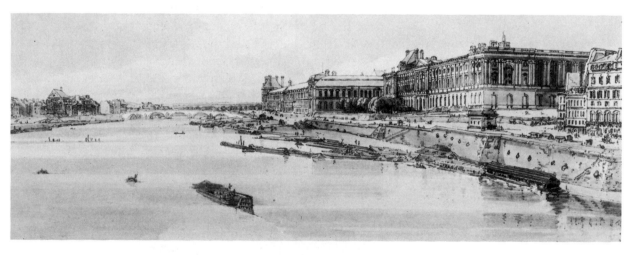

A view of the Louvre from the Pont Neuf by Thomas Girtin. It is a soft ground etching which has been hand coloured. While not usually quite as black and oily as the later lithographic line, that in a soft ground etching falls in clarity between pen and pencil. In fact the barges and small craft in the left foreground here are drawn in pencil, and the difference is obvious. This example came to the Newall Collection from that of the Duke of Bedford. Despite the hand colouring such things are very much less expensive than full watercolours with autograph outlines, and they are well worth the attention of the collector.

The unmasking of Tom Keating and his "Samuel Palmers" in 1976 provoked considerable public hilarity at the expense of art experts and the trade, but it was in fact remarkable how few of the leading auctioneers and dealers had actually been duped. Although Keating used features and mannerisms from geniune compositions, much more convincing than the drawings themselves was the attention which had usually been paid to the background features and the corroborative details, such as the creation of a plausible provenance which was difficult to check, and the provision of such homely inscriptions on the backing boards as "left side of the fireplace". Still greater conviction would have been carried had more care been taken to use correct papers and pigments. Keating, however, was one of the many forgers who actually wanted to be found out — indeed, eventually he unmasked himself. His subsequent career only confirmed the financial acumen of the move.

A Keating forgery might well have taken in someone with a passing and uninformed interest in English watercolours, although since the exposure it should no longer do so. It should not at any time have convinced anyone whose livelihood was made from the business. Keating also provided an excellent example of the way in which forgery follows the market. If a genuine Palmer had not just sold for £14,000, it is unlikely that he would have turned his attention to that particular artist.

However, there are other things on offer which should not bamboozle the most ignorant and philistine even for a moment, but in fact still take in supposed experts with the most tedious regularity. It is not so very long ago that senior representatives of a major London auction house took on a collection of more than 1,000 really poor amateur drawings and watercolours just because they were expensively mounted, and on the backs of many of them were notes to the effect that "as a joke Turner often signed with his initials in the left nostril", together with what turned out to be faked "stamps of authentication" by an American museum — which could not in any event have been expected to know much about the subject. As often as not the perpetrators of this fraud did not even bother to put the initials or whatever in the obscure places which they claimed for them, but still, so good was the marketing, several people who should have known better, and would have done had they stopped to think for a moment, were prepared to risk money or reputation to acquire the collection.

This serves to emphasise the fact that the most powerful ally of the forger is the would-be purchaser and owner. For many reasons, ranging from greed to vanity, all too many people will not use their critical faculties when confronted with a 'bargain', and later they will strive against reason rather than lose face by admitting that they have been had.

7. The Market Place

The first and most basic rule for anyone who wants to buy a watercolour is never take anything that you are told at its face value. However impressive and authoritative the cataloguing, however old and convincing an inscription, judge the information or the object for yourself. The greatest experts have their blind spots and moments of carelessness. Anyone may have misread and wrongly transcribed a signature or an inscription. Never buy anything that you do not believe completely, and never believe anything until you have subjected it to the most rigorous scrutiny.

Obviously good watercolours can turn up almost anywhere in Britain, and in many other parts of the world, and, equally obviously, one of the greatest mistakes that a collector can make is to overlook something merely because it appears unexpectedly, or in bad company. Dealers and auctioneers who are well known for handling rubbish will, by the law of averages, occasionally have something good despite themselves. Interior decorators, who generally know nothing, will often have something pretty and over-priced on their showroom walls for the sake of atmosphere. Once or twice these have turned out not to be over-priced at all. Junk shops which specialise in clearances find themselves with a decent picture from time to time. Destitute descendants may well be willing to cash in on great-grandfather if made a reasonable offer. Dealers and auctioneers who are well-known for handling the best may well have overlooked something merely good through carelessness or pressure of work.

The most successful dealers, contrary to their public image, are those who are prepared to work hardest, viewing no-hope sales with as much assiduity as the ones which will make headlines, travelling long and antisocial hours, really looking and testing, rather than taking on trust, gambling only when both instinct and common sense tell them it is worth while. The radar must never be switched off, since even a country pub or hotel to which they have retreated from a frustrating sale, may be willing to sell its decorations, and an overheard conversation may be a clue to something worth while. A serious collector who wishes to get the most pleasure out of his mania must be prepared to do much the same.

It is very easy to accept the propaganda of the museums and the auctioneers and to assume that they are the repositories of all knowledge, but in fact, thank Heavens, they are fallible, and a good specialist dealer or serious collector is likely to know more about his subject than either. There is a crude and simple reason for this: neither the museum nor the auction house expert has to back his opinion with his own money. Furthermore, the cataloguer at an auction house is likely to be hard working and hard worked. It is not often financially worthwhile for his employers to allow him to spend long hours in research, unless the object is obviously of prime importance, or a scholarly presentation of it will boost the reputation of the sale-room. He is governed by the numbers of objects passing before him, and is the servant of time in ways which need not always affect dealers and collectors.

This is why you may well find a potential bargain, or 'sleeper' in trade parlance, in a sale, but still not be able to secure it. The real experts are likely to be the competing bidders. Even so this is no reason to give up attending views and auctions; the very greatest expert may still overlook the most obvious treasure.

Most people come to collecting by chance; perhaps because they have bought one thing to fill a space on a wall and it has grown on them; perhaps because one view in a shop or an exhibition has had a value of association for them; perhaps because they have wanted scenes from the past of their locality. They may have caught the habit from a friend or a visit to a collection. If this first buy is a lucky one and turns out to be a good watercolour, as well as fulfilling its immediate need, then it may trigger off a lifetime of searching and acquisition. The important thing is to recognise the point at which occasional associative or impulsive buying is turning into serious collecting, and to prepare oneself as fully as possible. After all, if addiction really sets in it will affect not only one's pride in oneself and one's personal pleasure, but also one's reputation in the eyes of others and, to a greater or lesser degree, one's financial future.

As we have already said, a sure eye can only be acquired through looking at the best and the worst available, and the first task for anyone who thinks that they have been bitten by the bug is to look and look and look, so that the basic details of style and quality are fed into the brain at a glance, until such time as you will know, without conscious thought, roughly, if not exactly, what you are being shown. At the same time you must read both widely and deeply, always taking Messrs. Williams and Hardie as your Old and New Testaments (see Bibliography), and above all, you must never be too afraid, too self-confident or too secretive to ask.

There is a further course of self-instruction for anyone who intends to buy for himself, whether in the saleroom or from dealers. This is to spend as long a time as possible before making any serious purchases, in viewing sales and attending exhibitions. At first you must take no notice of any price lists, or printed lists of estimated prices. These are other peoples' opinions, and the purpose of this exercise is to give you yourself a reliable sense and scale of current prices. Values are, of course, an entirely different matter, and do not immediately concern us here. Write your own estimates in the catalogue, together with any observations as to condition, and any factors which you feel may or should affect the price. Then, if it is an exhibition, check with the price list. If the dealer is not particularly busy, ask him to explain any apparent anomalies to you. A good dealer, who is after all likely to be a fellow sufferer from the disease, will probably be happy to do this, since it is in his interest to encourage you to come back to him when you are ready to buy in earnest.

If you have viewed and marked up a sale, it is as well to try to attend it, even though you do not intend to buy. In this way you can not only check the accuracy of your estimates, but also discover who the leading dealers and specialists are, and perhaps work out some of the other factors which will affect the prices of particular works. For instance, you may notice that one particular dealer is paying what seems to be more than the odds for a particular artist. If so, he may be preparing an exhibition, which could in turn raise prices for the future. You will realise, too, that some subjects and views are more sought after than others, although they may be of similar quality. For instance, there is no sexual equality among portraits; all other things being equal a pretty woman is always more expensive than a man, and a man in uniform is likely to cost more than a sombre civilian. Swiss and Greek scenes may

well be more expensive than other equally attractive views.

If you can afford to do this sort of thing for six months or so, you may be ready to start buying without making too much of a fool of yourself.

Although when it comes to haggling, every man must fight his own corner, it is a great mistake to assume that every dealer you encounter is automatically your enemy. There are good dealers and bad ones, and, as in any other calling, there are many degrees of merit and demerit in between. On the whole it is as well to treat the trade as your allies until proved otherwise, and to remember that just as it is to the dealer's advantage not to overcharge you outrageously, so as to encourage you to return, it is also foolish of you to try to cut his profit to the bone, since he will be unlikely to bring good things to your attention in the future.

Auctioneers are often loud in their claims that they can get better prices for their vendors than would be paid directly by a dealer, and in many cases they are right. However, they tend to gloss over the corollary, that it may well be cheaper to buy from a gallery than at auction. I remember a case of a dealer who held a good exhibition in London, but only sold about a third of his stock, presumably because his contacts and mailing list were not up to scratch. He put the rest to auction, and in many cases they doubled up on his asking prices, a large proportion going to people who should have known about the original show.

The establishment of a working relationship with a reliable dealer is a very sensible move for the aspiring collector, although later on, of course, it is less necessary and it can be limiting to rely only on one source. Since, if he is any good, he will know more than you, he can guide you in the search for quality and point you towards good artists and examples of which you might not otherwise have heard. If you are interested in only one artist or subject, he will keep his eyes open for you, and his contacts and catchment area will probably be wider than yours. He will also, when you have enough mutual confidence, act for you at sales and views which you cannot attend yourself. He too is likely to be able to warn you off the things which you should not buy, and he may well be able to help with problems of restoration and framing.

If you prefer a totally disinterested agent and adviser, then go directly to a restorer, having first checked his professional capability as far as possible. Provided that you do not waste too much of his time, he too may be willing to view sales, either for or with you, and he will be able to advise you of the likely post-sale costs. Naturally enough, you are unlikely to get a true idea of these from the salerooms themselves, since they will have little practical experience, and in any event their first duty is to sell the wares for the client. Despite the imposition of the buyers' premium, the interests of the bidder must take a lower place in their order of priorities.

At least if you are buying from a gallery, rather than at auction, you can be fairly certain that what you are offered is in good condition, and if necessary it may already have been cleaned. You should get yourself on to as many dealers' lists as possible, in order to receive details of exhibitions and invitations to private views. At these you should soon work out which firms tend to over-restore once good objects, and some of the most prestigious do, and also, from the conversation and comments

of other dealers and collectors, who is thought to have the best reputation in any part of the field. Just as many collectors of the past and present are well-known for having accumulated junk, so too there are dealers with a well-merited reputation for the weakness of their eye, and the only way to find out who is reliable and who should be avoided is through personal contact. Some years ago there was a dealer in London who was handicapped by a fundamentalist religious faith. If God had told him that an attribution was right, but his customers later formed other ideas and tried to get their money back, there were painful scenes. Most dealers are, in fact, willing to rectify mistakes and buy back what they have sold you, but in this case rather more was involved.

Unless you find yourself with a demonstrable fake on your hands, you are not necessarily able to do very much about an unsatisfactory purchase at a sale room. The various conditions of sale are carefully honed to give very little scope to the disgruntled purchaser. While a dealer has by law to refund the purchase money if he sells you a fake or misattributed watercolour, unless his description has made it clear that the attribution is only a matter of opinion, a saleroom is under no such obligation. From this point of view the tyro is often better off going to a dealer, even if it means spending more. For this reason among others it is essential to do as much homework as possible before making any purchase at auction. In the better sale-rooms it is usually possible to view two or three days before the day of sale, and this allows time for taking second opinions — where you can do so without alerting unwanted competitors of course — and visiting museums and libraries.

If by chance you are unsuccessful at the sale, but have a suspicion that the lots you were interested in were bought in, and experience will tell you when this is the case, it can be worth contacting the auctioneers with an offer, usually somewhere near the last genuine bid. On one occasion I noticed a watercolour that interested me in the catalogue of a country sale which had taken place the day before. It was a view of one end of a court of the Alhambra by George Owen Wynne Apperley whose work was little known in this country, although he was English, since he had left his wife for a Spanish gipsy and spent much of his working life in Spain. At the time I was helping his daughter to prepare an exhibition, and so, when I heard that this example had been bought in without a bid, I was able to secure it, together with two atrocious amateur daubs, for £19. Two Saturdays later I happened to have time on my hands near Portobello, and there I found the companion view of the other end of the court for £8. This was covered by the price of the daubs, which I had left for a later sale. Coincidence and luck can play a great part in collecting, provided that one is wide awake and in a receptive frame of mind.

Another post-sale ploy is sometimes worth trying if you feel that an anonymous vendor may still be able to help with a little more of the history of a purchase, and this also applies to pictures bought at exhibitions where the gallery has agreed not to disclose their source of supply. It can be valuable to send a 'to whom it may concern' letter for the auctioneer or dealer to pass on to the vendor, who will then reply or not as he sees fit.

Although not strictly a matter of buying, it would be as well to indicate another

frequent source of irritation at this point. If you have bought something good from a sale or an exhibition in which it was illustrated, you may subsequently find it reproduced in a book or magazine without your knowledge or permission and without a credit to you. Some of the illustrations used in this book will no doubt fall into this category. Certainly you own the copyright of any photographs taken while the watercolour is in your possession, but you have no rights at all in anything taken at a previous stage in its career, whether by a former owner, a dealer, an auctioneer or even a newspaper.

It is rare to find a worthwhile and buyable watercolour either in a street market or at an antiques fair. Just occasionally you will find a specialist in a market, but they tend not to display the best of their stock, which they sell directly to trade or private clients during the rest of the week. Of course there will be some splendid token examples at such gilded venues as Grosvenor House or Burlington House, but the prices will also be a pretty sight. At smaller country fairs, however, dealers do occasionally have a folder or two of drawings which will bear investigation.

Alas, one of the greatest traditional sources of supply from which a number of magnificent collections were formed in the palmy days of the watercolour collector after the Second World War, has now virtually dried up. Among the bundles, boxes and albums of the second hand booksellers and the print dealers in areas like the Charing Cross Road there were treasures aplenty for those few who knew how to look, but nowadays the shoe boxes are given over to play bills and the albums contain only humdrum postcards. Even so, it is always worth asking a bookseller if he has a drawer of drawings about the premises, and a print dealer may well have a few architectural watercolours.

Buying directly from another private source can pose problems, since it may be necessary to call in a third party to fix a fair price, but collectors of watercolours are as gregarious as any others, and inevitably they swap and barter between themselves. There is a pleasant freemasonry among lovers of English watercolours, and most of them are civilised people. It does not usually take long to meet the owners of things that you want, but it may take many years before you can strike a mutually satisfactory bargain with them.

In 1944 Otto Wittmann, the Director of the Toledo Museum of Art promulgated ten basic rules for buyers of works of art, and they apply no less today:

1. Buy the best you can afford.
2. Increased value may be an indirect benefit of owning art, but should never be a primary requisite when buying it.
3. Know your museums.
4. Know your sources.
5. Observe good business practices.
6. Be curious.
7. Be courageous.
8. Be careful.
9. Don't be a cynic.
10. *Caveat emptor* means you.

These are included largely for my own pleasure — but I hope also for yours.

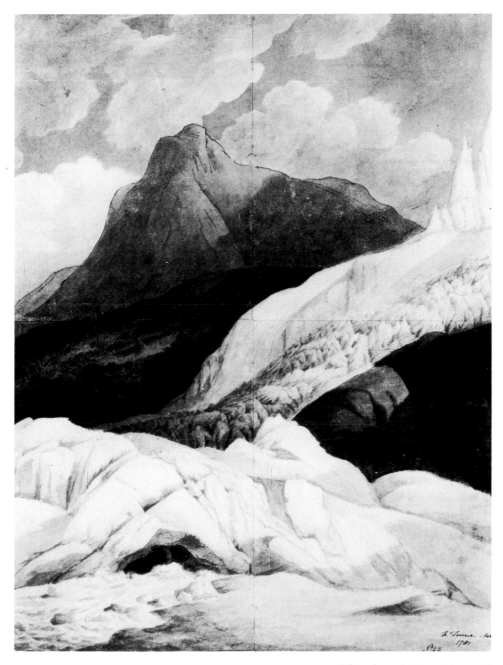

(Victoria and Albert Museum)

Francis Towne. The Source of the Arveiron, Mont Blanc in the background. Signed, numbered 53 and dated 1781. Pen and ink and watercolour 16¾ by 12¼ ins.

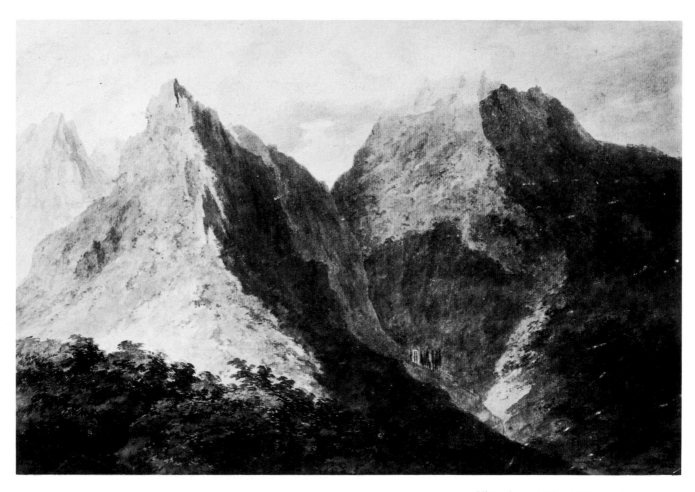

(Victoria and Albert Museum)

John Robert Cozens. The Island of Elba. Signed and dated 178(?) Watercolour, 14½ by 12⅛ ins.

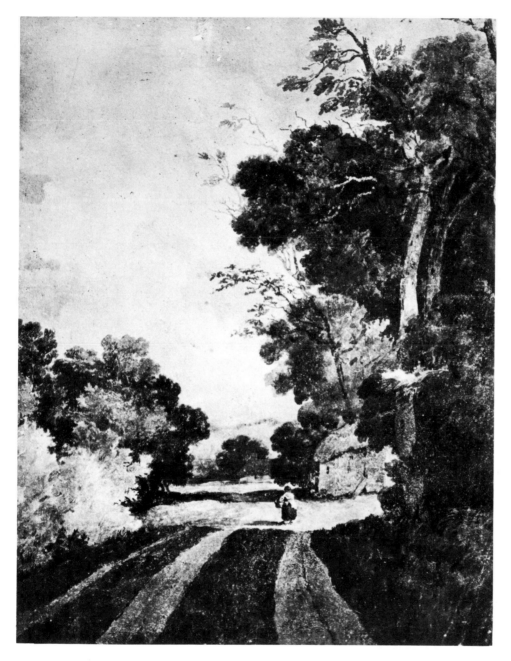

(Victoria and Albert Museum)

John Crome. The Shadowed Road, landscape with cottages. Watercolour. 20½ by 16¾ ins.

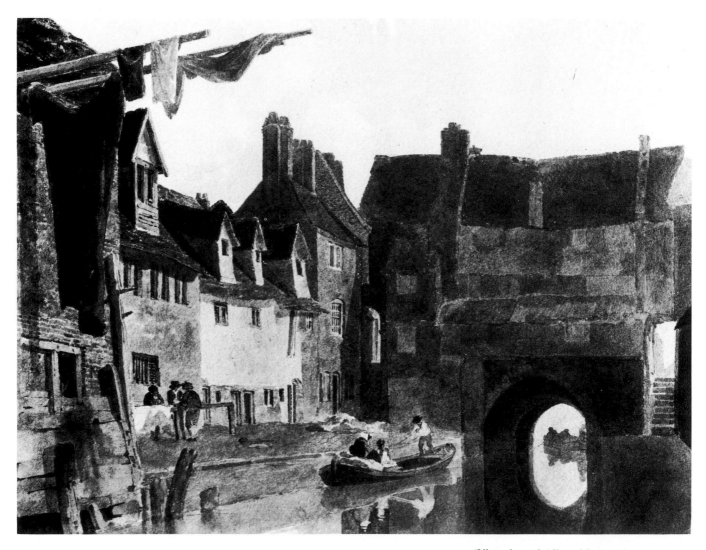

(Victoria and Albert Museum)

Peter de Wint. Old Houses on the High Bridge, Lincoln. Watercolour. 15⅝ by 20⅜ins.

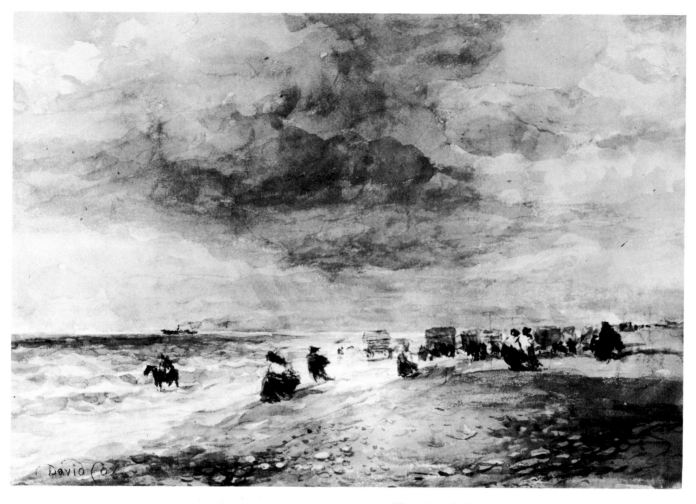

(Victoria and Albert Museum)

David Cox. Rhyl Sands. Signed, pencil and watercolour. 10⅝ by 14¼ins.

9. Caring for a Collection

In 1821, at the time of one of its periodic reorganisations, the Old Watercolour Society issued a manifesto, which it is worth quoting extensively. In part it claimed that: "Within a few years the materials employed in this species of painting, and the manner of using them, have been equally improved, by new chemical discoveries, and successful innovations on the old methods of practice... But when this art first began to develop (*sic*) new and extensive powers, the prejudices which probably originated in a contempt of its ancient feebleness, degenerated into a species of hostility, not very consistent with philosophy, or a genuine attachment to the Fine Arts. As the beauty and power of water colours were incontrovertible, an opinion was industriously spread abroad, that these qualities were evanescent, and the material on which these works were executed, so frail and perishable, that the talents of the artist were rendered useless by the ephemeral nature of his productions. Some failures which occurred in the infancy, or experimental age of the art, might appear, to a superficial observer, to justify these objections; but no philosophical reasons ever were, or could be, adduced against the possibility of producing, by means of water-colours, pictures equal in beauty and permanency of colour, as well as durability, to those executed in oil...

These prejudices... have now, in great measure, yielded to the evidence of many excellent works which have stood the test of several years uninjured; and the total extinction of such notions may be confidently anticipated as near at hand, although some critics, better acquainted (it is hoped) with books than paintings, still occasionally lament the infatuation of artists in throwing away so much time and talent on materials of so perishable a nature."

Ironically, in view of his production of accomplished if old fashioned watercolours, one of the most influential of these critics had been Sir George Beaumont. In 1811, at the beginning of another crisis in the affairs of the Society and of its rival the Associated Artists, A.W. Calcott had spoken to Farington "of the great change in the disposition of the public to purchase Water Colour drawings at the exhibitions of these Societies; said it shewed how temporary public opinion is; how much of fashion there is in liking any particular kind of art; and added that he believed Sir George Beaumont had done much harm to the Water Colour painters by his cry against that kind of art."

The criticism of the transient nature of watercolour pigments was really a compliment to the success of the O.W.S. in its policy of persuading the public to regard their branch of the art on equal terms to that of the oil painters. People had become used to seeing framed and glazed watercolours hanging in exhibitions, and that is how they had taken to displaying them at home. In the previous century most watercolours were kept in portfolios, which protected them from the worst effects of light; this was no longer the case. Unfortunately the Mr. Corner who wrote the 1821 manifesto, and was perhaps the engraver John Corner, was altogether too sanguine in his claim that "the total extinction of such notions may be confidently anticipated as near at hand." Watercolours continued to fade.

Artists of an enquiring nature, like John Varley, continued to experiment with solvents and admixtures which might give more permanency to their productions.

At one time Varley used gin as a solvent, and during the last decade of his life he added increasing quantities of gum arabic and sometimes also honey, which were intended to produce a close approximation of the finish of a varnished oil painting. In this he was too successful, since although the colours beneath the brown surface have not usually faded greatly, the surface itself has acquired the craquelure of a distressed oil painting.

One might have expected the problem to attract the attention of Prince Albert, whose interests combined both artistic and scientific matters, but in fact it was not until the 1880s that the first proper scientific investigations were carried out. In 1886 an exhaustive series of experiments was undertaken by Captain W. Abney and Dr W. S. Russell on the action of light, and they were shortly joined by a committee which included the watercolour painters Carl Haag, Henry Wallis, Sir James Linton and Frank Dillon, together with leading Royal Academicians and the curators of the British and South Kensington Museums. The Report, which was issued in sections in 1888 and 1889, emphasised two important findings. Firstly, that fading was directly linked to the amount of violet rays in light, and secondly, that light was not the only factor which contributed to fading. A damp atmosphere greatly accelerates it, and if it were possible to keep drawings in a vacuum, protected from violet rays, they should not fade. In 1929 a further series of experiments was undertaken with the intention of discovering which type of glass would give the greatest protection. The findings are summarised in the *Burlington Magazine,* LVII, 1930. There is now a glass which claims to cut out violet rays, but it has yet to be tested by time. One can only consult restorers and museum conservators for the latest consensus of opinion. There is also a perspex known as 'Lexon', which certainly helps, but has a drawback in that it can be damaged by so much as the touch of a finger on the surface. Experiments are also being carried out, by the National Trust among others, as to the efficacy of masking window-panes rather than picture glass with a translucent filter film. A byproduct of the 1929 investigation was the identification of the traditional colours which were most prone to suffer from exposure as rose madder and indigo, while vermilion was found to darken with prolonged exposure to light.

The sad conclusion is that a portfolio in a dry room is still the best place to keep a watercolour, but this is obviously a frustrating and impractical suggestion for most modern collectors. However, given that some examples will always be displayed on walls, there are a number of practical steps which the collector can and must take for their protection. They must never be hung in direct sunlight, or even in a strong artificial light. The atmosphere should be consistent, and kept as dry as possible without doing damage to the furniture. The ideal temperature is 20°C, or 68°F, plus or minus some ten degrees. To give an extreme example, exposure to a temperature of 100°C/212°F for seventy-two hours will have the same ageing effect on a piece of paper as would be observed had it been kept at a correct temperature for twenty-five years. Remember too that the amount of water effectively found in air at a given rate of humidity is the greater the higher the temperature, and it is damp that encourages many kinds of fungus and mould.

In general these remarks should seem obvious, but sadly, just as some people

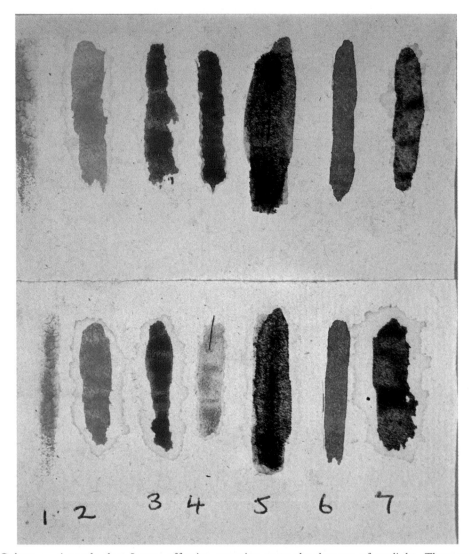

Colour — A crude, but I trust effective, warning as to the dangers of sunlight. These two samples were painted on July 4, 1983, and the lower exposed in direct sunlight until September 4 which was an unusually sunny period. The paper used was a late eighteenth century piece, and the exposed example has actually bleached. The colours are as follows:

1. Ackermann, Chrome Yellow, c.1835.
2. Lechertier Barbe, Chrome Yellow, c.1964.
3. Ackermann, Vermilion, c.1835.
4. Lechertier Barbe, Carmine, c.1964.
5. Ackermann, Neutral Tint, c.1835.
6. Winsor & Newton, Winsor Blue, c.1966.
7. Winsor & Newton, Ivory Black, c.1966.

It will be seen that the vermilion has darkened, in accordance with the findings of the 1929 investigation. The late, and otherwise lamented, firm of Lechertier Barbe of Jermyn Street, cannot be complimented on its carmine, but Ackermann's chrome yellow has stood up very well. The firm was then being run by the younger Rudolph, who had been trained in chemistry. The blue has faded a little, as has the neutral tint, but the Winsor ivory black also appears to have darkened.

should never be allowed to become dog owners or parents, so there will always be reprobates who should be barred from collecting watercolours.

The truth is that some insensitive if loving owners, like parents, just do not notice what is happening. Some years ago I was engaged to make a valuation of a collection, and as the *pièce de résistance* the proud owner placed me before his Turner, which had been given to him as a wedding present in an earlier decade. What I saw was a nice frame and label enclosing a blank piece of paper. What he, quite genuinely, still saw was the little jewel with which he had been presented. It was impossible to convince him of the truth, and the matter had to be concluded with an acrimonious correspondence. It is an interesting sidelight on human nature, that some people will refuse to break faith with their possessions whatever the occular evidence, and however badly they actually treat them.

For obvious reasons dealers tend to take better care of their stock, but some of them, no doubt to please an ignorant clientele, commit an opposite but equally heinous crime. These are the insensitive villains who automatically have everything cleaned and restored as much as possible, whether it needs it or no. Wonderful watercolours that have survived intact for two hundred years can have the rare bloom taken from them for ever because of an unthinking business habit. Naturally this is a border country in which the most sensitive and well informed judgement is necessary. An author and publisher with no fear of libel could quote many instances where it had been lacking at the most elevated levels of the trade.

Even worse is the dealer who foists a drawing that has not just been over restored, but totally rebuilt, on an unsuspecting buyer. While preparing this chaper I visited a restorer who was laboriously reconstructing in pastel a panoramic and almost entirely ruined nineteenth century view of London for a dealer. In perfect condition the original watercolour might have been worth from £2,000 to £3,000 at the then current prices. A few weeks later the dealer, from a respected and old established firm, sold what was really a twentieth century pastel copy to a tyro buyer for £8,000.

Fashions in framing and mounting have naturally changed over the years, and will doubtless continue to do so. For much of the nineteenth century the insistence on equality, rather than fraternity, with oil paintings meant that almost everything was heavily encased in gold. Towards the end of the century, under the influence of the Pre-Raphaelites and the Arts and Crafts Movement, many artists designed their own frames to complement their paintings. An excellent example of this is the Goodwin clan of painters, whose best known member is Albert. The eldest brother, Charles, made the frames and drew the mounts to suit the varied productions of Albert, Harry, Frank and Harry's wife Kate, as well as at least one nephew. Later still came a period of austerity, largely imposed by the great museum collections, when plain brown frames and overlarge cream mounts were the only acceptable fashion. Modern taste runs to window mounts with wash-lining, rather than a uniform colour which can sometimes look brash and usually detracts from the painting, and to plain wood or thin gilt frames. Perhaps, however, it is best to ignore fashion, and to let the watercolour demand its own style. It is surprising how often the vogue nearest to its own date — even the gold of the Victorians — will be found to suit the

This watercolour of a moorland scene by Robert Buchan Nisbet (1857-1942) was painted on an artist's board, with the rough drawing paper laid on a backing of cardboard. The impurities in the board had caused foxing, most noticeably in the sky. This would have worsened had it been left, so the board has been picked away, and the existing foxing has been removed. The water-colour has been given a light clean which has heightened the colours and brought out the contrasts of tone and composition. This exercise was com-paratively cheap, and is well worth while.

subject best. Whatever its style or pattern, the mount should ideally be of modern construction, and if you are having a watercolour remounted, you should insist on either Conservation or Museum Board. Conservation Board is largely made from rags and is acid free. Museum Board is 'all rag' and thus more pure still. It is inevitably the more expensive, but it should certainly be used on valuable drawings to avoid any future foxing, which is mainly caused by the minute particles of fungus spore in wood based paper.

However proud we may be of our practical skills, many of us are actually cack-handed, and cutting one's own mounts is more difficult than might appear. However, if you must, a few simple points must be kept in mind. Once again, use Conservation or Museum Board. On no account use a commercial self-adhesive

masking tape such as Sellotape, since this is very difficult to remove without causing damage. It softens and becomes tacky with age, and this will stain paper. Equally never use PVC or cellulose glue, or one that is spirit based or clear. Never glue the whole picture to the backing, since papers and boards have different rates of shrinkage. Old framed watercolours should usually be given new backing boards, and 2mm manmade hardboard is best for this. The old wooden boards have often split, giving the paper characteristic 'burn marks' at the gaps and encouraging foxing. New board should be taped in — using a flour-based adhesive tape — to admit as little air as possible.

Some people will tell you that you can save money by doing simple cleaning and repair jobs for yourself. I would most strongly advise against it unless you really know what you are doing and have complete confidence in your powers. Two problems, however, can be tackled without the risk of causing further damage. Pencil drawings can be cleaned with a vinyl powder, such as Magic Pad if you can find it, or with pounce, which is available from artists' shops. If using the latter you will need a fairly stiff brush, ideally an old fashioned bristle shaving brush, to clean off the powdery residue. The same sort of brush can be used to clean a mildewed drawing. First, however, it must be unframed and kept in a warm, dry place, such as a kitchen, for a week or so. For anything more advanced than this, go to a professional. Any good dealer should be able to recommend one, as should a museum. Both the British Museum and the Victoria and Albert Museum have excellent conservation departments, which will advise you as to the best way to proceed.

For your own peace of mind and that of your insurance company, anything good should be photographed, and you should make and keep proper descriptions, taking one of the better saleroom catalogues as your model. This will not only help the police and dealers if you should be the victim of a burglary, but it might also help to prevent future burglaries from taking place, since the more people who keep good records, the less easy will it be for thieves to market their pickings. If you have kept proper descriptions, you should place a stolen notice in trade papers, such as the *Antiques Trade Gazette* as soon as possible. It is remarkable how difficult it is to give a clear description even of something that you love and know well, when it is no longer in front of you. Do not wait until the task is forced on you. If you can draw, and do not wish to incur the expense of professional photography, then make a line drawing. This can be more informative than a blurred amateur snap, and your manuscript catalogue may itself become a collectors' item for a future generation. Naturally, you should keep such a record in a secure, and preferably fireproof, place.

10. A Brief and Basic Glossary

Camera Lucida: an apparatus much used in the eighteenth and early nineteenth centuries consisting of a box containing a prism which reflects rays of light from an object by way of a mirror on to a paper placed on a convenient sheet of glass for tracing. These were often handsome if rather cumbersome pieces of equipment. A more compact version was Varley's Patent Graphic Telescope, which looked much like a brass telescope and was invented by Cornelius Varley.

Dragging: Literally dragging a dry brush, or one charged with a new colour, over a previously laid and virtually dry wash. This gives a good rough texture. The example shown here is taken from a watercolour by John Martin (1789-1854).

Gouache or Bodycolour: An opaque paint, in modern terms Poster Paint.

Gum Arabic: Acacia gum which is used as a binding agent for watercolour, and also as a heightener to give a brown, varnish-like finish.

Heightening: As in "heightened with white". The addition of highlights or finishing touches in an opaque paint or a different substance such as gum arabic.

Prepared Paper: Used of papers that have been coloured in the manufacture. These, especially blue and a light grey-brown, were popular with drawing masters and amateurs in the middle decades of the nineteenth century — but have, of course, been used at other times.

Scumbling: As a sketching or a finishing technique this means that a large brush has been used in a rapid circular movement.

Sketching Frame: A light wooden rectangular frame provided with strips and clips on the edges to hold paper firmly. Usually the paper is wetted before being stretched over the frame and fixed down. Such frames vary in size from about 6ins. to perhaps 20ins., and the larger ones might be hung round the neck on a strap for outdoor work. **Prepared Artists' Boards,** in which watercolour paper is already laid on a cardboard backing have done away with the sketching frame since they were introduced in the late nineteenth century. The purpose of both is to prevent the paper from shrinking and buckling with the application of water and paint.

However, the prepared boards can produce stains and foxing because of acid and impurities in the cardboard. Watercolours should really be removed from early ones.

Stippling: The building up of an intensely worked finish by means of dots or other small strokes. It is an even smaller form of pointillisme.

Stopping out and **Fetching out:** At its simplest as used by Girtin and Turner, dabbing away of parts of a damp wash to expose the paper and thus create a highlight. Francis Nicholson would lay in a preparation of beeswax, turpentine and flake white before putting in his colour washes. This would repel the paint, and when removed later with more turpentine or spirits of wine would also leave the white paper exposed. **Scratching out** with a knife or the point of a brush handle has a similar intention.

11. How much do you really know?

1. Which Watercolourist:
 a. Saw angels sitting in trees
 b. Tried to burn down York Minster
 c. Murdered his father
 d. Had to escape from a mob through the back window when one of his faith healing cures went wrong
 e. Drew a portrait of King Harold from life
 f. Was killed by a stag in his studio
 g. Shared a doctor with George III — and who was the doctor?

2. Who were:
 a. E.M.W.; W.R.B.; H.B.P.; T.C.D.; J.W.A.; P.R.B.?
 b. Geoffrey Gambado; Ben Tally-Ho; Ape; Sir Dirty Didget?

3. Which is the odd man out:
 a. Payne; Perkins, Turner; Jutsum?
 b. Phiz; Bos; Dizz; Kyd?

4. What have the following in common:
 Edward Lear; Samuel Daniell; Andrew Nicholl?

5. What can you say immediately about a watercolour that employs:
 Chinese White; Emerald Green; Scheele's Green?

6. Which is the biggest:
 a. Double Elephant; Antiquarian; Double Demy; Imperial?
 b. Large Swan; Small Eagle; Small Goose; Lark?

7. Whose husband had a fear of a little men?

8. Who said of whom: "If — had lived, I would have starved"?

9. Who said "I give them wings and they fly away"?

10. Who was Girtin's favourite pupil?

11. Who gave his footman drawing lessons?

12. Name as many professional pupils of Paul Sandby as you can.

13. Which artist do you most associate with:
 a. Haddon Hall
 b. A Border Tower
 c. Norham Castle
 d. Windsor Castle
 e. Lincoln Cathedral
 f. Brandsby Hall
 g. Farnely Hall?

14. These two watercolours are painted by different artists:
 a. Who?
 b. Does it matter?

(Private Collection)

15. Who is this watercolour by?

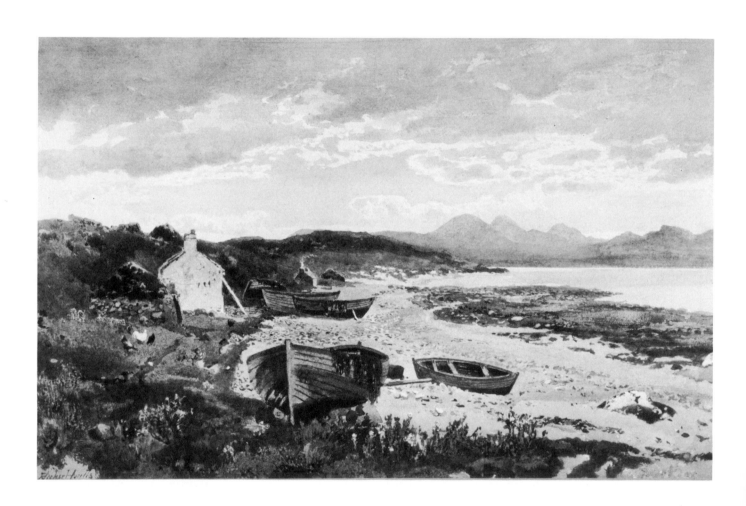

16. To whom would you attribute this watercolour — and does it matter?

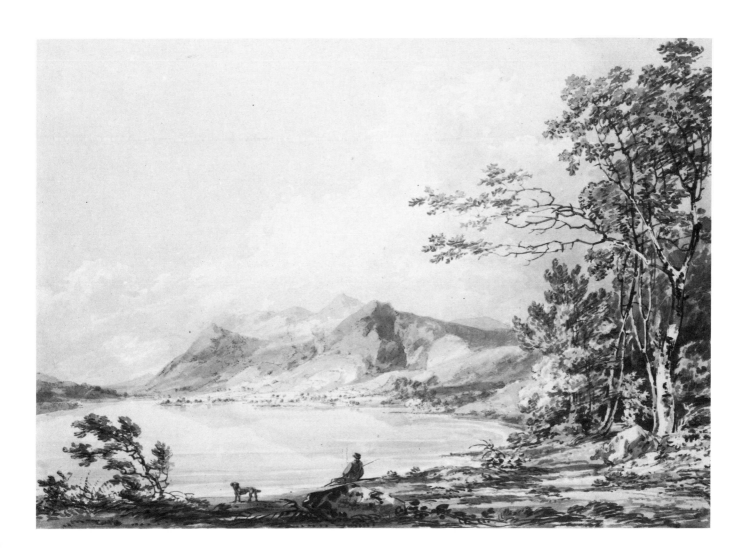

17. a. Who is this by?
 b. What bells should this inscription ring?

18. If you saw this tower in a watercolour, where would you begin your search for an attribution?

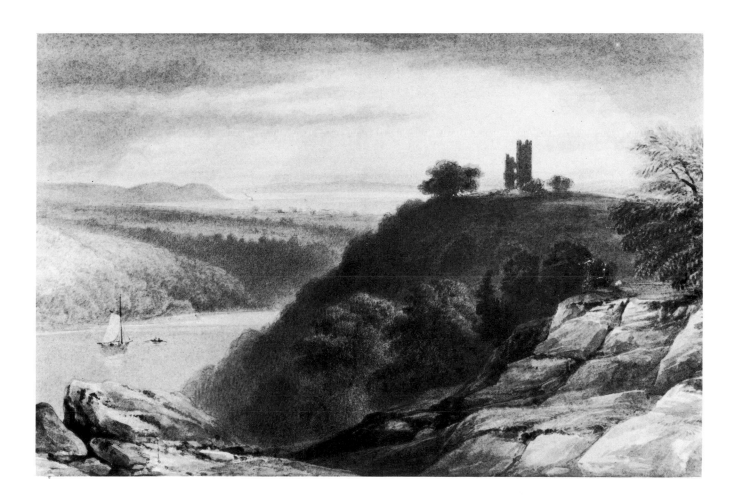

19. This illustration has been trimmed of two initials and the date 1833; who is it by?

20. This is a pen and wash drawing of a view in the Lake District; who is it by?

21. This is a collaboration between five artists, which was produced for the Haldimand Collection. They are Charles Wyld, John Massey Wright, George Fennel Robson, the younger George Barret and Anne Frances Byrne. Who did what?

22. What is wrong with this signature?

Answers

1. a. William Blake; b. Jonathan Martin; c. Richard Dadd; d. de Loutherbourg; e. John Varley; f. William Duffield; g. John Robert Cozens and Dr. Monro.

2. a. Edmund Morison Wimperis (minus your previous score if you put him down as "Monson"); b. William Roxby Beverley; c. Helen Beatrix Potter — her very first published illustrations have the full initials; d. Thomas Colman Dibdin; John White Abbott; e. The Pre-Raphaelite Brethren.

3. Jutsum; the others gave their names to paints, he to a brush.

4. If you said that they all painted watercolours, you were being bumptious; subtract two marks. The answer is that they all painted in Ceylon.

5. a. It was painted in or after 1834; b. It was painted after 1814; c. It was painted after 1778 and probably before about 1814.

6. a. Antiquarian; b. Small eagle.

7. Helen Allingham.

8. Turner of Tom Girtin.

9. Cox.

10. Precedence among Ladies is always difficult, but in this case the Duchess should probably give place to the Baroness: so 2 for Lady Farnborough, 1 for the Duchess of Sutherland.

11. John Varley.

12. I am sure of only six: M. 'A' Rooker, P.S. Munn, J.C. Schnebbelie, J. Harding, J. Cleveley and Thomas Paul Sandby. If you have firm evidence for others, score accordingly.

13. a. David Cox; b. Lady Waterford; c. Turner; d. Paul Sandby; e. Peter de Wint; f. J.S. Cotman; g. Turner.

14. a. J.R. Cozens; b. Turner. — It is possible that Turner's Monro School copy would be more expensive than the Cozens original, but if you said that it does not matter, you have the makings of a connoisseur and should take five extra points.

15. If you worked out the signature to be Herbert Coutts, you score one; if you knew him to be Herbert Coutts Tucker, you score two.

16. Edward Dayes. From the aesthetic point of view it matters not a jot. However, financially this and other traditional 'early Turners' suffer from re-grading.

17. Helen Allingham; b. Witley in Surrey was not only her home but that of Birket Foster, and was very much a late nineteenth century artists' colony.

18. Bristol City Art Gallery. This is Cook's Folly on Durdham Downs, and it appears in many Bristol School watercolours of the junction of the Avon and the Severn. It was built in about 1760, and bits of it still remain. This version, by the way (for an extra point) is by Samuel Jackson.

19. John Linnell. If you said Samuel Palmer, subtract two from your score for not thinking.

20. John Horner (1784-1867). This is a slight trick to remind you how similar many amateurs could be. If you said Thomas Sunderland, award yourself half a point for good sense.

21. Wyld, architecture; Wright, figures; Robson, landscape; Barret, painting to the left; Byrne, the flowers by it, and perhaps in the surround.

22. Nothing.

If you have scored anything like sixty points my publisher has made a mistake — you should have been writing this book.

If you are a dealer or an auctioneer and have scored less than thirty, you should seriously consider a change of career before legislation protecting the consumer catches up with you.

As a collector with less than about thirty, you have much to learn for your self protection — if only from your bank manager.

Index

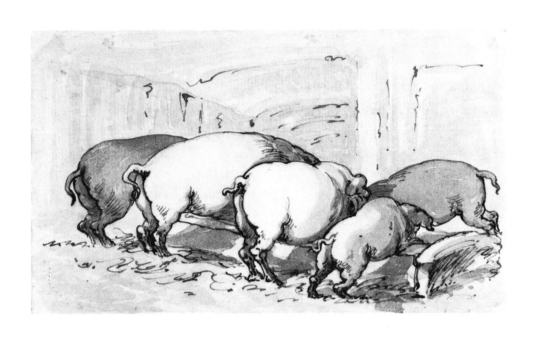

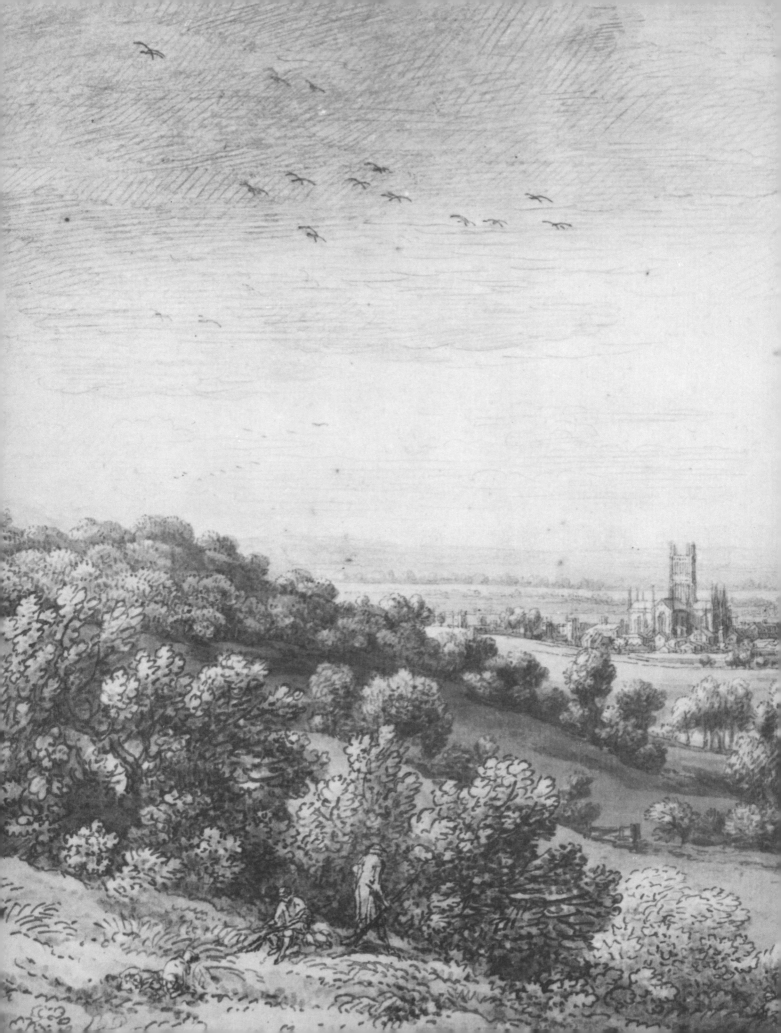

JAMAICA
in Pictures

Janice Hamilton

Boulder City Library
701 Adams Boulevard
Boulder City, NV 89005
DISCARD
JUL 2006

Lerner Publications Company

Contents

Lerner Publishing Group realizes that current information and statistics quickly become out of date. To extend the usefulness of the Visual Geography Series, we developed www.vgsbooks.com, a website offering links to up-to-date information, as well as in-depth material, on a wide variety of subjects. All of the websites listed on www.vgsbooks.com have been carefully selected by researchers at Lerner Publishing Group. However, Lerner Publishing Group is not responsible for the accuracy or suitability of the material on any website other than www.lernerbooks.com. It is recommended that students using the Internet be supervised by a parent or teacher. Links on www.vgsbooks.com will be regularly reviewed and updated as needed.

Copyright © 2005 by Janice Hamilton

All rights reserved. International copyright secured. No part of this book may be reproduced, stored in a retrieval system, or transmitted in any form or by any means— electronic, mechanical, photocopying, recording, or otherwise—without the prior written permission of Lerner Publications Company, except for the inclusion of brief quotations in an acknowledged review.

Lerner Publications Company
A division of Lerner Publishing Group
241 First Avenue North
Minneapolis, MN 55401 U.S.A.

Website address: www.lernerbooks.com

web enhanced @ www.vgsbooks.com

CULTURAL LIFE 46

► Religion. Music, Dance, and Theater. Art. Language. Literature and Media. Sports and Games. Food. Holidays.

THE ECONOMY 58

► The Service Sector. Industry, Manufacturing, and Trade. Agriculture. The Informal Sector. Transportation, Energy, and Communications. The Future.

FOR MORE INFORMATION

Library of Congress Cataloging-in-Publication Data

Hamilton, Janice.
 Jamaica in pictures / By Janice Hamilton.
 p. cm. – [Visual geography series]
 Includes bibliographical references and index.
 ISBN: 0-8225-2394-9 [lib. bdg. : alk. paper]
 1. Jamaica. 2. Jamaica—Pictorial works. I. Title. II. Series: Visual geography series (Minneapolis, Minn.)
F1868.H36 2005
917.292'0022'2—dc22 2004019768

Manufactured in the United States of America
1 2 3 4 5 6 – BP – 10 09 08 07 06 05

INTRODUCTION

When Christopher Columbus explored the coastline of Jamaica in 1494, he declared it to be the most beautiful island he had ever seen. More than five hundred years later, many people still agree with him. Jamaica's soaring blue-green mountains, lush forests and fields, cascading rivers, and white sand beaches are spectacular. Its people, their language, music, and art are full of vitality.

Jamaica is located in the Caribbean Sea, about 480 miles (772 kilometers) south of Florida. It is the third-largest of the Caribbean islands, after Cuba and Hispaniola (the island that is home to the Dominican Republic and Haiti), and is the largest English-speaking Caribbean country.

The island is formed primarily of limestone and volcanic rock. Fertile lowlands line the coasts, but more than half the island lies over 1,000 feet (305 meters) in elevation. A central limestone plateau forms about half of Jamaica's landmass, and the Interior Highlands, a chain of mountain ranges including the Blue Mountains, dominate the scenery.

Jamaica's climate is tropical but varies widely from one part of the island to the other. Constant trade winds cool the hills and bring moisture to the northeast, while small sections of the southern coast are almost desertlike. In some years, Jamaica is battered by hurricanes between August and November.

The land is rich in resources, including bauxite (the ore from which aluminum is obtained) and limestone. From its fertile soil, farmers produce many crops, especially sugarcane, coffee, and bananas, while fishers make their livelihoods from the ocean. Jamaica's beaches have been a favorite of sun-seeking tourists for more than forty years.

Jamaicans come from mixed racial and ethnic backgrounds, including British, Chinese, and Indian, but the majority of the population is descended from black Africans who were forcibly brought to the island as slaves. Jamaicans are proud that their ancestors have blended together to form one nation.

The first-known inhabitants were Taino Indians. They called the island Xaymaca, meaning "land of wood and springs." Spanish colonists arrived in 1510. The Spaniards began to bring slaves to the colony from West Africa in 1517 to clear the land and do other hard work.

In 1655 the British captured Jamaica's capital, Spanish Town, from the Spanish; made the island a British colony; and developed huge sugarcane plantations. The British imported thousands of slaves to plant and cut the sugarcane. The slaves never gave in to their fate, however, and more slave revolts occurred in Jamaica than on any other Caribbean island. The British banned the slave trade in 1808 and freed Jamaica's slaves in 1838.

Jamaica began to move toward self-government in the 1940s and achieved independence in 1962. The People's National Party (PNP) and the Jamaica Labour Party (JLP) dominate politics, but since the 1970s, election campaigns have been marred by violence.

In recent years, violence has been associated more with warring gangs of drug dealers than with politics. The high level of violence and crime, especially in the capital city of Kingston, is one of the country's most pressing problems.

Poverty is common in both urban and rural Jamaica, and a large income gap divides the small number of rich people and the many poor. The government is trying to attract new types of industries and to support small businesses in order to improve the economy and the everyday lives of citizens.

Nevertheless, Jamaica is known for its rich culture and contribution to the arts, especially in the field of music, where reggae rules. The slaves brought their traditions with them, and many African stories and religious beliefs remain part of Jamaican contemporary life. British influences also survive in the country's official language and legal traditions. Jamaica is also known for its world-class athletes in sports such as track and field, boxing, and basketball. For such a small country, Jamaica is making a big splash in the world.

THE LAND

Jamaica, with a total area of 4,243 square miles (10,991 square km), is about the size of Connecticut. Lying about 480 miles (772 km) south of Florida, Jamaica is one of the Greater Antilles, a group of large islands in the western Caribbean Sea that includes Cuba, Hispaniola, and Puerto Rico. The Greater Antilles, along with the Lesser Antilles (the islands of Barbados, Saint Lucia, and others) and the Bahamas together are often referred to as the West Indies.

Long and narrow, Jamaica is about 146 miles (235 km) long from Morant Point in the east to South Negril Point in the west, and between 22 miles (35 km) and 51 miles (82 km) wide.

◉ Topography

Jamaica's terrain is extremely mountainous. More than half of the country is at least 1,000 feet (305 m) above sea level. About two-thirds of the land, especially in the central and western regions, is covered by a thick layer of limestone, made up of the remnants of ancient

seashells and corals. Many large bays lie along the irregular coastline. Kingston is the world's seventh-largest harbor, and the city of Montego Bay also has a large port. Several cays, or small islands, lie off the coast.

Jamaica has three major landforms—the Coastal Lowlands, the Central Limestone Plateau, and the Interior Highlands. The Coastal Lowlands encircle most of the island but are widest in the south and west where they extend 5 to 10 miles (8 to 16 km) from the shore. Farms cover these lowlands, which are made up primarily of rich clay soil, deposited by water.

The Central Limestone Plateau, at an average height of 1,500 feet (460 m) above sea level, covers about half the country. It includes the remote 500-square-mile (1,295 sq. km) region known as Cockpit Country. Rain has seeped into the porous limestone and has dissolved the calcium carbonate in the rock, creating underground caverns and streams. Some caverns became so large that the ground

GEOLOGIC ORIGINS

Like all the islands of the Caribbean, Jamaica sits atop a submerged range of mountains. About 140 million years ago, volcanic activity pushed this new land out of the ocean. That land was worn down by erosion, and the island disappeared under the sea about 100 million years ago. While it lay under water for 20 million years, mollusks, corals, and other ocean creatures lived and died there. The calcium carbonate from their shells built up a thick layer that gradually compressed and became limestone. The land was pushed up by new volcanic activity about 80 million years ago, when the Blue Mountains were formed. Limestone and volcanic rock are common on the island.

above collapsed, forming depressions called sinkholes. Geologists call this type of limestone landscape with sinkholes and underground streams a karst region. In Jamaica, people call the sinkholes "cockpits."

The Interior Highlands include several mountain ranges, which are made of limestone, shale, and volcanic rock. Blue Mountain Peak, the island's highest point at 7,402 feet (2,256 m) above sea level, is located in the Blue Mountain Range. The Blue Mountains and the John Crow Mountains are in the eastern part of the island. The Central Range extends to Cockpit Country. The Western Range includes Dolphin Head, a landmark that can be seen from far out at sea.

◉ Rivers

The highlands give rise to many swift rivers, which rush through gorges and plunge over waterfalls. Some riverbeds are dry in all but the rainy season (August through November), when they can rapidly become torrents that overflow their banks.

The Blue Mountains, so called because the mist that often covers them appears blue in color, rise in eastern Jamaica. Spanning 30 miles (48 km) long, they average approximately 12 miles (19 km) wide.

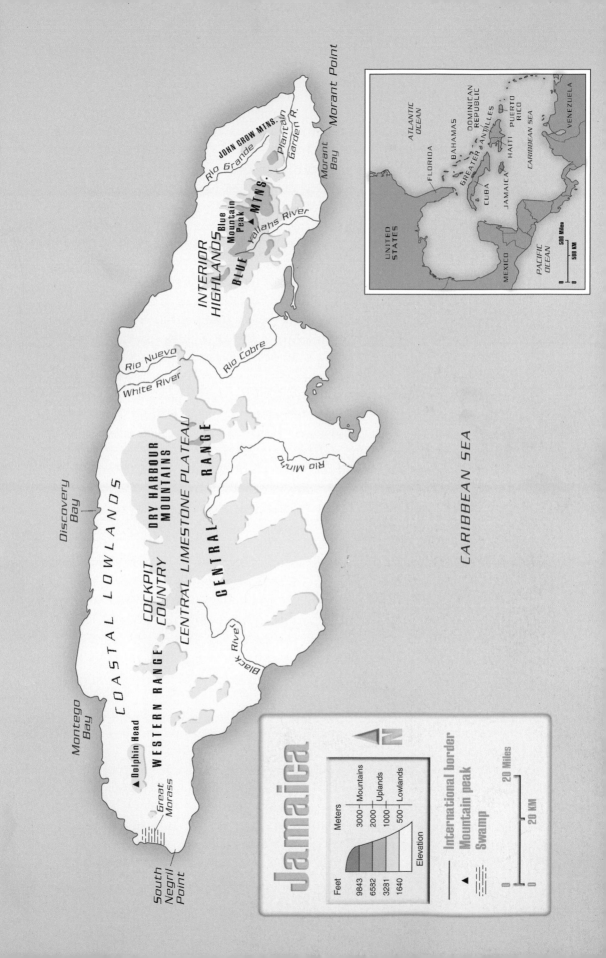

MORANT POINT

JOHN CROW MTNS.

Rio Grande

Plantain Garden R.

Morant Bay

INTERIOR HIGHLANDS

Blue Mountain Peak ▲

BLUE MTNS.

Yallahs River

Rio Nuevo

Rio Cobre

White River

DRY HARBOUR MOUNTAINS

CENTRAL LIMESTONE PLATEAU

CENTRAL RANGE

COCKPIT COUNTRY

COASTAL LOWLANDS

WESTERN RANGE

Rio Minho

Discovery Bay

▲ Dolphin Head

Montego Bay

Black River

Great Morass

South Negril Point

CARIBBEAN SEA

JAMAICA

N

Feet	Meters	
9843	3000	Mountains
6582	2000	Uplands
3281	1000	
1640	500	Lowlands

Elevation

International border
▲ Mountain peak
Swamp

20 Miles

20 KM

Inset map:
ATLANTIC OCEAN

FLORIDA

BAHAMAS

DOMINICAN REPUBLIC

GREATER ANTILLES

PUERTO RICO

HAITI

CUBA

JAMAICA

CARIBBEAN SEA

VENEZUELA

UNITED STATES

MEXICO

PACIFIC OCEAN

500 Miles
500 KM

Few rivers cross central Jamaica, because the porous limestone doesn't allow water to remain on the surface of the land. But several underground rivers flow in this region.

The Rio Minho is the country's longest river, flowing 58 miles (93 km) from its source in the central Dry Harbour Mountains to its mouth on the southern coast. In the northeastern area, the wild and remote Rio Grande tumbles 3,000 feet (914 m) from its source in the Blue Mountains. Its valley separates the Blue Mountains from the John Crow Mountains. Other large rivers in the north include the Rio Nuevo (New River) and the White River.

The Plantain Garden River is one of the few rivers that flows eastward, rather than north or south. It begins its course in the Blue Mountains, then crosses a fertile valley at the southern base of the hills. In the southeast, the Yallahs River originates high in the Blue Mountains. The Rio Cobre is a source of drinking and irrigation water around Spanish Town, the former capital.

In the southwest, the tranquil Black River gets its dark appearance from the peat (partly decayed plant matter) in the riverbed. It rises in the central region and flows westward before disappearing underground. After reemerging, it flows through a vast swamp called the Great Morass. Upriver, wild sugarcane, bulrushes, and wild ginger grow along the riverbanks, while mangrove trees thrive near the coast. Crocodiles, once plentiful but hunted almost to extinction, have a protected refuge in the region.

◉ Climate

Jamaica has a humid tropical climate influenced by the ocean, but the mountains create wide variations in both temperature and rainfall. Sea breezes keep temperatures fairly comfortable along the coast, while elevated areas are somewhat cooler and less humid. The average temperatures in Kingston are 76°F (24°C) in January and 81°F (27°C) in July. The predominant wind is the trade wind from the northeast.

The wettest periods are May and August through November. Average yearly rainfall totals 32 inches (80 centimeters), but considerable variations occur from one area to another. The wettest area is Portland Parish (county) in the northeastern part of the country. There the mountains squeeze up to 130 inches (330 cm) of rain out of the moisture-laden trade winds. The lowlands of the southern and southwestern areas get little precipitation and require irrigation for agriculture. This region is usually dry from December through April, and occasionally the dry season becomes an extended drought.

Sudden thunderstorms often appear in the hot summer months, and torrential downpours can cause flooding in low-lying areas. As a result, ditches are in place to catch excess storm water. Hurricanes are a threat from August through November.

Flora and Fauna

Jamaica has more than 3,000 species of flowering plants, including 237 species of orchids. About a quarter of them are found nowhere else. The blue flower of the lignum vitae tree, a tree valued for its extremely hard wood, is the national flower. Cactus plants grow in very dry regions, and palm trees are found almost everywhere.

Many of the plants common to the Jamaican landscape—including bougainvilleas, breadfruit, banana trees, sugarcane, and akees—were imported from elsewhere. About 286 species of indigenous (native) Jamaican plants are listed as extinct or endangered.

Several distinct types of forests grow in Jamaica. Mangrove forests dominate the western coast. Mangrove trees can grow in salt water and are distinguished by massive roots that rise into the air. In the swamps and marshes of the low-lying coastal regions, vegetation consists primarily of sedges and rushes.

Jamaica's **mangrove swamps** are very important to the island's ecosystem. The trees' roots help prevent soil erosion by capturing sediments. They also trap nutrients, making them an ideal spot for small fish to live and feed.

MONGOOSE

Jamaica's most common wild mammal is the mongoose. These relatives of the weasel were imported from India in the late 1800s to control rats, which had arrived as stowaways aboard ships and were thriving on the sugar plantations. Along with rats, mongooses kill snakes, birds, lizards, coneys, and domestic chickens, and they have become destructive pests.

The dry limestone forest, found in regions that receive little rainfall, is characterized by birch and cedar trees. In areas with more moisture, the wet limestone forest features trees with large trunks and a thick canopy of branches reaching about 100 feet (30 m) above the ground and a huge variety of ferns. The wet limestone forest of Cockpit Country is a refuge for the endangered giant swallowtail butterfly and several other species of plants and animals found only in the area.

The montane forest can be found at 1,250 feet (381 m) above sea level and higher. It consists of cedars and a variety of rare local species. On some mountainsides, the montane forest swirls with mist for much of the day. The mist not only provides moisture but reduces the amount of light reaching the plants.

Jamaica's unique wildlife includes several hundred species of insects, including 120 types of butterflies and 50 species of fireflies (which Jamaicans call peeny wallies). Jamaica has 24 species of lizards, 5 snake species, and 17 species of frogs. The country's largest land animal, the

Jamaican iguana, can grow up to 6.5 feet (2 m) long. The iguana was thought to be extinct until 1990, when a few were discovered in a small area of dry limestone hills along the southern coast.

Jamaica's 255 bird species include over 100 migrants that nest in Canada or the United States and spend the winter in Jamaica or pass through it on their way farther south. Year-round residents include hummingbirds, parakeets, and doves. The streamer-tailed humming-bird, or doctor bird, is the national bird.

At least 700 species of fish inhabit the warm sea surrounding the island, and several species of marine turtles lay their eggs on its beaches. An almost continuous coral reef along the northern coast pro-vides a habitat for parrot fish and nurse sharks. Dolphins are common marine mammals along the southern coast, but the once-plentiful West Indian manatee is almost extinct.

Jamaica's 23 species of bats feed on fruit or insects. The only other indigenous species of land mammal is the Jamaican hutia, or coney— a large, brown rodent that has been hunted almost to extinction.

▶ Natural Resources

Jamaicans excavate a variety of mineral resources from the earth. The country is one of the world's largest producers of bauxite. Bauxite is found in the red soil, called terra rosa, that is plentiful throughout cen-tral regions of the island.

Jamaica also has white limestone, used for building construction and to make cement, clay for ceramics, and silica sand, used to make

Because of the low number of **Jamaican iguanas** left in the wild, the University of the West Indies in Kingston established the Jamaican Iguana Research and Conservation Group. The group works to protect this endangered species, whose population is thought to number between fifty and two hundred animals.

glass. Peat, gravel, marble for ornaments, and gypsum (exported for cement making) are also found. Jamaica has small deposits of iron ore, copper, lead, zinc, and phosphates.

Fertile soil and black clay, combined with sufficient rainfall or irrigation, make agricultural land another important resource. Export crops include sugarcane, bananas, and coffee beans, while farmers grow other food crops and raise livestock for local consumption.

> **Some crops are particularly likely to cause erosion. For example, banana trees do not protect the soil because their roots grow close to the surface. In addition, some farmers clear steep slopes that have poor soil in order to plant highly profitable coffee trees, but this can make the hillsides more vulnerable to erosion.**

Jamaica's natural beauty, especially its northern coast beaches, attracts tourists to centers such as Ocho Rios, Montego Bay, and Negril. Jamaica's excellent harbors at Montego Bay, Port Antonio, and Ocho Rios welcome cruise ships.

Forests cover about a quarter of Jamaica's land. The most valuable indigenous hardwood trees include ebony, mahogany, and lignum vitae. People use gourds from calabash trees and the wood of the blue mahoe tree for crafts, while other craftspeople make the leaves of thatch palms into rope for wicker products.

The Caribbean Sea is another important resource, both for the variety of plants and animals that live in the underwater coral reefs and for the fishing industry. Island fishers bring in catches of bottom-dwelling species such as groupers, as well as free-swimming species including yellowfin tuna. Conch, shrimp, and lobsters are also abundant.

◉ Environmental Concerns

More and more Jamaicans are learning about how and why to protect the environment, and many are active in conservation organizations. In 2001 the government established a National Environment and Planning Agency (NEPA) to protect the environment and promote sustainable development. Jamaica is a member of the Alliance of Small Island States, a coalition of small island nations and countries with low-lying coasts vulnerable to the effects of global climate change, such as rising sea levels. Jamaica has laws to protect beaches, forests, and endangered species, but a lack of government funds limits enforcement.

When Columbus arrived, trees covered the island. Less than a third of that original forest is left, and deforestation is an important environmental issue.

The winds of **Hurricane Gilbert** were strong enough to hurl this plane into some trees along a road in Kingston.

Clearing land for farming and bauxite mining have caused most of Jamaica's deforestation. Many poor farmers must depend on small plots of land to produce their livelihood, and they lack the tools and education to use environmentally friendly agricultural techniques. Bauxite mining companies remove large areas of vegetation and topsoil to dig open-pit mines. Regulations introduced in recent years require these companies to replace the topsoil and replant grass or trees after mining out a bauxite pit.

Deforestation has consequences for vast areas. For example, mountain slopes that have been cleared of trees are easily eroded during heavy rains. Without tree roots to hold the soil and water together, topsoil is washed into the rivers and carried into the sea. Heavy rains run off too quickly, increasing the danger of flash flooding and potentially worsening the impact of hurricanes.

HURRICANES

Jamaica has been in the path of some of the worst hurricanes to hit the Caribbean region. At least seven extremely powerful hurricanes hit in the 1700s, five more between 1804 and 1944, and in 1980 Hurricane Allen left up to five thousand people homeless.

On September 12, 1988, Hurricane Gilbert made a direct hit on Jamaica, leaving widespread destruction in its path. It was one of the largest and wettest hurricanes ever experienced in the Western Hemisphere. The storm brought wind gusts to 127 mph (204 kmph), accompanied by heavy rainfall. Erosion was extensive and crops, including banana trees, citrus trees, and sugarcane, were flattened. The hurricane damaged or destroyed about 135,000 homes and hotels and tourist attractions took a big blow. Roads, water supplies, hospitals, and other services were also damaged.

In 2004, two hurricanes, Charley and Ivan, passed over Jamaica. Charley caused extensive flooding and one death. Ivan, a far more powerful storm, killed at least fifteen people.

Jamaica is particularly vulnerable to water pollution, which can kill fish, cause excessive algae growth, and destroy the recreational enjoyment of waterways. Kingston Harbour is polluted by a combination of domestic sewage, runoff from drainage ditches, and industrial waste. Sources of industrial pollution include coffee and sugar processors, rum distilleries, oil spills, and mining. Bauxite mining and refining produce large amounts of waste, called red mud, as well as wastewater. These waste products have to be treated and stored or recycled, but the danger of spills and contamination always exists.

Pollution is also harming coastal waters. Nutrients such as fertilizers and animal waste are washed into the ocean, where they stimulate excessive algae growth. Solid particles from industry and soil erosion remain suspended in the water and decrease the light reaching coral reefs. These conditions, along with harmful fishing practices, are damaging the island's coral reefs. The government has protected a number of environmentally important areas by establishing national parks, marine parks, fish sanctuaries, and forest reserves. Beaches and wetlands are among the protected areas.

Cities

Kingston, with a population of 538,100 in the Kingston-Saint Andrew region, is Jamaica's capital and main commercial center. It was founded in 1692, after an earthquake destroyed nearby Port Royal. In the 1700s, Kingston served as an important trade center for goods and slaves and became the capital in 1872. As well as government offices and services such as banks, Kingston has a busy port. Other facilities include a large sports stadium, theater, national art gallery, library, parks, and several university campuses. Its slums are notorious for their high crime levels. Suburban Portmore, a sprawling residential area of about 94,000 on the west side of Kingston Harbour, is connected to the city by a causeway (a raised road across water and wetlands).

Founded in 1523, Spanish Town was originally known as Villa de la Vega (the town on the plain). It was the colonial capital before Kingston, but many of its grand old buildings are deteriorating, and few tourists venture to the site. Located on the Rio Cobre, it is the country's second largest urban area and is home to about 110,400. Industries include the processing of agricultural products such as bananas, sugarcane, coffee beans, and citrus fruit.

When Christopher Columbus anchored in Montego Bay on the northern coast in 1494, he found a village that the Taino people inhabited. The Spanish established their settlement about 1655, and the community grew slowly through the early 1700s. Sugarcane was

Kingston, the capital city, has had many close calls with disaster. Its coastal location makes it a target for many hurricanes, but it has also suffered much earthquake damage. For links to websites about Jamaica's cities, regions, weather, and plants and animals, visit www.vgsbooks.com.

planted in the region, and Montego Bay's port brought slaves and supplies. After a slave rebellion in 1831–1832, the town declined. It was developed as a tourist center after 1900. Nicknamed MoBay, it is a busy tourist center, port, and center for light industry, with a population of 82,000.

Other smaller but significant towns include May Pen (population 46,000), a commercial center and market city for the surrounding farmland. Local industries include citrus fruit canning. Mandeville sits on a plateau in south central Jamaica. Founded in 1816, it prospered as a pleasant retreat for wealthy planters and others who could not stand the heat and humidity of the plains. The surrounding farmland supports cattle farming and the growing of pimento, citrus, and coffee beans. Bauxite is mined nearby. The city of 40,000 is home to many North Americans employed in the bauxite industry, as well as Jamaicans who have retired to their homeland.

HISTORY AND GOVERNMENT

The first people to live on the island of Jamaica were the Tainos. They originated in South America and slowly migrated north by canoe, settling on the islands of the Caribbean. The Taino lived in villages of thatched huts near the rivers and coasts of Jamaica. They ate seafood, birds, and turtles, and cultivated cassava (a tropical root crop) and maize (corn). They wove cotton into cloth and made pottery and jewelry fashioned from gold, bone, and shells. For enjoyment, the Tainos played a ball game on rectangular courts found in every village.

Two waves of Tainos settled in Jamaica. The first arrived about A.D. 650 and the second about 800. Experts estimate that as many as 500,000 Tainos lived in Jamaica when Christopher Columbus arrived.

Columbus landed at Discovery Bay during his second voyage to the New World in 1494. His men went ashore and, finding the Tainos hostile, killed and wounded several of them.

Finally, the native people agreed to trade and provide food. Columbus claimed the island for Spain and, after sailing around it,

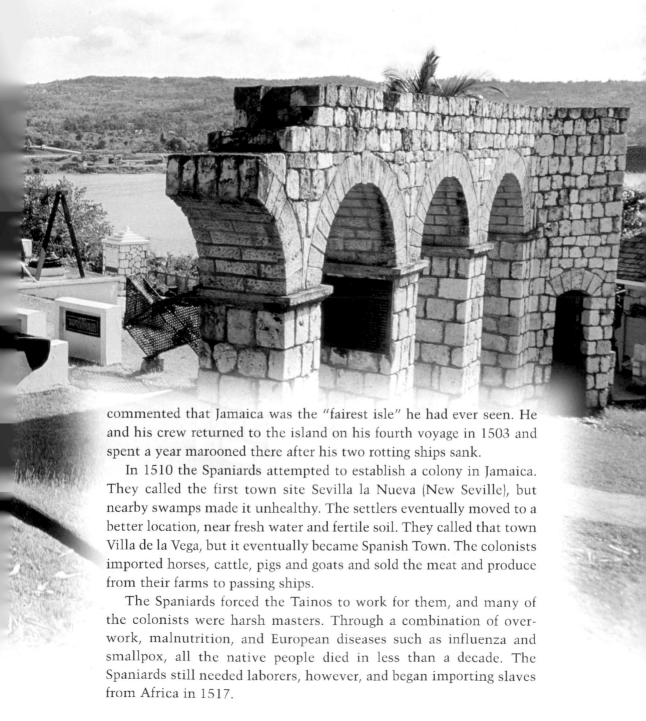

commented that Jamaica was the "fairest isle" he had ever seen. He and his crew returned to the island on his fourth voyage in 1503 and spent a year marooned there after his two rotting ships sank.

In 1510 the Spaniards attempted to establish a colony in Jamaica. They called the first town site Sevilla la Nueva (New Seville), but nearby swamps made it unhealthy. The settlers eventually moved to a better location, near fresh water and fertile soil. They called that town Villa de la Vega, but it eventually became Spanish Town. The colonists imported horses, cattle, pigs and goats and sold the meat and produce from their farms to passing ships.

The Spaniards forced the Tainos to work for them, and many of the colonists were harsh masters. Through a combination of over-work, malnutrition, and European diseases such as influenza and smallpox, all the native people died in less than a decade. The Spaniards still needed laborers, however, and began importing slaves from Africa in 1517.

The Spanish Colony

Jamaica, as a Spanish colony for about 150 years, was never more than an isolated supply station. The heart of the Spanish Empire was in gold- and silver-rich Mexico and Peru, and the Spanish government showed little interest in Jamaica. Most of the white colonists coming from Spain moved to Mexico, and in 1570 Jamaica's population totaled about 300 whites and 1,000 slaves.

The white settlers, most of whom were poor, killed wild cattle, pigs, and goats and exported the hides and fat to Cuba and the North American mainland. The settlers grew fruit, cotton, tobacco, and sugar for their own use and sold fresh food products to passing ships.

Pirates were a fact of life from the beginning of the Spanish colonies. For protection against pirate attacks, all the ships carrying gold and silver from the Americas to Spain traveled together in convoys (groups) once a year. The convoy system helped merchant guilds—associations of merchants that worked to advance their own business interests—to control and monopolize trade to the West Indies. As a result, European goods imported to the islands were very expensive, and the system held back economic development in Jamaica.

Meanwhile, beginning in the 1620s, European powers established other settlements in the West Indies, including the English in Barbados, the French in Guadeloupe, and the Dutch in Curaçao. Competition for control of these islands added to existing international tensions, as northern European countries became allies against Spain.

England wanted to end Spain's monopoly over trade and reduce its power. In 1653 the English organized a fleet of thirty-eight ships and ordered them to attack Santo Domingo, the capital of Hispaniola. After Santo Domingo's forces fended them off, the raiders attacked Jamaica, easily capturing Villa de la Vega in 1655. By the time the English soldiers marched into the town, the inhabitants and their slaves had escaped. Nevertheless, the invaders destroyed most of the buildings. From then on, the English controlled the island.

England encouraged planters, merchants, traders, and others to go to Jamaica. Approximately 12,000 English settlers arrived during the colony's first six years, but so many died of tropical diseases such as malaria and yellow fever that the population fell to 3,470 in 1661.

Despite these setbacks, England maintained its interest in Jamaica, creating a constitution that provided for courts of law and a local government based on the English model. England appointed a governor and council, and Jamaicans elected an assembly. The assembly had the powers to collect taxes and make laws regulating property and slavery. No blacks or Jamaicans of mixed race (called coloured, or mulattoes, by white settlers and the government) could vote.

Spain officially handed Jamaica over to the English in 1670. By then all the Spanish colonists had left, and little remained of Spanish influence except for some place names.

Buccaneers and Privateers

Until the end of the 1600s, Jamaica was a haven for buccaneers, or Caribbean-based pirates. Port Royal, at the entrance to Kingston Harbour, had so many bars and brothels (houses of prostitution) that people called it the wealthiest and wickedest city in the world. It was also a market center, ship repair station, and slave trade port.

During this period, England, France, Spain, and the Netherlands fought a series of wars to control colonies and world trade. In this atmosphere, piracy flourished. The warring nations even hired buccaneers to fight for them. Buccaneers working for a government were called privateers. In the 1660s, the governor of Jamaica hired privateers from Port Royal to attack Dutch settlements in the West Indies.

Buccaneers operated out of Port Royal until the early 1680s, when the Jamaican assembly began to enforce laws against piracy. Port Royal's infamous role finally ended in 1692, when half the town sank under the sea during a violent earthquake, killing a quarter of the population of 8,000. A new town, Kingston, was founded across the harbor.

WHITE MAN'S GRAVEYARD

From the 1600s through the mid-1800s, the Caribbean was known as the white man's graveyard because so many healthy young settlers and soldiers died there. The two biggest killers were malaria and yellow fever, both diseases transmitted by mosquitoes breeding in stagnant water. Because these diseases occur in West Africa, the African slaves had greater immunity to them.

The death toll in Jamaica was particularly high during the first years of British settlement, as well as between 1817 and 1836, when an average of 12 percent of soldiers stationed there died each year. The situation improved in the 1840s, when people began using quinine to treat malaria. Later, people realized the importance of controlling the mosquitoes that cause yellow fever. By 1871 Kingston had filtered water carried through pipes, and sewer pipes had been installed by the turn of the century. By the 1890s, people began to visit Jamaica to benefit their health.

Slavery in Jamaica

In the first half of the 1700s, disputes often arose between the Jamaican assembly and the British government. (England joined with

Scotland and Wales to become Great Britain in 1707.) In addition, the island suffered epidemics, a devastating hurricane, troubles with runaway slaves, and ongoing pirate attacks in Caribbean waters.

Nevertheless, after a 1713 treaty brought peace to Europe, the island's sugarcane plantations prospered. Many of the plantation owners became extremely wealthy and lived in luxury in Britain while managers ran the plantations. Sugarcane was by far the most important Jamaican crop, but some coffee trees were planted there in 1728. A deep blue dye obtained from logwood trees was also exported to color the robes of the aristocracy.

Cultivating sugarcane requires a lot of hard work, however. Forced white laborers (usually political prisoners or people who were sentenced to work in Jamaica because they could not repay their debts) could not stand the tropical climate, so the plantations depended on black slaves to plant and harvest the cane. By the eighteenth century, Jamaica had become a slave-based society, with slaves from Africa outnumbering their white masters seven to one.

The slave trade and the sugar trade were linked in a complex economic system. Ships took trade goods from Europe to Africa to exchange for slaves, then took the slaves to the Americas, and then returned to Europe filled with sugar.

SATISFYING EUROPE'S SWEET TOOTH

Jamaica's rising prosperity, especially in the 1700s, came from Europe's increasingly sweet tooth. The per capita consumption of sugar in Europe increased steadily from 1550 to 1950, as people drank more sweetened tea, coffee, and cocoa and ate more jam and candy. Jamaica was the second biggest sugar-producing island of the West Indies, after Saint Domingue (Haiti). After 1840 other sources of sweeteners came on the market, and prices and profits fell.

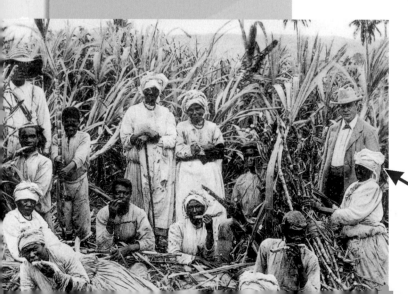

As Europe's demand for sugar grew, so did the demand for **slave labor** to work Jamaica's many sugarcane fields.

The life of a plantation slave was brutal and often short. Harsh masters used physical punishment for small mistakes, and slaves did the same heavy labor, day after day. They cleared the land, planted the cane, weeded and harvested it, then crushed the cut cane, and boiled it until it formed sugar crystals. Many slaves were essentially worked to death.

British West Indian colonies had the power to make their own laws regulating slavery, and the laws in Jamaica were particularly harsh. The planters could do what they liked with their slaves. Furthermore, slaves had little chance of becoming free in Jamaica, and many desperate individuals tried to run away.

Slaves were expected to build their own mud and straw houses, to tend gardens to feed themselves, and even to make their own clothes. Because of malnutrition and overwork, most slaves were unable to produce healthy children. Many died of hunger or disease. As a result, the island constantly needed more slaves from Africa. During the more than 250 years of the slave trade, almost 750,000 slaves were brought to Jamaica.

All the West Indian colonies experienced occasional slave revolts, when slaves killed their owners and destroyed property. But in the eighteenth century, Jamaica experienced more rebellions than all the other colonies put together and with greater numbers of slaves participating in revolts. Also, in the remote interior, the population of former slaves, known as Maroons, was growing. The Maroons built well-hidden settlements, one in Cockpit Country, the other in the Blue Mountains.

The slaves who arrived in Jamaica came from West Africa and were often captives of wars between various African ethnic groups. They were sold to slave traders who arranged their passage to North America, the West Indies, and Brazil. Many did not survive the two- or three-month voyage, dying of smallpox, diarrhea, or scurvy (caused by a lack of vitamin C). Before 1700 about 20 percent of slaves died during the trip, but after the mid-1700s, travel conditions and the survival rate improved.

The runaways began a guerrilla warfare campaign known as the First Maroon War in the 1730s. They launched swift night attacks on the plantations, set cane fields on fire, stole cattle, then disappeared into the hills. Finally, a party of British soldiers destroyed their stronghold at Nanny Town, in the Blue Mountains, in 1734.

By then the slaves outnumbered the colonists by fourteen to one. Afraid that an even bigger slave revolt might occur, the colonists

decided to make the Maroons a good offer. In 1738 Cudjoe, an escaped slave and the leader of the Cockpit Country Maroons, signed a peace treaty with the governor. The agreement gave the Maroons freedom, 1,500 acres (607 hectares) of land, and the power to govern themselves. In return, the Maroons agreed to stop their attacks and to return runaway slaves to the settlers. The next year, a similar treaty was signed with the Maroons in the Blue Mountains.

Slave revolts continued, however. In 1760 a serious slave revolt broke out in the north and spread across the island. The rebels wanted to kill all white people and organize Jamaica as a West African society. Named for its slave leader, Tacky's Rebellion resulted in the deaths of about sixty white people and five hundred blacks. Tacky was killed by a Maroon sharpshooter (the Maroons were obliged by the treaty to help crush the rebellion), but the revolt was not contained for more than a year.

Other slave uprisings occurred in the 1760s and 1770s, and in 1795 a Second Maroon War took place. Worried that the Maroons of Cockpit Country posed a threat, the government attacked them with troops and tracking dogs. Almost six hundred Maroons surrendered and were exiled to Nova Scotia, Canada. Unhappy there, they moved to Sierra Leone, Africa, in 1800.

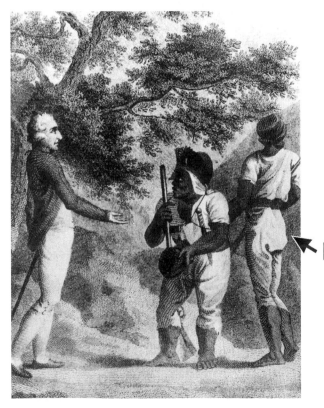

Cudjoe meets with an emissary of the British government in 1738. The peace treaties that followed granted the Maroons 1,500 acres (607 hectares) of land and made Cudjoe and his successors chief of Trelawny Town.

Maroons lie in ambush during the Second Maroon War. For links to more information about the Maroons and the Maroon wars, visit www.vgsbooks.com.

By the turn of the century, many Jamaican slaves lived in better conditions than they had one hundred years before. Slaves did a wide variety of jobs as household servants, on the docks and in town shops, as fishers, cooks, carpenters, and skilled craftspeople. Some slaves grew and sold vegetables and eventually bought freedom, while other owners freed their slaves.

Abolition of Slavery

By the 1800s, antislavery movements were growing in Britain and other parts of Europe. In 1808 the British government made it illegal to import slaves into British colonies. Still, it did not want to force emancipation (freedom for the slaves) on its colonies, and it tried unsuccessfully to make the Jamaican assembly pass laws to improve working and living conditions for slaves.

Finally, a rebellion in Jamaica helped to end slavery. Just after Christmas in 1831, Samuel Sharpe, an educated slave and preacher, led an uprising of sixty thousand slaves. More than two hundred sugar estates were damaged, and many white people fled to coastal towns. After the Christmas Rebellion, the authorities severely punished the participants. Sharpe was hanged, and many black churches were destroyed.

After hearing of the rebellion and its harsh suppression, the British government passed the Abolition Act in 1833, to take effect in all its colonies the next year. In some colonies, slaves were freed immediately, but in Jamaica, plantation workers had to work forty hours a week for

THE CHURCH'S ROLE IN ENDING SLAVERY

The Church of England, or Anglican Church, to which most of the British settlers belonged, was not interested in converting Jamaica's slaves to Christianity. But after 1754, Moravian, Methodist, and Baptist missionaries from Europe converted many of them. By the 1820s, slaves were allowed to attend church on Sundays. This meant that they had a gathering place where they could also discuss politics, and black preachers (some of whom were former slaves) became community leaders. Meanwhile, church leaders in Europe and missionaries in the West Indies actively supported the antislavery movement.

their former masters without pay until 1840. Antislavery activists in Britain continued to pressure the government, and finally, their tactics worked. On August 1, 1838, two years ahead of schedule, 311,000 Jamaican slaves became completely free. On that morning, most of them went to church to give thanks and celebrate.

Jamaican society and economy had been based on slavery, so emancipation (freedom) had an enormous impact. No one had planned for it. The colony suddenly needed to build schools and hospitals and create new public services for a majority of its citizens. Meanwhile, rather than pay rent to their former masters, most former slaves left their homes on the plantations and established new villages in the island's interior.

Cane exports immediately declined by 50 percent. Most former slaves refused to do the backbreaking labor they hated, or they demanded extremely high wages. At the same time, sugar prices dropped. Cheap sugar was available from Cuba and other countries where slave labor was still legal and where sugar made from European-grown sugar beets came on the market. By the mid-1800s, about a third of Jamaica's plantation owners had abandoned their estates. The Jamaican coffee industry also collapsed when labor became scarce and foreign competition increased.

The economic decline meant that black farmers had to scrape by, living on whatever they could grow on their small properties, and they suffered from hunger and disease. Things improved in the latter half of the nineteenth century, when bananas became a successful export crop and provided an income for many small farmers.

Meanwhile, new immigrant workers came to Jamaica after emancipation, hoping to find jobs on the plantations and elsewhere. During the nineteenth century, about thirty-three thousand people arrived from India. Nearly five thousand Chinese came in the second half of the century.

In 1865 the Morant Bay Rebellion led to changes in the Jamaican government. When the local court unjustly found a black man guilty of assault, a riot broke out in the Morant Bay marketplace, east of Kingston. When police tried to arrest Paul Bogle, whom they accused of starting the riot, Bogle's armed supporters drove them away. Several days later, Bogle and about four hundred armed men attacked the police station and burned the courthouse, killing about fifteen people. Maroons captured and executed Bogle. British troops quickly ended the rebellion, but for weeks they continued to beat or shoot the rebels and to destroy their homes.

On the same day Bogle died, a popular community leader and businessman, George William Gordon, was arrested. The son of a black slave woman and her white master, Gordon sympathized with the rebels, but he had not been present at the rebellion. The authorities gave him a quick and unfair trial and put him to death.

The British were upset when they heard how harshly the government had dealt with the rebels. The governor was fired. But before leaving, the governor persuaded the assembly to give up its two-hundred-year-old system of elected government. Jamaica became a Crown Colony. A British governor and the members of a legislature that the British chose ran the colony.

The governor of the Crown Colony had broad powers, and in the next decade, many public services improved. The justice system was reorganized, and a modern police force formed. Free medical services were introduced, and water supplies improved. Roads, railways, and communications services were built, and the number of elementary schools on the island doubled. In 1872 the capital was moved to Kingston.

Around 1871 American fruit shipper **Lorenzo Dow Baker made Port Antonio** the "banana capital of the world" and a wealthy town. (Almost a century later, the sight of workers called tallymen loading bananas inspired American folk singer Harry Belafonte's hit "Banana Boat Song.") In the early 1900s, Baker built Port Antonio's first hotel and began bringing visitors from the United States.

The Twentieth Century

At the beginning of the twentieth century, Britain was more interested in its newer, more profitable colonies in Africa and Asia than in its possessions in the West Indies. The once-thriving sugar industry had shrunk, and most Jamaicans were poor and uneducated. Nevertheless, Jamaica began a long process to self-government.

In 1907, the century started ominously with an earthquake that destroyed much of Kingston. Less than a decade later, eleven thousand Jamaicans fought proudly as members of the British West Indies Regiment in France, Italy, and the Middle East during World War I (1914–1918).

During the 1920s, resentment of the Crown Colony government grew, especially among Jamaicans of mixed racial background. Many of them were professionals, educated at British universities, and they believed that Jamaicans were qualified to manage their own affairs.

The Jamaican economy suffered badly during the worldwide economic depression of the 1930s. The prices of its exports fell, and unemployment rose. Throughout the Caribbean, bitterness grew. Violence in Trinidad and Barbados spread to Jamaica in 1938, when strikes by sugar workers and Kingston laborers resulted in riots and forty-six deaths.

When one of the strike organizers, Alexander Bustamente, was arrested, his distant cousin, lawyer Norman Manley, represented him. Bustamente then founded the Bustamente Industrial Trade Union (BITU) to represent the interests of Jamaican workers.

The budding labor movement was closely associated with politics. Bustamente and Manley formed the People's National Party (PNP) in 1938

Sir Alexander Bustamente was one of Jamaica's important political leaders. He was declared a national hero on October 20, 1996, the first National Hero Day.

to be the political wing of the BITU. The PNP favored increased welfare payments and the nationalization (state ownership) of major industries.

Bustamente was jailed again, making him an even bigger hero. But he and Manley had a serious disagreement, so Bustamente formed his own political party, the Jamaica Labour Party (JLP), in 1943. (These two men and their parties would dominate Jamaican politics for decades.)

About then the British government set up a royal commission, headed by an official named Lord Moyne, to find out what was behind the unrest in the West Indies. Moyne's report recommended that Britain's Caribbean colonies move toward self-government and that all citizens should have the right to vote (at this point, only people who owned land could vote). But before that happened, World War II (1939–1945) interrupted. Jamaica became a naval base and source of food for Britain and its allies, and many Jamaicans served in the British armed forces.

In 1944 Britain granted Jamaica a new constitution and universal suffrage. The new legislature had two houses, one elected and the other appointed, but an appointed governor headed the government. The constitution was changed several times over the next fifteen years as Jamaicans took on greater responsibilities.

The country also progressed economically. During the war years, a Jamaican businessman discovered that the soil on his property contained large amounts of bauxite. Three North American aluminum companies bought land, and the first bauxite mine opened several years later. Jamaica soon became the world's largest bauxite producer.

Following World War II, many of Britain's colonies in Africa and Asia gained independence. The British government was willing to give its West Indian colonies self-government but said the islands were not large enough to be independent countries and should form a federation (union).

They did so reluctantly in 1958. The West Indies Federation included Jamaica, Trinidad and Tobago, Barbados, Grenada, Saint Kitts-Nevis, Anguilla, Antigua and Barbuda, Saint Lucia, Saint Vincent and the Grenadines, Dominica, and Montserrat.

Soon disagreements and rivalries boiled over between the federation members. In 1961 Jamaicans voted in a referendum to withdraw from the group, and Britain dissolved the federation completely. On August 6, 1962, Jamaica became an independent nation.

Independence

Elections in 1962 placed the JLP in power. Bustamente became independent Jamaica's first prime minister, but his health declined, and he retired in 1965. He was replaced by JLP members Donald Sangster—who died in office in 1967—and then Hugh Shearer.

During Jamaica's first years of independence, the island became a popular tourist destination, as new and better airplanes made travel fast and easy. The island's musicians also started to make names for themselves, especially reggae singer Bob Marley, who caught the world's attention with hit songs in the 1960s. A global economic upswing helped the bauxite and sugar trade, but these industries did not provide enough well-paying jobs to sustain a strong economy. In the 1970s, another economic slump dropped the average income in Jamaica by one-third.

Michael Manley, who had succeeded his father as leader of the PNP, won the 1972 election. Two years later, he adopted a program of socialist policies, including state ownership of major industries,

NATIONAL HEROES

The Jamaican government wanted to instill pride in its long struggle against slavery and toward independence. In 1965 the government named the country's first national heroes. Their statues stand in National Heroes Park in Kingston, and they are honored on National Heroes Day each October. They include the political leaders who helped achieve independence, Alexander Bustamente and Norman Manley; Paul Bogle, who led the Morant Bay Rebellion; George William Gordon, who was hung for his alleged role in that event. Two more heroes were announced in 1975. Sam Sharpe was leader of the 1831 Christmas Rebellion, and Nanny was the legendary leader of the Windward Maroons. (No definitive historical evidence exists that she was a real person.)

Edna Manley—Norman Manley's wife and Michael Manley's mother—created this statue, which rests in National Heroes Park.

larger taxes on the bauxite industry, and an extensive program to build houses and provide free education. He also developed closer ties with nearby Communist Cuba, a move that alarmed the anti-Communist United States.

Edward Seaga, who had become the leader of the JLP, strongly opposed these policies. Violence erupted between the followers of the two parties in the months leading up to the 1976 election. More than one hundred people died in shoot-outs, bombings, arson attacks, and reprisals during the campaign.

Both parties armed their supporters and hired members of criminal gangs to ensure that everyone in a particular neighborhood voted for their party. Those who didn't were often persecuted, forced out of their homes, or killed. In Kingston, people erected barriers in the streets leading to their neighborhoods to stop drive-by shootings. Such neighborhoods became known as "garrison communities." In June, Manley announced a state of emergency, giving police special powers to control the violence. Six months later, the PNP scored a huge electoral victory.

But solving the country's financial problems was no easier in Manley's second term. Tourism and bauxite production did not support enough jobs to create a strong economy, and the government had amassed huge debts to pay for its socialist programs. The Jamaican government could not afford to repay its lenders.

Manley turned to the International Monetary Fund (IMF) and the World Bank, international organizations that promote economic development and provide financial assistance to developing countries. They agreed to help Jamaica if the government cut spending. Manley froze wages and reduced programs that helped the poor. But when widespread demonstrations took place to protest the cutbacks, he canceled them and announced Jamaica would not depend on the IMF.

Manley called an election for 1980, and political violence grew once again. During the months leading up to the vote, about eight hundred people were killed. The JLP swept to power on promises that it would attract international business investment to boost the economy. Seaga's government broke off diplomatic ties with Cuba and reversed the PNP's socialist programs. This move improved relations with the United States, which began to give considerable economic aid to Jamaica.

Jamaica's ties to the United States grew stronger during the 1980s, when the U.S. and Jamaican governments established a joint program to try to destroy Jamaica's flourishing ganja (marijuana) trade. By then Jamaican-grown ganja had became the country's biggest export crop, bringing more than $1 billion to the economy. Most was smuggled into the United States.

In 1983 several Caribbean nations, including Jamaica, asked the United States for assistance when rebel soldiers overthrew the government of the nearby island of Grenada and killed the prime minister. U.S. forces led a successful invasion of Grenada, and the Jamaican government strongly approved of this military action.

Soon after, Seaga called a snap election, giving only four days for candidates to be nominated. The PNP boycotted the vote, protesting that the lists of voters were incomplete, and the JLP won all sixty seats.

Still, Seaga's government made little progress against Jamaica's chronic poverty, violence, and unemployment. A worldwide economic recession during the 1980s hurt the bauxite industry. Then, in 1988, Hurricane Gilbert, the worst hurricane in the island's recorded history, devastated the country. More than 100,000 homes, as well as the agriculture industry, tourist facilities, and roads, were destroyed.

The 1989 election was relatively peaceful, and the PNP returned to power. The government looked to private business to support economic growth and sold hotels, sugar plantations, factories, banks, and other government-owned properties to private investors. In 1992 Manley retired for health reasons, and lawyer Percival "P. J." Patterson became prime minister. But the economy still lagged, and Jamaica's gross domestic product per capita (the average amount of money earned by each citizen in a year) in 1995 was only U.S. $1,510, slightly more than that of Dominican Republic but far less than Trinidad and Tobago or Barbados.

Elected prime minister in 1992, **P. J. Patterson** has held political office in Jamaica since 1967, when he was nominated to the Senate.

Drugs and Violence

Despite the joint U.S-Jamaican efforts against the ganja trade, by the mid-1990s, Jamaica remained the Caribbean's largest marijuana producer. It also became a shipment point for cocaine from South America en route to North America and Britain. The gang rivalries that were once purely political became linked to drug trafficking. In 1997 the Jamaican government agreed to allow U.S. drug enforcement agents to pursue suspected traffickers into its waters and airspace.

Meanwhile, the Jamaican government's financial difficulties continued. In 1999 Patterson's government introduced a large tax on gasoline to raise money for improved roads and public transportation. The resulting protests led to eight deaths and the burning and looting of many businesses. The government cut the fuel hike in half. Later that year, the level of drug-related criminal activity in the streets of Kingston became so serious that the government ordered the army into the streets to restore order.

Violence made headlines again in 2001 when 1,139 Jamaicans died violent deaths—many from gang-related murders. In the worst incident, 28 people, including police officers and children, died when police and soldiers, using helicopter gunships and tanks, tried to stop fighting between heavily armed gang members.

Jamaica's role in the drug trade remains central to the violence. In 2001 an estimated 100 tons (91 metric tons) of cocaine passed through the island on its way to markets in the United States and Britain. To try to control drug trafficking, scanning machines were installed at airports and special security forces were trained in drug enforcement. But these developments have done little to slow the drug trade and the violence that follows with it.

During the 2002 general election, Patterson and Seaga signed an agreement urging their supporters to refrain from violence during the campaign. Although international observers assessed the vote was fair, more than fifty people were killed in the final two weeks before the vote.

POLICE FORCE

A recent United Nations report on human rights in Jamaica determined that some police use excessive force in controlling crime. They fire their guns indiscriminately, killing innocent bystanders. One Jamaican civil rights group says police kill about 140 people every year. Many of these activities go unpunished, the report said, adding that witnesses are often afraid to testify against the police. As a result, many Jamaicans have no confidence in the justice system.

This commercial property was shot up and **covered in graffiti** during the heated elections of 2002.

Following the election, Prime Minister Patterson announced a major anticrime program. The police and military worked together to disarm criminal gangs and to dismantle their activities. But drug- and gang-related violence remains one of Jamaica's biggest challenges. The summer of 2004 was one of the most violent periods in Jamaican history, with forty-seven murders in a single week in August.

That same month, Hurricane Charley added to the country's difficulties, causing hundreds of millions of dollars in damage, mostly to agricultural lands. Charley was followed a month later by an even more devastating hurricane, Ivan. These continuing troubles have made it difficult for the government to deliver on its promises to reduce poverty, to renew the inner cities, and to provide affordable housing for all Jamaicans.

⦿ Government

Jamaica's constitution provides for a sixty-member House of Representatives, elected every five years by all citizens ages eighteen and over. The party winning the most seats forms the government, and its leader becomes the prime minister. The queen of Britain is the official head of state, but this is largely a symbolic position.

Visit www.vgsbooks.com for links to websites with additional information about Jamaica's government and history, including slavery, the independence movement, National Heroes Park, and more.

The governor-general (the queen's representative), the prime minister, and the leader of the opposition appoint the twenty-one-member Senate. The courts are independent of the government, with the Court of Appeal being the highest in the land.

Many Jamaicans would like their country to drop the queen as head of state and become a republic, with a president as head of state. The government is debating this and other constitutional changes.

Jamaica is officially divided into three counties: Surrey, Middlesex, and Cornwall. They are of little relevance, however. Most rural Jamaicans think of themselves as residents of one of the fourteen parishes. Local governments and services are organized by parish. In the east are the parishes of Saint Andrew, Saint Thomas, and Portland. In the central region are Saint Catherine, Clarendon, Manchester, Saint Mary, and Saint Ann. Saint Elizabeth, Westmoreland, Trelawny, Saint James, and Hanover parishes are at the western end of the island. Local government is administered jointly in Kingston and Saint Andrew. Voters elect councillors to administer the parishes.

THE PEOPLE

Jamaica's national motto, "Out of Many, One People," reflects Jamaica's diverse racial and ethnic backgrounds. The modern mixture includes Africans, Europeans, East Indians, Chinese, and peoples from the Middle East.

People of black African origin make up 91 percent of the population. Their ancestors belonged to many ethnic groups in West Africa, including the Ibo, Dahomey, Yoruba, and Ashanti peoples.

The next largest group, representing 7 percent of the population, is of mixed ethnic background. People of mixed race are often called coloureds or mulattoes. Some blacks have green eyes and light hair that they attribute to Scottish seamen who were stranded on the coast in the 1800s. Many other Jamaicans trace their mixed ancestry to white plantation owners and managers who fathered the children of black slave women.

Whites make up less than 1 percent of the population. Some descend from British families that owned or managed plantations in

colonial times. Some Irish, Welsh, and Scots who arrived as laborers never prospered, and many of their descendants remain poor. Jamaica also has a small community of families of German descent.

The East Indian community—many of them Hindus from northern India—represents 1 percent of the population. Indians first came to Jamaica as indentured laborers (required to work for a certain amount of time to pay for their travel expenses) after the black slaves were freed. Most live in Kingston or other cities.

The Chinese also represent less than 1 percent of Jamaicans. Like the East Indians, they came as indentured laborers after the slave era. Yet more than thirty thousand of them left Jamaica and moved primarily to the United States in the 1970s to escape the political turmoil of the time. Many remaining Chinese Jamaicans live in urban areas, where they run businesses or restaurants.

Jamaicans call people from the Middle East Syrians. Many of them actually have roots in Lebanon, and they make up Jamaica's newest

SHADISM

While Jamaicans claim to be proud of the racial mix of their nation, they are also very aware of each person's racial background. Shadism, or discrimination on the basis of skin color, is common. Some people call Jamaican society a "pigmentocracy" because lighter pigmented skin is associated with privilege and prosperity, while those who are very dark skinned often find it more difficult to climb the social ladder. This attitude goes back to when the children of black slave women and white fathers had more opportunities than those of purely African blood. To lighten their skin, some women bleach it with creams and chemicals.

ethnic minority. They arrived in the early 1900s to work as merchants or in the garment industry. The so-called Syrians include a small group of Jews who came to the island in the twentieth century to join the remnants of a Jewish community that began in the 1500s, when Jews from Spain and Portugal came here to escape religious persecution.

◉ Population Trends

Jamaica's population in 2004 was approximately 2.7 million. Many Jamaicans have moved to the United States, Canada, and Britain. This has helped to check population growth on the island. Nevertheless, the number of people living in Jamaica is expected to increase by 46 percent between 2002 and 2050, when it could reach 3.8 million. Each Jamaican woman gives birth to an average of 2.4 children. The population is equally urban and rural.

Jamaicans are young, with 31 percent under the age of 15, and only 7 percent over the age of 65. Life expectancy averages 75 years—men can expect to live to the age of 73, women to 77.

Poverty is widespread in Jamaica, with a large income gap between the wealthy few and the many poor. The good news is that poverty declined steadily in the last decade of the twentieth century, from 30 percent in 1989 to 17 percent in 2001. In most countries, women and female-headed households are usually poorer than those headed by men. In Jamaica the number living below the poverty line is an even split between men and women. This is probably because more girls than boys complete higher education.

Kingston has vast slums, although the government has promised to undertake urban renewal projects to improve housing. But the incidence of poverty is even greater in the countryside than in the cities. About 10 percent of people in the Kingston area and 12 percent of residents of other towns live in poverty, compared with 22 percent of rural residents.

A mother and her child walk through a **slum** in Kingston. To learn more about Jamaica's diverse population, visit www.vgsbooks.com

The Jamaican government has a number of programs to support the needy. A food stamps program provides coupons that can be exchanged for groceries for pregnant women, young children, the elderly, and the disabled. Schools also offer meal programs.

Education

Education is free in public schools and compulsory (required) up to the age of eleven. Enrollment in preprimary schools and primary schools is 91 percent and 99 percent, respectively. Children begin primary school at the age of six.

The secondary school system includes three years of junior secondary school and four years of secondary school. The most recent data shows that 67 percent of girls and 63 percent of boys were enrolled in secondary school. Many children from poor families drop out after primary school because they have to work. They often end up doing odd jobs, such as washing windshields on street corners or helping their self-employed parents at their jobs.

The government has struggled to provide enough funding for the education system. Teachers and secondary schools have a reputation for providing a good education, despite crowded classrooms and run-down facilities. Local churches also run schools, and private schools exist for those who can afford them.

Community colleges, vocational training centers, and teacher training colleges are located across the island. The University of the West Indies

has campuses in Jamaica, Barbados, and Trinidad and Tobago. Other post-secondary institutions include a college for the visual and performing arts, an agricultural college, and a college of physical education and sports. People learn computer skills at the Caribbean Institute of Technology and the University of Technology, Jamaica. Northern Caribbean University in Mandeville is associated with the Seventh-day Adventist Church.

In 2000, 91 percent of women and 83 percent of men over the age of 15 could read, but literacy statistics for young men point to a serious problem. While 6 percent of girls aged 15 to 19 are illiterate, 18 percent of boys in this age group cannot read. In 1997 Jamaica had the highest difference in literacy rates between the sexes in favor of women in the world.

▷ Health

Jamaica has twenty-four public hospitals and several hundred health clinics, but people often experience long waits for treatment. Private health care services are available to those who can afford them. Wealthy people usually go to the United States or other countries for treatment of serious conditions.

The leading causes of death in Jamaica are chronic, noncommunicable diseases, such as heart disease, diabetes, and cancer. Babies of less than a year of age are susceptible to diarrhea and respiratory illnesses. The main causes of hospitalization and death of children aged 5 to 14 are poisoning, accidents, and violence.

Criminal violence is a serious public health issue. There were 953 murders in 1998, and at a rate of 37 murders per 100,000 persons, this was five times the murder rate in the United States. In 2001, 1,139 murders were reported, equivalent to a rate of 43 per 100,000. Continuing drug- and gang-related violence in 2004 may result in a further increase in murder statistics.

Meanwhile, immunization programs against diseases such as polio, diphtheria, and measles have

TEENAGE PREGNANCY

Jamaica has one of the highest levels of teenage pregnancy in the Caribbean, with a birthrate of 108 births per 1,000 young women aged 15 to 19. While many teens say they are familiar with birth control methods, they do not use them consistently. Most pregnant girls quit school, and many do not return after the baby is born. One program that has been running through a women's center since 1978 encourages girls to continue their studies during pregnancy and return to school soon after their child is born. It offers day care for infants, classes in nutrition and parenting skills, and birth control information to help young mothers avoid a second unplanned pregnancy.

been successful. No cases of these diseases have appeared since the early 1990s. Occasional outbreaks of dengue fever—a tropical virus spread by mosquitoes—occur.

There are 120 maternal deaths per 100,000 live births, and 24 infant deaths for every 1,000 live births. That compares with 12 maternal deaths per 100,000 live births in the United States but is similar to statistics for Panama and the Dominican Republic.

Only 71 percent of Jamaicans (including 59 percent of rural residents) have access to clean drinking water sources, compared with 84 percent of all Caribbean and Latin American residents. In 1999, 84 percent of all Jamaicans had access to adequate sanitation facilities (toilets or pits), but that figure decreased to 66 percent in the countryside.

A lack of adequate housing in both urban and rural areas means that many poor families are crowded together in little shacks made of wood and corrugated metal. Hurricanes can sweep away these fragile homes and also increase the risk of waterborne diseases such as diarrhea, cholera, dysentery, and typhoid.

HIV/AIDS HIV and the deadly disease it causes, AIDS, are a growing problem in Jamaica. The Caribbean is the second most seriously affected area in the world, after sub-Saharan Africa. Jamaica has one of the highest incidences of HIV/AIDS in the Caribbean region.

In Jamaica HIV/AIDS and sexually transmitted diseases (STDs) are the second leading cause of death for both men and women in their early thirties. Two-thirds of Jamaicans wait to seek treatment until they are in the late stages of the disease when effective treatment is no longer possible. In 2000 about half of the people who were newly diagnosed died that same year.

About 80 percent of HIV/AIDS cases are transmitted through heterosexual (between a man and a woman) contact. Young women are contracting the virus that causes AIDS at an alarming rate, and an estimated 32 percent of Jamaican women ages 15 to 49 have HIV/AIDS. This happens because many teenagers tend to engage in unprotected sexual activity and have multiple partners.

In the Kingston and Montego Bay areas, one out of thirty and one out of fifty pregnant women, respectively, test positive for HIV/AIDS. The disease can be transmitted from mother to baby. The government provides free medication to infected pregnant women who give birth in public hospitals in order to reduce the risk of transmission to the baby. Nevertheless, HIV/AIDS is the second leading cause of death in Jamaican children under the age of five.

By 2002 an estimated 50,000 Jamaican children under the age of eighteen had been orphaned by the disease or had a sick parent. Since many Jamaican fathers are not involved in raising their children, grandparents, aunts, and other extended family members generally step in. Nevertheless, these children are at a higher risk of skipping school, abusing drugs, or committing suicide.

Government, the media, businesses, schools, and other organizations are trying to help prevent the spread of AIDS, but many obstacles exist. Many men believe unfounded myths—for example, that mosquito bites spread the virus—and they underestimate their risk of becoming infected in other ways. While 40 percent of women occasionally use condoms to prevent disease and pregnancy, many people do not. Another problem is that the stigma associated with the disease prevents many people from getting tested to see whether they are infected, from learning about prevention, and from seeking treatment. A further complication is that in 2002 less than 10 percent of rural Jamaican hospitals and health centers could offer confidential HIV/AIDS testing and counseling.

This poster warns Jamaicans of the risk of AIDS and what they can do to protect themselves against the virus.

The government is training more health workers to care for AIDS patients, as well as improving access to treatment for secondary infections associated with the disease. Safe sex programs are aimed at educating adolescents, young adults, and other people at high risk of contracting or spreading HIV/AIDS.

Jamaican Women

Jamaican women tend to be very independent. They have to be. In four out of ten households, they are the main breadwinners. Many women have their first baby before they are married, and their children may have different fathers. Many Jamaican men are not interested in helping with child rearing, and some do not even provide financial support. Although women learn to rely on themselves, they face many difficulties, including lack of employment opportunities, widespread domestic violence, and poverty.

Nine out of ten women are literate, and many are university-educated. Women outnumber men seven to three at the University of the West Indies. Jamaican women also outnumber men in top occupational groups—as senior officials, professionals, and technicians—although few break into political or business leadership circles. Nevertheless, many women have difficulty finding jobs. The majority of Jamaican employers pay women less than men with equivalent qualifications or do not give women positions that match their abilities.

Violence in the home is a serious problem. In 2000 more than 2,100 sexual offenses, including rape and indecent assault, were reported to police. Women who are unable to financially support themselves and their children often stay with men who physically or sexually abuse them. Several laws are in place to protect women against domestic violence.

The government set up the Bureau of Women's Affairs in 1975. It focuses on problems that affect young, elderly, and rural women, and women who work as household domestics. Still, women's rights advocates want the government to do a better job of preventing sexual crimes and of ensuring that women hold more decision-making positions in government and business. Women's rights advocates say changes are needed less in the country's legal framework than in peoples' attitudes.

CULTURAL LIFE

Each group of immigrants has contributed aspects of its own culture to Jamaican society, but British and African traditions are dominant. The British left the English language, legal and democratic traditions, and the game of cricket. African influences were renewed throughout the centuries of slavery by the steady influx of new arrivals and remain strong in stories, music, and superstitions. Music and sports are especially important in Jamaican life, and reggae music has influenced musical trends around the world.

⊙ Religion

Jamaicans claim that their island has more churches per square mile than anywhere else in the world. Every weekend, people dress in their best clothes and flock to parish churches, where they sing, shout, clap, and dance. More than 80 percent of Jamaicans are Christian, and more than one hundred denominations are active, including the Anglican Church, the Church of God, the Baptist Church, the Seventh-day

Adventists, and the Moravian Church. About 7 percent of Jamaicans—primarily Lebanese, Chinese, and East Indians—are Roman Catholic.

The Catholic and Anglican churches arrived with the Spaniards and the British, respectively. Moravians and Baptists brought Christianity to the slaves at the end of the eighteenth century. In recent years, fundamentalist and evangelical churches such as the Pentecostals have gathered new followers, spreading their message with the help of religious television stations from the United States.

Several forms of worship combine elements of Christianity and West African religions. Pocomania is uniquely Jamaican. Its followers gather around a long table, covered with a white tablecloth and bowls of white rice, white bread, and chicken. Drumming and dancing accompany prayers to the Holy Spirit, and some worshippers believe they are possessed by spirits.

Kumina is of African origin. During Kumina ceremonies, followers calm the wandering and dangerous spirits of dead people who have not

yet received the proper rites. The ceremony involves the sacrifice of a goat and frenzied drumming and dancing.

Rastafarianism became prominent in the 1950s. It has had an influence far out of proportion to its actual number of followers, primarily because some musicians incorporated its message into their music. Rastafarianism is a set of beliefs, not an organized church with a specific place of worship. Rastafarians believe that Africans are one of God's chosen people. God, whom they call Jah, will one day lead them from evil Babylon (Jamaica, where they were enslaved) to Zion, the Promised Land (Ethiopia). They consider the late Haile Selassie I, emperor of Ethiopia from 1930 to 1974, a god who will lead them back to Africa.

Rastafarians follow the moral rules of the biblical Old Testament, condemning greed, dishonesty and envy, and preaching love and non-violence. Strict followers eat a vegetarian diet and do not smoke tobacco or drink alcohol. They believe smoking ganja (marijuana) helps them communicate with God. Many people instantly recognize Rastas from their dreadlocks (long, kinky hairstyles) and knitted red, gold, and green caps.

OBEAH AND DUPPIES

Many Jamaicans, including many Christians, are strong believers in the powers of obeah, or witchcraft, a custom that stems from their West African heritage. Although obeah is technically illegal, usually an "obeah man" or "obeah woman" lives in every village. He or she uses knowledge of medicinal herbs and spells to exact revenge or to influence the outcome of a love affair, for example. When bad things occur in their lives, people sometimes blame duppies (ghosts) and turn to obeah for help to control them.

At first, middle-class Jamaicans scorned Rastafarians, and the police harassed them. But they gradually came to tolerate the movement, which is popular primarily among poor blacks.

▶ Music, Dance, and Theater

Music is undoubtedly Jamaica's greatest contribution to the world's culture. Jamaican-born reggae, popular everywhere, is just one phase of the island's distinct musical tradition.

In the 1950s, the owners of Kingston liquor stores and bars would set up huge speakers in nearby fenced-in lots (called lawns, or dance halls) where DJs played records. At first, they played American rhythm and blues, but later they began to feature songs recorded in Kingston studios. The first distinctive Jamaican style, ska

Bob Marley (1945–1981) is perhaps Jamaica's most well-known figure. His albums still sell more copies than any other reggae artist, and many Jamaicans have come to revere him as almost a religious figure.

music, has a joyous beat and lots of brass sounds. Its unique rhythm puts the emphasis on the second and fourth beats of each bar, rather than on the first and third, as in American rhythm and blues.

After the optimism accompanying Jamaica's independence in 1962 wore off, angry young people of the ghettos made their voices heard in rock steady music. Rock steady is slower than ska, and the electric bass and rhythm guitar emphasize the off beat. This musical form was at its peak from 1966 to 1968.

Then Jamaican record producers began to promote a new style—reggae. It marries rock steady with mento, folk music popular in rural areas. Reggae evolved its own beat, and many of its stars incorporated their Rastafarian beliefs into the lyrics. The reggae rebel music of the 1960s and 1970s reflected Jamaicans' social discontent in songs about black self-determination. Bob Marley took his reggae on tour to Europe, where he achieved international fame.

In the 1970s, some producers began releasing instrumental pieces on the flip side of records. Dub music evolved when DJs dubbed their own lyrics and filtered and echoed sound effects on top of the instrumentals. Later, between about 1979 and 1985, dancehall music—an energetic Caribbean rap with a mixture of horns and

PANTOMIME

The biggest theater event in Jamaica is the Pantomime, which opens every year on Boxing Day (December 26) in Kingston's famed Ward Theatre. Pantomime dates back to the British tradition of performing fairy tales, comedy, and music at Christmastime. Jamaican pantomime includes folktale characters such as Anancy, spoofs on politics, Pocomania drummers, and the rhythms of reggae. The country's best writers, designers, and performers all volunteer for this show.

basses—reigned in Jamaica. Lyrics turned from social protest to sex and drugs. Eventually, ragga music, a type of dancehall with computerized instrumentation, appeared.

Roots reggae enjoyed a renewal in the 1990s, with Bob Marley recordings and other past hits as popular as ever. Reggae is still evolving, influenced by American jazz and Cuban salsa, while ragga has influenced American hip-hop. Meanwhile, soca—a new sound that blends soul music with calypso from Trinidad—has become popular.

Two factors stimulated the development of Jamaican music. Aggressive record producers were always looking for something new to attract people to the dance halls, and the people themselves loved to dance.

Jamaica has several professional dance troupes. They perform in styles that range from African and classical to modern. The dancers, singers, and musicians of the National Dance Theatre Company explore African themes, while the L'Adaco dance company mixes folk dance with reggae and dancehall. Amateur theater groups also perform in many cities, towns, and villages. Audiences are particularly fond of comedies that make fun of daily life. Some of these plays, written by nationally known playwrights, go on tour around the island.

Art

The first Jamaican artists were the Taino people, who drew on the walls of caves. Jamaicans are still decorating walls with "yard art." Even in the ghettos, bold color is everywhere, as murals brighten the walls of public spaces.

Until about 1940, most Jamaican artists followed European art styles. Then a group of Jamaican artists and writers insisted that the Institute of Jamaica, which was supposed to encourage the arts, science, and culture, help Jamaicans develop their own style and subject matter. Jamaicans started to appreciate the paintings of self-taught "intuitive" artists such as John Dunkley. The National Gallery in Kingston displays the work of intuitive artists such as Bishop Mallica "Kapo" Reynolds and internationally known artists such as Barrington Watson and sculptor Christopher Gonzalez.

One of the most important individuals in the development of Jamaican art was British-born Edna Manley. A sculptor, she began teaching art in the 1950s and helped establish the Jamaican School of Art. It eventually became the Edna Manley College of the Visual and Performing Arts.

The National Dance Theatre Company is Jamaica's most famous dance troupe. Dressed in vivid costumes, the dancers explore African themes in their performances based on Jamaican history.

Language

English is Jamaica's official language, but in everyday life, people of all ethnic origins, rich or poor, educated or not, speak Jamaican patois. Patois has its own accent, vocabulary and grammar rules. Some of its words, such as *duppy* (ghost) and *nyam* (to eat), come from Africa. Much of Jamaican music, theater, and literature—at least the dialogue—is in patois.

The deeper in the countryside that people live, the thicker their patois accent, and even other Jamaicans may have trouble understanding them. Although English is taught in schools, uneducated people may be unable to speak standard English, although they may understand some of it.

Literature and Media

Although most Jamaicans are literate, only a minority are avid readers. But the country has a tradition of oral storytelling with roots in Africa. Anancy, a tricky spider with a knack for getting the better of much larger creatures, is a familiar character in Jamaican and West African folktales.

The first black Jamaican-born author to achieve international recognition was Claude McKay in the 1920s. Many of his novels were set in the United States, where he lived as an adult. In the mid-1950s, Roger Mais wrote about Rastafarianism and the brutality of life in Kingston's poor neighborhoods. About ten years later, Orlando Patterson's book, *Children of Sisyphus,* also set in the slums of Kingston, received international acclaim.

In the 1970s and 1980s, dub poetry became popular, as drums and reggae rhythms accompanied rhyming verses. One of the country's best-loved poets is Louise Bennett, usually known as Miss Lou. Most people enjoy her patois poems, which often speak of themes of everyday life, by listening to them on record albums rather than reading them. In recent years, several new Jamaican writers, including Margaret Cezair-Thompson, have achieved success.

Jamaica has been the backdrop for many movies, including *Island in the Sun* (1957), starring American folksinger Harry Belafonte, and *Cool Runnings* (1993), based on the story of Jamaica's 1988 Olympic bobsled team. *The Harder They Come* (1973), a low-budget film with a soundtrack by reggae star Jimmy Cliff, became a classic. It is the story of a boy who moved from a carefree home in the countryside to the tough slums of Kingston and dreamed of becoming a recording artist. Instead, he achieved fame as a "rude bwoy," or criminal. Michael Thelwell later wrote a book based on the same story.

Jamaica has three daily newspapers. Jamaican television viewers have access to Television Jamaica Limited (TVJ), formerly the Jamaica Broadcasting Corporation. The government sold it to private owners in 1997. CVM-TV is another private broadcaster. Most rural Jamaicans don't have television sets, but many enjoy listening to music and talk shows on the more than a dozen local radio stations.

Sports and Games

Jamaica has produced a long list of world-class athletes in cricket, track and field, boxing, and basketball. Athletic training starts young, as schools encourage students to participate in sports and to compete with each other for national championships every year.

Cricket, a game somewhat similar to baseball, has been the nation's favorite sport for decades. A legacy of the British, cricket is a sport Jamaicans have made their own. One of the sport's all-time greats, Panamanian-born batsman George Headley, played in Jamaica in the 1930s. Some of Jamaica's best cricketers play for the West Indies team or play professionally in Britain.

The country's professional soccer team, the Reggae Boyz, won many hearts when they qualified for the final round of the 1998 World Cup. However, they experienced a slump after that. Basketball is currently the country's fastest-growing sport. Its popularity has been boosted by professional basketball televised from the United States. A number of American basketball stars, such as Patrick Ewing, the former New York Knicks great, have family connections to Jamaica. Boxing and netball, a game somewhat similar to basketball that is primarily played by girls, are also popular.

Jamaica took part in the Olympic Games for the first time in 1948 and has been particularly successful in track and field. Forty-six of Jamaica's forty-seven medals were won in track and field. This trend

FACT AND FICTION

Jamaica has figured as the setting of many books. *White Witch of Rose Hall*, by Herbert de Lisser and published in 1929, was based on a local legend about the mistress of a plantation-era mansion who murdered several husbands. The legend was not based on fact, but the mansion does exist and is one of Jamaica's most popular tourist attractions.

British-born Ian Fleming, author of the James Bond spy novels, spent many winters in Jamaica until his death in 1964. He used Jamaican settings in five of the Bond books. More recently, American writer Russell Banks wrote about the Maroons in two of his novels, *The Book of Jamaica* and *Rule of the Bone*.

Claude Davis *(right)* of Jamaica goes up for a header against Jairo Castillo (left) of Colombia during an international soccer match.

continued through the 2004 Olympic Games in Athens, Greece, when Jamaican athletes won five medals—two gold, one silver, and two bronze—all in track and field. Sprinter Veronica Campbell became a national hero after earning three medals—gold in the women's 200-meter event, gold again as part of the women's 4 x 100-meter relay team, and bronze in the women's 100-meter event. Jamaica even fielded a bobsled team at the Olympic Winter Games in the 1980s and 1990s.

▶ Food

Jamaican food is a delicious blend of fresh, local ingredients and a variety of hot spices. Akee and saltfish is considered the national dish. It

consists of salted, dried codfish, simmered in oil with boiled akees (a type of fruit), onions, and peppers. People sometimes enjoy this dish as a Sunday breakfast treat, along with roasted breadfruit, boiled green bananas, fried plantain (similar to the banana), or bread.

Many Jamaicans eat a big breakfast. Other popular breakfast dishes include cornmeal porridge, bammy (a round flat bread made from cassava) and callalou, a leafy vegetable that resembles spinach.

RICE AND PEAS

This is a favorite everyday side dish, generally eaten with meat and vegetables. Around Christmastime, Jamaicans use small brown and green gungo peas (also known as pigeon peas or congo peas), but the rest of the year, when gungo peas are not in season, they often substitute red kidney beans. You can buy coconut milk at a West Indian specialty store.

½ cup dried gungo peas or red kidney beans

1 teaspoon oil

1 green onion (scallion), finely chopped

1 clove garlic, finely chopped

¼ teaspoon dried thyme

1 bay leaf

⅛ teaspoon salt

dash of pepper

3 cups hot water

1½ cups uncooked white rice

½ cup coconut milk or cream

1. Put the dried peas or beans to soak in a bowl of water for at least two hours. Then drain off the water.
2. In a large saucepan, heat the oil on medium. Add the onions and garlic. Sauté for several minutes until soft, keeping them moving with a spatula so they don't burn.
3. Add the peas (or beans), thyme, bay leaf, salt, pepper, and half the hot water. Turn up the heat to high until the water starts to boil. Cook on low for at least an hour, until the peas are nearly cooked. (The gungo peas will start to break open when they are done.)
4. Add the rice, the remaining water, and the coconut milk. Bring to a boil. Cook on low for about 20 minutes, until the rice is cooked and the water has been absorbed. If the water is gone before the rice is tender, add ½ cup more water as often as needed.

Serves 4 to 8

AKEES

Akees (above) are the fruit of a tree that grows across Jamaica. Captain William Bligh brought the first akees from West Africa in 1793. (He also took Jamaican pineapples to Hawaii and transported breadfruit from the South Pacific to Jamaica.) Unripened Akees are poisonous, but when the fruit is ripe, it turns bright red and splits open to reveal black seeds and bright yellow flesh. The flesh is the only edible part.

The island is well-known for its barbecued jerk chicken, pork, or fish. The meat is seasoned with a mixture of lime juice, hot peppers, pimento berries, and other spices and is then barbecued. The recipe dates back to the Maroons, who cooked the meat of wild pigs over slowly burning pimento-wood fires in pits in the ground. In modern times, street vendors grill jerk over fires in halved metal oil drums.

Fresh shrimp and fish are sometimes boiled in coconut milk or seasoned, fried, and marinated in vinegar, onions, hot peppers, and other vegetables. Most families rely on chicken as a daily source of protein, but no village wedding feast would be complete without curried goat and rice.

Many different types of fruit drinks are available. Locally brewed beers are also popular, and the island is famous for its rum, an alcoholic beverage made from sugarcane.

◉ Holidays

August is a festive month, with the country's two most significant national holidays. At midnight, drums and church bells welcome the arrival of Emancipation Day on August 1—the day their ancestors were freed from slavery in 1838. Independence Day, August 6, marks the day that Jamaica officially became an independent nation. In the preceding weeks, an arts festival, including painting, photography, and writing competitions, takes place. Independence Day events include a parade and cultural performances.

On October 18, National Heroes Day, Jamaicans hold flag-raising ceremonies and lay wreaths on monuments dedicated to national heroes such as Paul Bogle. Labour Day, observed on May 23, means volunteer work, as people clean, paint, and repair community centers, churches, and other public spaces.

For links to more information about Jamaica's cultural life, including religion, music, holidays, literature and media, and more, visit www.vgsbooks.com.

Other national holidays include New Year's Day, Ash Wednesday (the beginning of a forty-day period leading up to Easter), Good Friday, and Easter Monday.

On Christmas Day, many Jamaicans go to church, exchange gifts, and eat Christmas dinner. The next day, December 26, is Boxing Day, when families go to the beach or attend community fairs and dances.

Many other festivals are held throughout the year. Some are for local people, while others are aimed at tourists. The Accompong Maroon Festival takes place in January, while fans remember Bob Marley for a week in February. A reggae festival in July attracts thousands of tourists.

No one is certain how it got its name, but the annual John Canoe (or Jonkonnu) celebration dates from the plantation era, when groups of masked and costumed slaves would parade through the streets at Christmastime. The custom was banned for about a century as Christian churches tried to eliminate anything that recalled West African rituals. The festival was revived in 1951. Participants dress up as horses, kings, queens, and devils, while musicians accompany them with drums, banjos, and flutes.

THE ECONOMY

Despite Jamaica's resources—including beautiful beaches and scenery, agricultural land, mining, and other industries—the country's economy has struggled for several decades. In 2003 Jamaica's gross domestic product (GDP, or the value of production within the country's borders by its workers) was U.S. $10.2 billion. By comparison, Vermont, Wyoming, and Montana have the lowest GDPs among U.S. states at $18 billion each. Compared to its neighbors, Jamaica's GDP ranks below Haiti ($12.2 billion), Cuba ($31.6 billion), the Dominican Republic ($52.2 billion), and Puerto Rico ($65.3 billion).

The economy depends on several industries, such as bauxite, that are affected by the world economy. (Since bauxite is the source of aluminum used in cars, airplanes, and many other manufactured products, the market is affected by the demand for aluminum.) Jamaica also suffers when world oil prices rise, since it depends heavily on imported petroleum products. Unpredictable natural disasters such as hurricanes, floods, and drought can further disrupt the economy.

Jamaica is working hard to attract new businesses. The government has established free zones for international companies in major cities. Businesses operating in free zones benefit from not having to pay taxes and can import raw materials for manufacturing without import taxes. Foreign investment grew from U.S. $28 million in 1980 to U.S. $722 million in 2001, with money not only going into the traditional sectors such as mining and tourism but increasingly into financial services and information and communications technology.

The Service Sector

The service sector—which includes hotels, restaurants, banks, health, and educational services—is the largest part of Jamaica's economy. It contributed an estimated 70 percent of the country's GDP in 2003 and employed about 60 percent of the labor force.

In the late 1990s, tourism brought in more than U.S. $1 billion. However, the industry has suffered ups and downs since then, especially

after the September 11, 2001, terrorist attacks on the United States, which caused a sharp drop in air traffic. The tourist industry improved slightly in 2003. Three-quarters of Jamaica's tourists are from the United States.

Other service workers are employed by call centers, data entry services, and software developers that provide services for North American and European companies. The government considers the information and communications technology sector a key to Jamaica's future economic growth.

Commercial banks, including subsidiaries of North American and British banks, provide loans and other financial services to individuals and businesses, and there are a number of insurance companies. The Jamaica Stock Exchange lists about forty local companies.

▶ Industry, Manufacturing, and Trade

Industry (including mining, manufacturing, public utilities, and construction) contributed an estimated 24 percent of GDP in 2003 and employed 19 percent of the labor force. Bauxite is the backbone of Jamaican industry, but it does not provide many jobs because most of the work is done by heavy machinery. The bauxite industry accounts for more than half of Jamaica's export earnings. Limestone and other quarries supply road repair and construction projects.

BAUXITE

Aluminum is the second-most abundant metallic element on the earth's crust, after silicon, but it is always found chemically bonded with other elements. Bauxite *(right)*, which contains aluminum hydroxide and mineral impurities, is plentiful in Jamaica, and mining companies dig it out of open pits. Most of Jamaica's bauxite is refined to produce alumina (aluminum oxide) at local refineries, but some is exported without being refined. Large amounts of electricity are needed to transform alumina into aluminum. Since electricity is expensive in Jamaica, the alumina is shipped abroad for further processing.

Manufacturing industries include the processing of agricultural products such as sugarcane. Bauxite refining produces alumina. Companies refine petroleum and manufacture garments.

Jamaica's principal exports are bauxite and refined alumina, sugar, bananas, other food products, and gypsum. Its main export markets are the United States, Britain, Canada, Japan, and Norway.

The island imports consumer goods, including food and beverages, raw materials, construction materials, machinery, and equipment. The island's suppliers are in the United States, Trinidad and Tobago, Japan, Canada, and Britain. Most of Jamaica's oil comes from Venezuela.

Agriculture

Agriculture, including forestry and fishing, contributed an estimated 6 percent of GDP in 2003 and employed 21 percent of the labor force. The main cash crops are sugarcane, bananas, coffee beans, citrus fruits (mainly oranges and lemons), and cacao (the seeds that produce cocoa and chocolate). The government is also encouraging farmers to grow more vegetables, fruit, and rice to decrease the island's dependence on imported foods.

The best farmland belongs to large-scale farmers who grow cane, bananas, and other cash crops with mechanized equipment. However, the vast majority of farmers have only small plots of land and no access to loans, equipment, or education about improved farming and conservation techniques. They grow a variety of foods for domestic consumption, such as yams, cassava, peas, beans, tropical fruits, and vegetables. Few young people are interested in farming careers, however, and even many of those who attend agricultural schools end up going into other lines of work.

Sugarcane, a tropical grass, grows well in Jamaica. Much of the work of planting, weeding, and cutting sugarcane is done by machine, rather than by hand.

Jamaica is one of the world's leading banana producers. Bananas grow best on the mountain slopes of Portland and Saint Mary parishes, where they receive the abundant rainfall they require.

Blue Mountain Coffee is a brand-name, high-quality coffee bean, grown only on

After it has been harvested, sugarcane is transported to large, centralized factories for crushing and processing. As well as sugar, processing produces several by-products, including rum, molasses, molascuit (a type of cattle feed), and bagasse, a dry pulp used to make paper and fiberboard. All the island's cane factories burn bagasse in boilers to produce steam. The steam generates electricity to run the cane crushers and other processing equipment.

the southern slopes of the Blue Mountains where the trees are sheltered from the cool trade winds. Other types of coffee beans are grown in the lowlands.

Jamaica's main cacao-growing area is Saint Catherine Parish, a region sheltered from the trade winds by the central mountains. Cacao trees must be protected from strong sunlight, so they are planted among shade trees. Four plants on the island process harvested cacao pods into cocoa and chocolate.

Coconut palm trees grow in many regions of the island. Local processors make most of the coconuts into soap or edible oil.

Jamaica does not produce enough timber to meet its needs, so it imports wood and paper. The government encourages Jamaicans to replant trees, and it protects and develops some forested areas in national parks for recreational uses.

Cattle and goats are Jamaica's most important livestock animals, but the dairy industry has declined because of competition from imported dairy products. People also raise pigs and poultry.

Jamaica's fishers catch nearly all—93 percent—of their fish, shrimp, conch, and lobsters from the sea. Jamaica's catch has been declining steadily since the 1980s. Most fishers operate from canoes on the shallow coastal shelf surrounding the island, using fish traps and pots to catch fish, such as groupers and snappers. These fishers do not venture more than 40 miles (64 km) from the mainland. Others, equipped with large vessels, travel up to 300 miles (480 km) away. Jamaica is also home to a small freshwater fishery. Since the 1980s, ponds, rivers, and irrigation canals have been stocked with young fish, providing a cheap source of protein for many Jamaicans.

The Informal Sector

Jamaica's extensive informal economy includes many small-scale producers and distributors of goods and services. Self-employed individuals—such as small-scale farmers, street vendors (known as "higglers"), taxi operators, gardeners, and hairdressers—are also part of this sector.

A 1997 study estimated that 27 percent of Jamaica's employed labor force could be described as informal sector workers. These people usually have low and irregular incomes because they produce on a small scale, have low skill levels, and have difficulty borrowing money to improve their businesses. Many of their activities fall outside government regulations, so most do not contribute to the national pension plan, for example.

The Jamaican government is encouraging small businesses to improve productivity and generate higher incomes. Loan programs make some money available, and business management counseling is available. The

government is also trying to improve job training. Some Jamaicans learn work skills in formal training institutions or through courses offered by community groups, but many others learn by doing on-the-job tasks.

Transportation, Energy, and Communications

Most Jamaicans get around by bus, car, and truck. Roads and tracks crisscross the island, but there are only about 2,700 miles (4,345 km) of main roads. Many roads are badly designed and maintained, and road travel can be very slow and dangerous. Major highway construction and improvement projects are under way.

International airports are located near Kingston and Montego Bay, with passenger and freight air service provided by Air Jamaica and about a dozen international carriers. Business travelers and those who can afford it travel around Jamaica by air, using small airports near major towns and resorts.

Jamaica's main shipping ports are at Kingston and Montego Bay, but Ocho Rios and Port Antonio have facilities for cruise ships. Alumina and bauxite are shipped from specialized facilities on the north and south coasts.

Jamaica has no major rail lines. The British built a railroad that carried passengers and freight between Kingston and Montego Bay. However, service was discontinued after 1989. Sections of the rail line are still used to transport bauxite.

Air Jamaica flight attendants stand outside a Boeing 727. Air Jamaica is Jamaica's largest airline. For links to more information about Jamaica's economy, visit www.vgsbooks.com.

Jamaica's main energy source is imported oil. It is refined in Kingston to produce gasoline and diesel fuel for transportation and fuel for electrical power generators. To reduce their dependence on oil, Jamaicans are looking at various energy conservation measures and at using alternative fuel sources, such as alcohol, a by-product of sugarcane, for transportation.

The Jamaica Public Service Company generates and distributes most of the country's electricity, although some large industries generate their own power. Established in 1923, the company was the largest state-owned business in Jamaica until 2001, when a U.S. company acquired 80 percent ownership. Its generating stations are powered primarily by diesel and by hydroelectric power. More than 60 percent of Jamaican homes have electricity, and power is available in rural communities as well as in towns and cities.

Private companies run the telecommunications industry. The government is encouraging the expansion of this sector and competition between providers. The number of telephone landlines stood at 444,400 in 2002. With an estimated 1.4 million cellular phone subscribers in 2002, Jamaica is said to be one of the fastest growing cellular markets in the world.

The Future

Jamaicans are asking themselves how best to solve their many economic problems. In 2003 the country's national debt was greater than the GDP. The government has borrowed so much money over the years that, in 2003, almost two-thirds of its annual budget went toward repaying loans and interest. Some observers say the country's formal economy, based on the production of primary products such as food and bauxite, will be unable to pull it out of debt. Business and government are trying new approaches, such as developing programs for tourists who want to enjoy Jamaican heritage and culture rather than just sit on the beach.

Unemployment, especially among young people, represents another dark cloud on the horizon. A 2002 report revealed that 47 percent of young people aged 14 to 19, and 28 percent of those aged 20 to 24 are unemployed. The government attributed the cause to a lack of job opportunities, poor education, and lack of motivation or morale among young people.

Violence, especially in Kingston, still harms the country's international reputation and scares off visitors, putting the vital tourism industry at risk. Despite four government-sponsored studies of crime and violence published between 1993 and 2002, the problem continues. Violence is clearly linked to the economy. High unemployment, especially among

men, may be one reason for the prevalence of crime, as people turn to stealing or drug dealing to survive. Also, violence in the home often increases during periods of economic hardship and stress.

How to solve the crime problem has become a national debate, discussed in newspaper editorials and on radio talk shows. Some say poverty causes crime. Others say tough police action is needed, while others say law enforcement should accompany economic development. Many Jamaicans believe the key to reducing crime is to improve the living conditions of the poor. Others say that this would require massive government spending on social programs and put the country even more heavily into debt.

Some observers argue that the root of the problem is a breakdown of the country's moral principles. They say that because few underlying moral principles exist to guide their behavior, some people do whatever they think they can get away with. Furthermore, many young Jamaicans grow up in a culture in which violence is respected, gangsters are regarded as celebrities, and even some police have such nicknames as "cowboy."

Fundamentally, they say, Jamaican society is unstable because the old social values have collapsed, and new ones have not taken their place. A variety of measures, such as conflict resolution programs, drug abuse counseling, family life education, and sports and cultural activities for teens and communities, could help break the cycle of violence.

On top of these challenges, the government must provide its citizens with a good education and training if it wants to continue to attract high-tech businesses and keep its most promising young people from leaving. It must also control the spread of HIV/AIDS and protect its beautiful but fragile forests, mountains, and shores.

Jamaica has rich natural resources, a long and strong democratic tradition, and citizens who have proved to be survivors. It must find innovative ways of improving its economic situation and controlling violence to assure a bright future.

VIOLENCE IN THE CITY

Violence between members of rival gangs or between political opponents affects the residents of poor city neighborhoods in many ways. It sometimes reduces services such as garbage collection because city workers are afraid of being robbed or shot if they enter certain neighborhoods. Some people take a risk just going to work or school, even if they are not associated with gangs, since walking through the wrong neighborhoods can make them targets. Also, the fear associated with violence strains relationships and prevents people from trusting each other and working together.

CA. A.D. 650 The first wave of Tainos arrives from South America.

CA. 800 A second wave of Tainos moves to Jamaica from South America.

1494 Christopher Columbus anchors in Discovery Bay.

1510 The Spaniards establish the first European colony on the island.

1517 The first black African slaves are brought to Jamaica.

CA. 1520 The native Taino people have died out.

1655 A British force captures Spanish Town.

1663 The First Maroon War—which will last for seventy-six years—begins.

1670 Spain officially hands over Jamaica to Britain in the Treaty of Madrid.

1692 Half of Port Royal sinks into the sea during a violent earthquake.

1734 British soldiers destroy Nanny Town, the Windward Maroon stronghold.

1738 The colonial governor and the Maroons of Cockpit Country sign a peace treaty.

1795 Following the Second Maroon War, 600 Maroons are exiled to Nova Scotia.

1808 The British government declares the slave trade illegal.

1831 Government forces put down the Christmas Rebellion, led by Sam Sharpe. Violence continues for several months afterward.

1838 Jamaica's slaves are freed.

1850 A cholera outbreak in Jamaica kills an estimated 30,000 people.

1865 The Morant Bay Rebellion is put down, and Paul Bogle and George William Gordon are executed.

1872 The capital is moved from Spanish Town to Kingston.

1907 A large earthquake, followed by fire, destroys much of Kingston.

1938 Norman Manley and Alexander Bustamente found the People's National Party (PNP).

1940 The Moyne Commission report recommends self-government based on universal suffrage for the British West Indies.

1943 Bustamente founds the Jamaica Labour Party.

1948 Arthur Wint wins a gold medal in the 400-meter sprint during Jamaica's first appearance at the Olympic Games.

1953 The first shipment of refined alumina leaves Jamaica.

1958 The West Indies Federation is established.

1962 Jamaica officially becomes independent.

1965 Bustamente resigns as prime minister. Donald Sangster succeeds him.

1966 Thousands of Jamaicans come to the airport to greet His Imperial Majesty Haile Selassie I, emperor of Ethiopia, regarded as a god by Rastafarians.

1972 The movie *The Harder They Come*, starring reggae singer Jimmy Cliff, is a success.

1974 Democratic socialism becomes the government's political philosophy.

1976 Political violence escalates, and the government declares a state of emergency.

1978 Reggae singer Bob Marley holds the One Love Concert and sings on stage with the country's two leading politicians to encourage peace.

1981 Jamaicans mourn the death of thirty-six-year-old Bob Marley.

1988 Two earthquakes, in May and November, rattle the island. In September, Hurricane Gilbert devastates Jamaica, and the government declares a state of emergency.

1992 Prime Minister Michael Manley resigns for health reasons and is succeeded by P. J. Patterson.

1997 Jamaica's Reggae Boyz soccer team becomes the first Caribbean nation to qualify for a World Cup final round.

1999 Riots erupt after the government announces an increase in fuel prices.

2001 More than 1,100 people are killed in gang-related violence or by overzealous police.

2002 P. J. Patterson's PNP is reelected for a fourth term.

2004 Two hurricanes, Charley and Ivan, cause hundreds of millions of dollars of damage to Jamaica.

COUNTRY NAME Jamaica

AREA 4,243 square miles (10,991 sq. km)

MAIN LANDFORMS Coastal Lowlands, Central Limestone Plateau, Interior Highlands

HIGHEST POINT Blue Mountain Peak, 7,402 feet (2,256 m) above sea level

LOWEST POINT sea level

MAJOR RIVERS Rio Minho, Black River, Rio Grande, Rio Cobre, Yallahs River

ANIMALS Jamaican iguana, streamer-tailed hummingbird (doctor bird), giant swallowtail butterfly, green parakeet, hawksbill turtle, bottle-nosed dolphin

CAPITAL CITY Kingston

OTHER MAJOR CITIES Montego Bay, Spanish Town, Mandeville

OFFICIAL LANGUAGE English

MONETARY UNIT Jamaican dollar. 100 cents = 1 dollar.

JAMAICAN CURRENCY

Jamaica's monetary unit is the Jamaican dollar. The government adopted a decimal currency system in 1969, replacing the previous British-style system. Coins come in denominations of 1 cent, which pictures the akee fruit, and 10 cents, 25 cents, $1, $5, and $10 coins, illustrated with the faces of national heroes Paul Bogle, Marcus Garvey, Sir Alexander Bustamente, Norman Manley, and George William Gordon, respectively. Paper money is available as $10, $20, $50, $100, and $500 bills. All feature the pictures of national heroes or government ministers and colorful Jamaican scenes or national symbols.

The Jamaican flag was adopted when the country achieved independence in 1962. A committee of members of the House of Representatives designed the flag, which consists of a gold diagonal cross that creates four green and black triangles. Gold stands for the wealth and beauty of the sunlight, green represents hope and agricultural resources, and black depicts the strength of the Jamaican people.

The Jamaican national anthem, selected in 1962, has words by the Reverend Hugh Sherlock and music by Robert Lightbourne.

Jamaica, Land We Love
Eternal Father bless our land;
Guide us with thy mighty hand.
Keep us free from evil powers;
Be our light through countless hours.
To our leaders, great defenders,
Grant true wisdom from above.
Justice, truth be ours forever.
Jamaica land we love,
Jamaica, Jamaica
Jamaica land we love.

Teach us true respect for all;
Stir response to duties call.
Strengthen us the weak to cherish,
Give us vision lest we perish.
Knowledge send us Heavenly Father;
Grant true wisdom from above.
Justice, Truth be ours forever,
Jamaica land we love
Jamaica, Jamaica
Jamaica land we love.

For a link where you can listen to Jamaica's national anthem, "Jamaica, Land We Love," visit www.vgsbooks.com.

PAUL BOGLE (1822?–1865) Paul Bogle, one of Jamaica's national heroes, was born free (not a slave) in the village of Stony Gut. He learned to read, owned a small farm, and was a preacher at his village Baptist church. A friend of George William Gordon, Bogle led a rebellion at the Morant Bay courthouse in 1865. Bogle was captured and hanged, but his actions paved the way for a court system that treated people more fairly and improved social and economic conditions.

ALEXANDER BUSTAMENTE (1884–1977) Born Alexander Clark in Blenheim, on Jamaica's western coast, to an Irish planter father and a Jamaican mother, he took the name Bustamente from a sea captain who befriended him when he was young. As a young businessman, Bustamente worked in the United States. When he returned home in 1932 and set up a money-lending business, he sympathized with Jamaica's poor workers. He founded the Bustamente Industrial Trade Union and the Jamaica Labour Party. A strong nationalist, he helped lead the campaign to independence. This national hero was Jamaica's first prime minister when independence arrived in 1962.

MARCUS GARVEY (1887–1940) Born in Saint Ann's Bay, Garvey is a national hero in Jamaica. He founded the Universal Negro Improvement Association (UNIA) in 1914. The organization encouraged black people to be proud of their heritage and to regard Africa as their spiritual home. He moved to the United States in 1916 and set up branches of the UNIA, started a newspaper, and founded the Black Star shipping line to help people travel to Africa. The U.S. government jailed him for fraud in 1925 but later changed his sentence and deported him to Jamaica. He eventually moved to Great Britain, where he died in obscurity.

GEORGE WILLIAM GORDON (1818–1865) Born in Saint Andrew, this national hero and namesake of the national parliament building was a landowner, businessman, and member of the legislative assembly. Gordon criticized the British-appointed governor for not doing enough to help Jamaica's poor black peasants. The governor blamed him for the 1865 Morant Bay Rebellion, and Gordon was hanged after a brief trial. Gordon's efforts paved the way for changes that eventually led to self-government and democracy.

NORMAN WASHINGTON MANLEY (1893–1969) Manley, who was of Irish and black descent, was born in Roxborough, Jamaica, and first gained fame in track and field as a youth. He won a scholarship to study in Britain, became a skillful lawyer, and eventually a politician who helped guide Jamaica to universal suffrage and independence. He and Bustamente founded the People's National Party in 1938, and Manley led it until 1969. One of Jamaica's national heroes, he was married to sculptor Edna Manley, and his son Michael was also a national leader.

BOB MARLEY (1945–1981) The reggae superstar was born in tiny Nine Mile to a black mother and a British father who soon abandoned them. He spent much of his youth in a Kingston ghetto. He gained fame with his first hit song with his band, the Wailers, in 1963. Performing solo in the 1970s, he became world famous. He wrote songs that reflected the struggles of the urban poor, his rural roots, and his Rastafarian beliefs. Shortly before he died of cancer, he received Jamaica's highest honor, the Order of Merit.

MERLENE OTTEY (b. 1960) This great sprinter was born in Pondside (Cold Springs) in 1960 and attended the University of Nebraska. She began competing in international track meets in 1978 and has won more than forty-five gold, silver, and bronze medals in competitions including the Pan American Games, the Commonwealth Games, the World Cup, the indoor and outdoor World Championships, and the Olympic Games. Between 1989 and 1991, she had an unbeaten streak of seventy-five races. She is still running in her forties. The Jamaican government honored her in 1993 by appointing her an ambassador-at-large.

PERCIVAL JAMES PATTERSON (b. 1935) P. J. Patterson was born in Saint Andrew Parish, where his father was a farmer and his mother was a teacher. After attending university in the West Indies and in Britain, he became a lawyer and an active member of the PNP. Patterson was nominated to the Senate in 1967 and elected to the House of Representatives in 1970. He became party leader and prime minister in 1992 and won consecutive reelections in 1993, 1997, and 2002. He is Jamaica's first black prime minister.

MARY SEACOLE (1805–1881) Born in Kingston, Seacole was a nurse who worked at the same time and place as the more famous Florence Nightingale. The daughter of a Scottish soldier and a free black woman, she learned to use medicinal healing herbs and other nursing skills from her mother. After her husband died, she worked tirelessly during outbreaks of cholera and yellow fever in Jamaica. At the age of fifty, she went to the front of the Crimean War (1853–1856), near the Black Sea, to care for sick and injured British soldiers. She went from the warfront to Great Britain. Sick and poor, her former patients helped her, and her autobiography became a best seller.

OLIVE SENIOR (b. 1941) This award-winning writer was born in rural Jamaica and grew up in two households—that of her parents, who were peasants in the mountains, and that of well-to-do city relatives. A journalist, poet, and short story writer, her first collection of short stories, *Summer Lightning and Other Stories*, won a Commonwealth writers' prize in 1987. She is also the author of *A-Z of Jamaican Heritage*, an encyclopedic work on the island's natural and social history. She has taught at universities in Canada, the United States, and the West Indies and divides her time between Canada and Jamaica.

BATH MINERAL SPA Jamaica has several springs with varying mineral contents and radioactivity levels. This mineral spring in the southeast interior contains sulfur, lime, magnesium, and other minerals. The water emerges from the ground at both hot and warm temperatures, and these are mixed so visitors can bathe comfortably. The story goes that a runaway slave came across the spring in the 1690s, and when the water healed sores on his leg, he reported the discovery. People have bathed in its therapeutic waters ever since.

BOB MARLEY MUSEUM The birthplace and final resting place of the reggae musician is located in the Dry Harbour Mountains, a rugged, wooded region of Cockpit Country. Fans from around the world come to this remote site to see the hut where he spent part of his childhood, the rock where he sat while learning to play the guitar, and the marble crypt where he is buried.

GORDON HOUSE This simple brick and concrete building in downtown Kingston is the meeting place of Jamaica's Parliament. It became the official home of the government in 1960, replacing Headquarters House, the official site since 1872. Gordon House was named after George William Gordon. As a member of the House of Assembly in the 1850s, Gordon promoted the interests of the newly emancipated black peasants and helped bring about political reforms.

THE GREAT MORASS This 125 square-mile (324 sq. km) area, the country's largest wetland, extends inland from the mouth of the Black River. It is home to many crocodiles and more than one hundred species of birds, including egrets, herons, water hens, and jacanas. One resident of the Great Morass, the god-a-me, is an endemic species of fish that can also live out of water in damp leaves and mud.

MOUNTAIN RIVER CAVE Also known as Cudjoe Cave, this site of Jamaica's oldest artwork is hidden in a limestone cliff northeast of Spanish Town. The walls and ceiling of the small cave are covered with pictures done in charcoal mixed with animal fat. The drawings depict the silhouettes of birds, turtles, lizards, fish, frogs, humans, and other patterns. The Taino Indians made these drawings between 500 and 1,300 years ago.

PORT ROYAL This historic site sits at the tip of a long gravel strip at the entrance to Kingston Harbour. Port Royal was the principal port of the buccaneers who sailed the Caribbean in the 1600s. It was not only a very wealthy town, but some called it "the wickedest city in the world." Much of the town disappeared into the bottom of the harbor during the 1692 earthquake and tidal wave. Port Royal later served as the regional headquarters of the British Royal Navy. Efforts are under way to restore the site.

Anancy: (also spelled Anansi) a clever character who appears in many West African and Caribbean stories. He always has an answer for every situation.

bauxite: an impure mixture of earthy hydrous aluminum oxides and hydroxides that is the principal source of aluminum

breadfruit: a starchy fruit that can be baked, boiled, roasted, fried, or made into a flour substitute. It is a dietary staple in Jamaica.

buccaneer: a pirate, or sea adventurer, based in the Caribbean region during the seventeenth century

duppy: a ghost; an evil spirit

emancipation: the act of freeing from bondage, slavery, or control of another

ganja: marijuana

gross domestic product: the value of production within the country's borders by its workers. (This figure excludes the value of net income earned abroad.)

higgler: a seller in the marketplace

indentured labor: a system whereby a person makes a binding agreement to work for another for a specified period of time in return for the payment of travel expenses and maintenance

jerk: a type of barbecued meat or fish, seasoned with a special mixture of spices

Maroons: members of a community whose original members were escaped slaves. The name probably derived from the Spanish word *cimarrón,* meaning wild or untamed.

mulatto: free person of color; a person of mixed black and white ancestry

parish: a local government administrative region

patois: the language most Jamaicans speak on an everyday basis

obeah: black magic; voodoo

Rastafarianism: a religious cult among black Jamaicans that teaches the eventual redemption of blacks and their return to Africa. The cult employs the ritualistic use of marijuana, forbids the cutting of hair, and venerates the late Ethiopian emperor Haile Selassie I as a god.

reggae: popular music of Jamaican origin that combines local styles with elements of rock and soul music. Reggae is performed at moderate tempo with the accent on the offbeat.

trade wind: a strong, steady wind that blows across the Atlantic and Pacific oceans near the equator

Glossary

Selected Bibliography

Baker, Christopher P. *Jamaica.* 2nd ed. Melbourne: Lonely Planet Publications, 2000.
This travel guide has an extensive introductory section on Jamaican society, flora and fauna, and reggae music.

Black, Clinton V. *The Story of Jamaica.* Rev. ed. London: Collins, 1965.
This classic volume brings to life Jamaica's history, from the Taino people to independence.

Central Intelligence Agency (CIA): *The World Factbook.* 2004.
http://www.cia.gov/cia/publications/factbook/geos/jm.html (July 30, 2004)
The World Factbook contains basic information on Jamaica's geography, people, economy, government, and other areas.

Europa Publications. *Europa World Yearbook, 2002.* London: Europa Publications Limited, 2002.
This annual guide to the world's countries describes recent political events and lists many useful statistics and contacts.

Gordon, Lesley, ed. *Insight Guide: Jamaica.* London: APA Publications, 2000.
A beautifully illustrated guide, it describes the culture, history, flora and fauna, and interesting places of Jamaica.

Jamaica Information Service. 2004.
http://www.jis.gov.jm/ (September 10, 2004)
This government service provides news and feature reports about government departments and initiatives, as well as background information on Jamaican culture, sports, media, history, and national symbols. It also supplies information about acts passed by Parliament, national holidays, and election results.

Jamaica National Heritage Trust. 2004
http://www.jnht.com/l (September 10, 2004)
This organization is responsible for promoting Jamaica's rich heritage. The website includes a brief history of the country; descriptions of historic forts, churches, and properties of cultural significance; and news about archaeological projects and special events.

Jamaica Sustainable Development Network. 2004.
http://www.jsdnp.org.jm/ (November 5, 2004)
This website provides information on various environmental concerns in Jamaica, including threatened marine ecosystems and eroding hillsides. It also describes farming practices, energy sources, and human uses of the land. The site also has links for children and teachers.

Mason, Peter. *In Focus Jamaica: A Guide to the People, Politics and Culture.* New York: Interlink Books, 2000.
This slim but informative volume outlines the country's geography, history, economy, and culture.

Pan American Health Organization. 1999.
http://165.158.1.110/english/sha/prfljam.html (September 10, 2004)
This website has demographic and socioeconomic data on Jamaica, as well as descriptions of the health problems faced by young people, women, and the elderly and specific diseases commonly found in the country.

Planning Institute of Jamaica. N.d.
http://www.pioj.gov.jm/default.asp (September 10, 2004)
The Planning Institute of Jamaica publishes statistics and publications on the country's health, education, trade, and labor market, as well as annual reports on economic and social indicators.

PRB 2004 World Population Data Sheet. Population Reference Bureau (PRB). 2004.
http://www.prb.org/ (September 10, 2004)
This is a reliable and annually updated source of demographic data, such as birth and death rates, for countries and regions.

Rogoziński, Jan. *A Brief History of the Caribbean: From the Arawak and Carib to the Present.* Rev. ed. New York: Plume, 2000.
This book sketches the history of the whole Caribbean region, comparing differences and similarities between the islands as they became colonies and moved toward nationhood. It puts Jamaican events in a regional context.

Turner, Barry, ed. *The Statesman's Yearbook 2002: The Politics, Cultures and Economies of the World.* New York: Macmillan Press, 2001.
This annual resource provides concise information on Jamaican climate, government, and society.

Bradley, Lloyd. *This is Reggae Music. The Story of Jamaica's Music.* New York: Grove Press, 2000.
This book gives a detailed account of the origins of reggae in the downtown neighborhoods of Kingston and describes the personalities who shaped it and the links between the music and Rastafarianism.

The Chemistry of Things Jamaican
http://wwwchem.uwimona.edu.jm:1104/lectures/index.html
This website from the chemistry department of the University of the West Indies brings together a hodgepodge of facts about Jamaican products, including bauxite, spices, and rum.

Hausman, Gerald, and Upton Hinds. *The Jacob Ladder.* New York: Orchard Books, 1996.
This short novel, written for young people, is based on a true story about a twelve-year-old Jamaican boy and what happens when his father deserts the family. It is full of the sights, sounds, and smells of a small coastal town.

Jamaica Gleaner
http://www.jamaica-gleaner.com
The homepage of the daily newspaper that has been around since 1834 has all the major news and sports stories of the day, as well as links to Jamaican tourist destinations and community information. It also links to Pieces of the Past, a series of feature articles on the country's heritage and culture.

Jamaicans.com
http://www.jamaicans.com
This on-line magazine is a treasure trove of information on Jamaica and Jamaicans, including music, stories, patois, and recipes. There are feature articles about people, places, and issues, and a special section for children.

Kaufman, Cheryl Davidson. *Cooking the Caribbean Way.* Minneapolis: Lerner Publications Company, 2002.
This cookbook describes the cuisine and culture of the Caribbean and offers recipes for side dishes, main courses, desserts, and holidays, including vegetarian options.

Lewis, Matthew. *Journal of a West India Proprietor.* New York: Oxford University Press, 1999.
This is a reissue of an account, first published in 1834, by the British owner of two Jamaican plantations. He is fairly sympathetic toward his slaves and gives vivid descriptions of his experiences crossing the Atlantic to visit his properties. This edition includes background material.

Library of Congress, Federal Research Division. *Caribbean Islands: A Country Study.*
http://lcweb2.loc.gov/frd/cs/cxtoc.html#cx0000
The book posted on this website is part of a series of studies, sponsored by the U.S. Library of Congress, that examine the geography, history, and economic potential of various countries. The report on Jamaica is part of an on-line resource on the former British colonies in the Caribbean, including the Bahamas and Grenada.

Manley, Rachel. *Drumblair: Memories of a Jamaican Childhood.* **Toronto: Vintage Canada, 1996.**
The daughter of Michael Manley and granddaughter of Norman and Edna Manley focuses on the political events that were the fabric of her family's life. This book brings a personal perspective to recent Jamaican history.

National Heroes
http://www.moeyc.gov.jm/heroes/index.htm
This site, prepared by the Ministry of Education, Youth, and Culture, has images and stories about the seven historic figures revered as national heroes in Jamaica.

National Library of Jamaica
http://www.nlj.org.jm/
This institution's website includes tidbits of Jamaican history, biographies of well-known Jamaicans, a list of recommended Jamaican websites, and an extensive bibliography of books and articles on Bob Marley.

Portland Bight Protected Area
http://www.portlandbight.com.jm/index.html
This area on the southern coast includes mangrove swamps and dry limestone forests surrounding an ocean bay called Portland Bight. The website describes the vegetation, marine life, and terrestrial wildlife of the area, including endangered sea turtles and manatees and endemic species such as the Jamaican iguana.

Rouse, Irving. *The Tainos: Rise and Decline of the People Who Greeted Columbus.* **New Haven, CT: Yale University Press, 1992.**
Written by a noted archaeologist and anthropologist, this book describes the people who inhabited Jamaica when Columbus arrived, their ancestors, neighbors, and culture. It chronicles their eventual disappearance and their lasting contribution to modern culture, diet, and language.

Senior, Olive. *Discerner of Hearts.* **Toronto: McClelland & Stewart, 1995.**
This collection of short stories by the Jamaican-Canadian writer is filled with characters who are searching for their identities and trying to figure out what they really want in life. All the stories are set in Jamaica.

Story of Reggae
http://www.bbc.co.uk/aboutmusic/features/reggae/history_intro.shtml
This website from the BBC features the history of reggae and related music forms such as ska and dancehall, as well as articles on ragga dancing and fashions. These pages have lots of links.

vgsbooks.com
http://www.vgsbooks.com
Visit vgsbooks.com, the homepage of the Visual Geography Series®. You can get linked to all sorts of useful on-line information, including geographical, historical, demographic, cultural, and economic websites. The vgsbooks.com site is a great resource for late-breaking news and statistics.

Index

Captions for photos appearing on cover and chapter openers:

Cover: An aerial view of Montego Bay, Jamaica's most popular tourist spot. MoBay, as it is commonly called, is Jamaica's second-largest city and boasts more hotel rooms than any other part of the island.

pp. 4–5 Jamaica's Cockpit Country, covered in dense vegetation, is largely uninhabited. The area is home to many of Jamaica's native wildlife species.

pp. 8–9 One of Jamaica's most popular tourist attractions, Dunn's River Falls cascades 600 feet (183 m) down limestone boulders to a white sand beach. Visitors to the falls like to climb up the boulders, which workers routinely scrape clean of slippery algae.

pp. 20–21 Columbus Park is an open-air museum on Discovery Bay, where Christopher Columbus first set foot on Jamaica. The park contains various historical artifacts.

pp. 38–39 Methodist schoolchildren peer over a fence. Although primary education is free in Jamaica, more than half of the island's schoolchildren drop out before the age of fifteen.

pp. 46–47 On January 6, Maroons in the town of Accompong sing and drum under a large mango tree during the annual Maroon festival to celebrate the signing of the 1739 peace treaty.

pp. 58–59 A man catches shrimp on the Black River. Despite being an island, Jamaica imports about half of the fish it sells.

Photo Acknowledgments

The images in this book are used with the permission of: © Art Directors/D. Saunders, pp. 4–5, 17, 41, 49; © Ron Bell/Digital Cartographics, pp. 6, 11; © Sergio Pitamitz/CORBIS, pp. 8–9; © Art Directors/J. Highet, pp. 10, 13, 19, 20–21, 32, 56; © Robert Rattner, pp. 14–15; © Rykoff Collection/CORBIS, p. 24; Courtesy of the Institute of Jamaica, pp. 26, 27; © Hulton-Deutsch Collection/CORBIS, p. 30; © Najlah Feanny/CORBIS SABA, p. 34; © Reuters/CORBIS, p. 36; © Joan Iaconetti, pp. 38–39; © Sue Ford; Ecoscene/CORBIS, p. 44; © Tony Arruza/CORBIS, pp. 46-47; © Denis Anthony Valentine/CORBIS, pp. 50-51; © AFP/Getty Images, p. 54; © Bojan Brecelj/CORBIS, pp. 58–59; © James L. Amos/CORBIS, p. 60; © Art Directors/J. Greenberg, p. 63; www.banknotes.com, p. 68; Laura Westlund, p. 71.

Cover photo: © Danny Lehman/CORBIS; Back cover: NASA.